Studying Dance Cultures around the World

An Introduction to Multicultural Dance Education

Pegge Vissicaro, Ph.D.

Arizona State University

Foreword by Joann Keali'inohomoku, Ph.D.
Cross–Cultural Dance Resources, Inc.

KENDALL/HUNT PUBLISHING COMPANY
4050 Westmark Drive Dubuque, Iowa 52002

Cover design and dancer photographs: Sigrun Saemundsdottir, 2004 (Clockwise: Mari Kaneta—performer with Suzuyki-Kai Traditional Japanese Dance, Tucson, Arizona, Tony Duncan—World Teen Hoop Dance Champion and performer with Yellow Bird Dancers, Mesa, Arizona, Dana Brown—performer with Agbe Nunya, Tempe, Arizona). Background photograph courtesy of Fermilab National Accelerator Laboratory, Batavia, Illinois, 2004.

Contents

Acknowledgments

The creation of this textbook was not the effort of a single individual; rather it was a collaborative work in progress that took numerous years to complete. Material for the chapters was taken largely from lecture presentations that I had given for general studies dance appreciation courses where discussions focused on dance in diverse contexts. From those experiences, I gained valuable insight from my students whose feedback shaped the content of each class as well as the format to promote an effective and interesting learning environment. Also many colleagues, friends, and family members contributed ideas, edited sections, offered advice, and provided moral support.

A primary source of motivation for doing this project is my sons, Caio and Ari, and husband, Vito, a native of Brazil. We share an interest in exploring music and dance from around the world, influenced greatly by working with the renowned master drummer/dancer C.K. Ganyo of Ghana, and living in Brazil. This exposure to varied cultural knowledge systems fuels a desire to travel and discover more information. Through our journeys we recognize the value of understanding multiple perspectives and respecting all ways of life.

It is important to acknowledge my undergraduate and graduate alma maters since so much of what happened in those formative years defined my path. At the University of Michigan, Ann Arbor I became a Dancer and learned to love and appreciate various movement forms, especially "West African style" dance taught by the enthusiastic Vera Embree. Additionally, a rigorous academic orientation at the University of North Carolina, Greensboro opened my eyes to dance scholarship and awareness of the an-thropological basis of dance under the direction of Dr. Lois Andreasen.

Since I began working on this project several years ago, two individuals have been extremely instrumental to writing the text and who profoundly informed my ideas. One person is Elsie Dunin, a respected dance researcher, who is known for her work as a co-founder of the dance ethnology program at the University of California, Los Angeles (UCLA) and for her service with the International Council on Traditional Music, Ethnochoreology Study Group. The organization of this book is due to Elsie's vision and careful guidance. The other individual who stands as a pillar of wisdom and a powerful inspiration is Joann Keali'inohomoku, a major force in the development of dance cultural theory. She continues the legacy of Franz Boas, the father of modern anthropology, inherited through her teachers, Melville Herskovits, Alan Merriam, and Gertrude Kurath. By carrying the torch, Joann lights the path for future generations of scholars to follow. The entire theoretical foundation for the textbook is based on her work; thus, realizing this project would be impossible without Joann's generous support to clarify salient details and respond to the constant barrage of questions I had throughout the process.

I also would like to express my sincerest appreciation to the talented artist and photographer, Sigrun Saemundsdottir. She contributed the majority of images, which complement the text so beautifully, and created the extraordinary cover design. Finally, I am very grateful to Kendall/Hunt Publishing for allowing me to produce the book. It is because of their assistance, along with all the positive, encouraging people throughout my life, that I am able to offer this tool for promoting dance cultural study.

Preface

Studying Dance Cultures around the World is an introductory textbook for college and university students in dance appreciation and humanities-based courses. This book facilitates the critical examination of dance in its varied contexts around the world. The objective is to provide a holistic approach that addresses key topics for learning about dance cultures, situated within a broad theoretical framework. There are many important scholars whose contributions have provided a strong foundation for dance cultural study. Some of the work by individuals not discussed in the text is compiled in a selected bibliography intended to direct students and teachers towards other excellent research. Additionally, it is not possible to include all dance cultures of the world, nor have definitive, detailed descriptions of those that are presented in the book. Instead, this is a subjective treatment that offers food for thought, whetting the appetite to learn more. The selected bibliography is beneficial as a resource list and may raise awareness of various media that does exist.

Teachers will observe that examples of diverse dance cultures, with nearly 50 photos, illustrate ideas featured in the text. Supplementary discussion questions and creative projects stimulate thought processes to promote social knowledge construction and deepen understanding. Many variables impact the implementation of these materials. Class size, room configuration, student composition, and time factors may dictate that certain modifications be made. There are four activities that are meant to accompany the text and support instructional delivery. They are (1) engaging class participants in movement experiences, (2) interacting with people able to share traditional dance and music knowledge representing various areas of the world, (3) developing assessments for assignments using criteria defined by students, and (4) viewing videotape/DVD or other recorded media of different dance cultures. Having movement experiences is a fundamental part of learning about dance. This should occur in studio spaces or venues that allow for unrestricted movement exploration, which means that scheduling these areas must take place before classes begin. Similarly, schedules and budgets for hiring people to teach special movement sessions or provide demonstrations of traditional dance and music need to be established early in the planning process. It is important to incorporate the students' expertise about their own dance traditions. An attempt should be made during the first few classes to identify individuals who may be willing to teach a movement session or facilitate a presentation, for which they could receive extra credit. Assessments, created for certain assignments, can be collaboratively designed by the entire class or a designated group. Defining qualitative and quantitative evaluation guidelines sharpen critical thinking as well as create a learner-centered environment, emphasizing student accountability. Finally, a thorough investigation of media, such as videotapes/DVDs or other recorded information about dance cultures, will determine what is available in libraries, how to access materials, and if necessary, what must be ordered and budgeted to purchase for the future.

Students will find that the text functions as a guide for self study since many of the discussions questions/statements pertain to descriptions of personal experiences relative to the concepts presented. To broaden understanding, it is highly recommended that each individual keep a journal to record ideas and observations on a regular basis and to periodically assess new insights and changes in

perspective. A challenge for students is to positively embrace new experiences and interactions, which enhance knowledge construction and powerfully impact the process of studying dance cultures around the world.

Studying Dance Cultures around the World is the first book of its kind specifically designed to advance the field of multicultural dance education. Proponents of the field advocate the use of integrative teaching methods to create interdisciplinary curricula for cross-culturally studying dance and other human behaviors. This study leads to performance, research, publications, conferences, lectures, and classes often involving community collaborations or other types of socially embedded projects. Multicultural dance education exemplifies the *zeitgeist* of the past 30 years concerning a heightened consciousness about dance cultures of world. That consciousness is evident in work beginning with the 1972 Committee on Research in Dance Conference on "New Di-

mensions in Dance Research," through the present with events like those sponsored by Florida International University's Intercultural Dance and Music Institute (INDAMI) and UCLA's Department of World Arts and Cultures, as well as the 2003 National Dance Education Organization's conference on "Culture, Language, and Dance." This spirit grows even stronger since the demand for providing effective multicultural learning environments and instructional tools to compare diverse ideas and information is rapidly expanding due to an increasingly dynamic global society. People are recognizing and valuing cultural study as a skill that encourages greater acceptance towards those practicing different customs and traditions, which may lead to more benevolent relations between all humans. *Studying Dance Cultures around the World* is a point of departure for expanding multicultural dance curricula and serves as a catalyst to further develop content, learning strategies, and resources to strengthen the field as well as explore new directions.

Foreword

Two developments have surfaced in the curricula of many university and college dance departments in the last two or three decades. One is the addition of performance courses in dance genres drawn from various dance cultures around the world. This has expanded the limited selection typically offered in university and college studio classes for most of the twentieth century. The other is the augmentation of academic courses in dance theory, history, and philosophy, as teachers begin to honor many world dance traditions. These developments, although not yet fully accepted by many dance educators as heralding the future of dance education, show definite signs of becoming a trend. They emerge from the awakening that the whole world is richly endowed with a multitude of dance traditions.

In the past, and even to this day in the twenty-first century, the usual course concentrations in dance departments have been on concert dance forms derived from European classical ballet and the form ambiguously labeled "modern dance." The newly discovered wider world of dance is a revolutionary breakthrough, a bursting of the narrow ideas about dance that have bound the minds and bodies of dancers from mainstream Europe and mainstream North America.

Likewise, academic courses in dance departments are beginning to be considered incomplete unless they pay attention to dance cultures that represent the whole world. Until this new realization about "Other" dance cultures, academia was as bound as the university dance performance studio practices were bound. For many years private studios and culture centers made dances from various cultures avail-

able to those who sought them, but universities and colleges seldom officially paid attention to nonstandard dance forms. It is a fact that the full participation of the halls of academia is necessary to give the seal of approval to any studious endeavor and without that endorsement dances and dance cultures from around the world were ignored or undervalued.

A noteworthy exception was the movement for ordinary people to learn and perform folk dances. By the end of the nineteenth century folk dance classes were offered in settlement houses and parks and recreation centers throughout the United States, Canada, and Europe. Universities and colleges, too, often included folk dancing in their physical education curricula. But this interest in folk dancing did not address two problems endemic to university and college dance departments. First, folk dancing seemed to confirm elitist ideas that polarized art dance, thought to be superior, with "traditional" forms. Second, folk dancing itself was drawn primarily from European traditions, so the "world" in "world dances" was narrowly defined. Certainly most universities and colleges were slow to realize that the real world included interesting and valuable dance cultures beyond those found in the confines of the academy.

With the dawning of the realization that dance has domains other than the Western concert hall, some universities and colleges began to include studio classes of an invented category listed in their catalogs as "Primitive Dance." This was not only a misnomer, it was a fiction. There is not and never has been a dance genre that could rightly be called "Primitive Dance." The movement styles of this

contrived form resulted mainly from stereotypical ideas about West African and Caribbean dances. The innovators of this phenomenon did not include, and probably did not know about, the dances of many other societies throughout the world that might be called "primitive," and whose dance styles and form were very different from those in the so-called "Primitive Dance" fad.

However, some universities and colleges began to realize the value of legitimate dance genres outside the Western tradition. Most notably, classes for dances from Indonesia, West Africa and Spain and a few other notable forms were included in some academic settings. But learning new performance forms does not guarantee the understanding and appreciation of the dance cultures that fostered those forms. That is where courses in dance theory, history, and philosophy became especially important.

As so often happens when innovative ideas begin to enter the academic mainstream there is a lack of appropriate teaching materials. Bewildered teachers who are expected to work with new ideas do not have the tools to do so.

This is the situation I have seen over the years. Some university and college teachers seek advice about teaching classes in the history and anthropology of world dance for which, they confess, they have no previous training or experience. Some teachers seeking help feel desperate when a course in world dance appreciation is arbitrarily assigned to them. Typically they have no choice about their assignment to teach a course in world dance history or appreciation for which they are unprepared. Usually they have only a few weeks to become familiar with complex ideas and nuanced materials that have to be organized into a valid course.

Teachers often have to climb the learning curve so fast they cannot sort out which materials are significant, or how to evaluate their findings. In their search for cross-cultural understanding of dance cultures students are short changed or worse, when they are given faulty interpretations, misleading ideas, and vocabulary used loosely or incorrectly.

This presents a conundrum. On the one hand, educators should not be obliged to teach a class for which the preparation is inadequate. On the other hand, the new awareness of the richness of the world of dance should not be stifled. Insufficiently prepared teachers should be given the tools to proceed successfully rather than having to abandon new courses.

This book, *Studying Dance Cultures around the World*, by Pegge Vissicaro, provides a lifeline for such a teacher. It has valuable tools for addressing theory and methods to teach and learn about the dance cultures around the world. The text will serve as a template for immediate and future studies as it introduces the concept of dance cultures and comparative cross-cultural studies. It identifies important vocabulary words and presents approaches to the study of dance cultures. With stimulating ideas drawn from the work of dance ethnologists and from the author's personal experiences in the classroom as well as in the field, this is a helpful book. It is written clearly and nicely organized with a wealth of examples and resources. This book will take teachers and students alike into the rich world of dance and dance cultures.

What the book is NOT is a book of instructions for performing dances from various cultures. Neither is it an encyclopedic indexing of dances around the world. Instead, it is a book of discovery that opens doors to a world of dance cultures. This book will provide new avenues of thought. In truth, this book fills an academic and practical void.

The author, Pegge Vissicaro, addresses the challenges facing faculty and students as they enter that world of multiple dance cultures. Throughout her life Pegge has felt compelled to learn about peoples and their dances. Early in her career she began serious studies of Caribbean dances and that led her to both West African dance cultures and the Latin American dance scene.

When C. K. Ganyo, dancer extraordinaire from Ghana, relocated in Phoenix, Arizona, Pegge served as Executive Director for his performance group, "Adzido West African Folkloric Ensemble" from 1991–2002.

Pegge pursues serious studies of dance cultures in Brazil and divides her time between Brazil and Arizona. In Arizona she is committed to refugee groups located in the Phoenix area. Her visionary program of "Freedance," encourages homesick refugees to find solace by dancing and socializing together.

As an educator and scholar, a dancer and performer, and participant in many dance cultures, she is the ideal guide for *Studying Dance Cultures around the World*. In her role as a faculty member of the Dance Department at Arizona State University, she has ushered hundred of students through her popu-

lar class "Dance in World Cultures." As Pegge shares her expertise, experiences and enthusiasm, students discover that entering the world of dance cultures is an adventure to savor. She provides them with study tools so that their journey is a fascinating and rewarding experience.

Pegge is the founder/director of the dance company Terra Dance. She is also the President of the Board of Directors for the nonprofit organization, Cross-Cultural Dance Resources.

Joann W. Keali'inohomoku
Flagstaff, Arizona
June 2004

Dance as Orientation

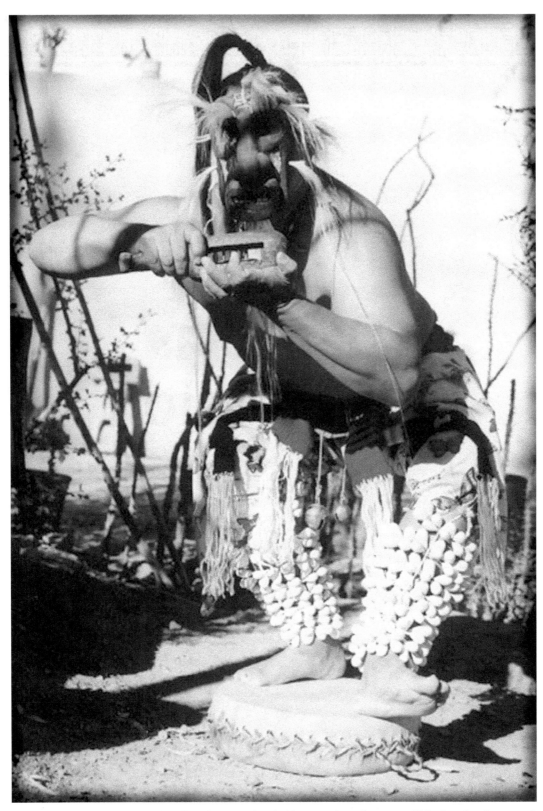

"Mother Earth is like a drum. What I do here or when I visit somewhere far away will be heard at home and all around the world. News will spread of what I have done whether it is good or bad. The sound I make when I dance on one end of the drum carries to the other side of the drum. So I am reminded that no matter wherever I am or what I do, the news will eventually come back to my community. I am always on the drum head and I want good news to get back to my community." Merced Maldonado, Yaqui Pascola, Guadalupe, Arizona (Photograph by Sigrun Saemundsdottir Guadalupe, Arizona 2003).

Chapter 1

Multicultural Dance Education

Introduction

The focus of this textbook is dance as a human cultural phenomenon. Phenomenon refers to an observable fact or event, usually described as any state or process known through the senses.[1] Importantly, dance has existed in all societies throughout geographic space and historical time. With that understanding, we quickly realize how overwhelming a task it is to provide a specific curriculum or set of instructional tools for the purpose of studying dance cultures around the world. It is literally impossible to compile all materials for every type of dance form into a single comprehensive package. Taking an alternative approach, it is realistic to develop key strategies and critical techniques that facilitate learning about this extraordinary behavior as it occurs and has occurred among diverse groups of people. That is the objective of multicultural dance education, which involves collaborative knowledge construction to promote interactions and broaden perspectives.

Dance provides a lens for exploring the world, its people, and their cultures. Evolving from everyday movement, dance is one way that individuals interact with the environment and each other. By nature, people differ, adapting to their dynamic surroundings. Just like our Earth habitat, humans and their behaviors continually change as a result of various conditions. We react to these changes in environment that shape subsequent interactions. Traveling in an ever evolving continuum of events, our past actions inform the present and influence the future.

Living in a Multicultural World

We live in a world consisting of people that represent a wide range of viewpoints, traditions, and lifestyles. This diversity increases by the dissemination of ideas generated today from telecommunication systems. Those of you who have access to the Internet know how easy it is to journey across the globe and visit Web sites created by individuals from practically every country on the planet. On a day-to-day basis, it is not always obvious that we are interacting with people who have different cultural frameworks for interpreting information. Like the Internet, our interactions are mostly seamless, with smooth transitions as we pass from one set of values and beliefs to another. Culture is invisible since we usually do not notice or are not consciously aware of its influence upon people's behaviors. Yet of course, if we sit down and think for a moment about why we act the way we do, we realize that indeed there are many differences and factors impacting these variations. The differences have to do with individual information databases that we use to store, interpret, and construct meaning.

This notion of an internal information system that guides our actions is, in fact, how we may describe culture, discussed more thoroughly in Chapter 6. All humans have a personal cultural system that shapes how they understand the world in which they live. Using that idea, we see ourselves as living in a culturally heterogeneous world, or one with "many cultures."

3

Multicultural Education

Multicultural education today is a result of many historical events. The civil rights movement in the United States is one of these events that began in the mid-twentieth century. This movement stimulated interest in minority concerns, which continued to grow and influence the creation of programs such as affirmative action in the 1960s. Affirmative action policies assisted people who were identified as a minority by providing increased opportunities for employment and promotion, college admissions, and the awarding of government contracts. The term "minority" might include any underrepresented group, especially one defined by race, ethnicity, or sex. Generally, affirmative action has been undertaken by governments, businesses, or educational institutions to remedy the effects of past discrimination against a group, whether by a specific entity, such as a corporation, or by society as a whole. There certainly are advantages and disadvantages for instituting affirmative action programs; however, it is important to recognize that the initiation of these programs fulfilled a need to create and enrich environments, whether in the workplace or in school, with people having a wider range of perspectives about the world.

Discrimination, which will be addressed again in Chapters 7 and 8, is a complex socio-political issue motivated in large part by ignorance. The most effective way to address ignorance about minority groups is by providing education to increase awareness of and thus place greater value on their unique customs, ways of life, and expressions. This type of education also helps to empower underserved groups by allowing their voices to be heard.

The philosophy of multiculturalism surfaced to diminish the earlier idea of building a social "melting pot." A melting pot ideal encouraged assimilation of minorities into the dominant group and thus became a powerful tool of control. Multiculturalism worked against that concept by embracing diversity and bringing issues of ethnic and cultural identity to the forefront. Multiculturalists, or people whose work emphasized these types of issues, hoped to extinguish minority discrimination especially in school systems with curriculum reform that addressed culturally diverse instructional content. Major attempts at reforming academic institutions occurred throughout the 1980s. This reform was fueled by research about social learning theories, which emphasized the importance of treating students as critical agents who were provided the conditions to speak, write, and assert their own histories and experiences.[2]

Central to multicultural education is the focus on identity—specifically a wide representation of identities that reveal a more accurate picture of the world in which we live. By being exposed to and experiencing different points of view, we attain essential life skills that help us get along with others in an increasingly dynamic social environment. Educator James A. Banks explains that, through a multicultural approach, people become more fulfilled and able to benefit from the total human experience.[3]

However, one problem arises in contrast to the positive aspects of multicultural education. In an attempt to overstress ethno/cultural distinctions, we sometimes promote greater separation between individuals or groups of people. Multiculturalism encourages us to distinguish ourselves from others by placing specific boundaries as a form of identification. This kind of cultural segregation digs trenches which are difficult to cross. For some, the thought of entering boundaries created by ethno/cultural dissimilarities is like encountering a border patrol between national or state lines. In most cases, we are required to pause and recognize our advancement into another territory. The percussive or abrupt stopping of movement that characterizes this observance of difference may be an inhibiting factor that actually prevents us from passing through the border. It is important to realize that often these borders are managed or controlled, usually serving political purposes. Aside from politics, are these boundaries really necessary? Will we lose our identity if we relax

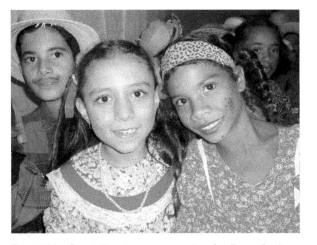

Figure 1-1. Quadrilha dancers preparing for Festas Juninas, Guaraná, Espírito Santo, Brazil (Photograph by Pegge Vissicaro, Guaraná, Espírito Santo, Brazil, 2003).

our cultural borders? Can we fill the trenches that are perceived to surround us? If so, how?

Dance and Multiculturalism

Dance creates a bridge for traversing cultural borders because fundamentally it involves the human body, something that all people have in common. This commonality provides a thread of connection and promotes unity among many people of the Earth. The body is an amazing instrument, extending human perceptions and thoughts. Each person has his or her own particular body for which there is no duplicate (unless cloning is an option). We all move in our special ways through space and time. By observing people move, it is easy to find variations based on multiple factors such as height, weight, age, and clothing. Importantly, movement is a reaction of how a person senses and thinks in relation to their surroundings and what is happening within that environment.

Likewise, every human being dances with idiosyncratic characteristics and qualities, defining that individual. No two people dance the same way. Even in the most synchronous movement activity where dancers try to do the steps in perfect unison, there are always subtle nuances differentiating each person's style.

As previously discussed, all of us possess a personal cultural system that shapes how we make meaning and interact in the world. Culture also impacts the way a person dances. In other words, dance is culturally derived and therefore culture specific. Why, where, when, and especially how you dance is unique because it is it is your personal cultural system that informs your understanding, and no one else is able to replicate it. Dance can reveal as many different cultural systems as there are people on this planet. Further, any discussion or critical study of dance that includes more than one individual representation, geographic space, and/or historical time is multicultural.

There are two basic ways to employ dance as a tool to explore different cultures. One is as a theoretical approach, which uses conceptual frameworks for looking at dance around the world, as our text

provides. The second approach is through the physical application, or doing the actual movement. This type of "trying on" culture is an extremely interesting entry to learning about world perspectives. Perhaps it is the intimacy and vulnerability of using one's body that opens us up to experiencing something new. We may feel uncomfortable at first, but even with limited exposure, movement activities are a most satisfying and pleasurable way to journey across cultural boundaries.

It makes sense that, in a world where we constantly interact with others representing varied cultural perspectives, there is a need for educational opportunities that promote diverse experiences. Multicultural dance education is one fascinating way to explore cultural knowledge as revealed through the body. Movement study, because of its focus on the physical self, offers insight as to how people from different regions understand themselves and each other.

Summary

The phenomenon of dance as human behavior is universal in every society. Studying the multiple manifestations of this behavior around the world is a complex process that involves acknowledging the different ways each individual interacts within the environment, informed by a personal knowledge system from which to construct meaning. Dissemination of new ideas impacts the development of these knowledge systems to promote greater diversity. Multicultural dance education includes both the theoretical and practical study of dance to examine viewpoints and learn about people.

Notes

1. Cognitive Science Laboratory. Princeton University. Word Net. Accessed April 20, 2004 at http://www.cogsci.princeton.edu/cgi-bin/webwn?stage=1&word=phenomenon.
2. Aronowitz, Stanley, & Giroux, Henry A. (1993). *Education still under siege* (2nd ed.). Westport, CT: Bergin & Garvey.
3. Banks, James. (1999). *An introduction to multicultural education.* (2nd ed.). Boston: Allyn and Bacon.

Discussion Questions/Statements

Write your responses to the following questions in the space provided. Collaborate with one or two other students and explore their ideas to the same questions. Examine similarities and differences in the various responses.

1. When you think of dance, what images come to your mind?

2. How many people have you interacted with in the past 24 hours, week, month, and year that come from areas of the world different than yours? Describe.

3. How would you describe multicultural education and what type of experiences would you include in an educational program geared toward increasing awareness of people around the world?

4. Have you attended any activities or special events in the past that promote multicultural awareness? If so, what were they?

5. What courses or components of courses have you participated in that address multiculturalism? Describe.

6. Have you ever studied dance representing diverse regions of the world? If so, what were they? Describe your feelings toward learning dances that differ from those you knew or were accustomed to doing. If you have not studied any dances from different places around the world, how would you feel about doing so?

Creative Projects

Movement Activity—Try the following experiment: Ask a volunteer in class to move "naturally" from one side of the room to the other. Write down as many details as possible to describe his or her movement. Also have this person describe on paper how he or she felt while moving and in what ways his or her past experiences affected the movement. Now repeat this process with another volunteer. After you have finished, ask both individuals to move at the same time. Again, ask each individual to comment on his or her feelings about moving in conjunction with the other person. Compare "data" by responding to the following questions.

1. What similarities did both individuals exhibit (physical features)? How did these similarities impact the way they moved?

2. What differences were there between the two people? How did these differences influence their movement?

3. How did the classroom space affect the movement of both students?

4. Listen to what each student's response was toward moving alone and with each other, and ask yourself, how did these feelings inform movement?

Curriculum Design—Create a proposal, which you will submit to the local Board of Education, requesting the implementation of a Multicultural Dance Education Program for an elementary school (K–5). Your proposed annual budget is $10,000.00. How would you design this proposal and what types of activities would you include? Describe as many details as possible.

Internet Resources (a required assignment to be completed by all students)
Surf the Internet and locate one Web site that describes dance culture of people from a country other than the United States. Critically evaluate the site for its authority, accuracy, coverage, and objectivity by responding to the following questions. After assessing your response to these questions, determine to what extent the site increases awareness about this particular dance tradition.

1. Is it clear what organization, individual, company, etc. is responsible for the contents of the page?

2. Does the organization, individual, company, etc. responsible for the site provide credentials or describe qualifications for writing on this topic?

3. Is the material protected by copyright?

4. Are the sources for any factual information clearly listed so they can be verified in another source?

5. Is there a bibliography provided to reference information described?

6. Is the information free of grammatical, spelling, and typographical errors?

7. Do all the links to other pages and/or Web sites work?

8. If there are charts, graphs, photos, video and/or audio clips, are they clearly labeled and easy to read?

9. Are downloads available to support software needed to "read" these media files?

10. Is the information free of advertising? If not, is it clear what the motivation is for advertising on the Web site?

11. Are there dates on the Web site to indicate when the page was written, first placed on the Web, and/or last revised?

12. Is there an indication that the site has been completed and is not under construction?

13. Is the information provided sufficiently described or adequately detailed?

14. Is the site available in multiple languages?

15. Is there a mirror site to facilitate access in various parts of the world?

Notes

Chapter 2

Humanities and Dance

Introduction

This chapter situates multicultural dance study in the field of humanities. The questions of how and why dance fits into the scope of that discipline also are examined in more detail. Part of our focus is to construct working definitions of the terms humanities, anthropology, and dance. We also explore historical events and major contributors to the development of dance cultural study.

As we observed from Chapter 1, dance is a human phenomenon. When we observe dance, we are observing the specific movement of a people. Some individuals think that animals, fish, and/or insects dance. However, it should be emphasized that although these creatures exhibit patterned movements or create certain spatial designs that appear to be dance-like, they are not dancing. The renowned dance scholar, Joann Keali'inohomoku, supports this idea. "So far as is now known, no species other than human formulates ideas about <u>d</u>ance or <u>D</u>ance, and no animal other than human willfully attempt to achieve dance skills; neither do they identify themselves as <u>d</u>ancers or <u>D</u>ancers."[1] As we provide parameters for understanding what constitutes dance behavior, it is easier to remain focused on germane ideas pertaining to our topic of multicultural dance education.

Minimal Definitions

HUMANITIES

The field of humanities broadly refers to discovering knowledge about human nature. Humanities study explores traits, qualities, feelings, thoughts, actions, interests, and values of people as well as their interrelations. From the Latin, *humanus*, humanities are clearly rooted in understanding the human condition.

According to the 1965 National Foundation on the Arts and the Humanities Act, "The term "humanities" includes, but is not limited to, the study of the following: language, both modern and classical; linguistics; literature; history; jurisprudence; philosophy; archaeology; comparative religion; ethics; the history, criticism and theory of the arts; those aspects of social sciences which have humanistic content and employ humanistic methods; and the study and application of the humanities to the human environment with particular attention to reflecting our diverse heritage, traditions, and history and to the relevance of the humanities to the current conditions of national life."[2]

The National Endowment for the Humanities (NEH) uses this information as a guideline for cultural institutions, such as museums, archives, libraries, colleges, universities, public television, and radio stations, and to individual scholars that submit grant proposals. Annually the NEH, an independent grant-making agency authorized by the United States government, requests an appropriation for grants, which for 2004 was $152 million, that (1) strengthen teaching and learning in the humanities in schools and colleges across the nation, (2) facilitate research and original scholarship, (3) provide opportunities for lifelong learning, (4) preserve and provide access to cultural and educational resources, (5) strengthen the institutional base of the humanities. The NEH does not typically fund dance performance or the creation of new work. Rather, they support activities that involve history, literature, philosophy, sociology, and anthropology studies.

ANTHROPOLOGY

This link to the discipline of anthropology is very important to investigating humanities and dance. Anthropology comes from the Greek words *anthropos* meaning "human" and *logia,* which means "study." Thus, anthropology is a systematic study of humankind in all of its aspects. The work of many researchers and scholars shape the field. However, it is Franz Boas (1858–1942) (fig. 2-1) who provided the elemental components for building a theoretical foundation for cultural anthropological study. Perhaps Boas's single most significant contribution is the recognition that every group of people has a cultural network or shared knowledge system, which provides social integration as well as a unique history with rules that govern how they operate. His research on the Northwest Pacific Coast Indians at the beginning of the twentieth century reveals that the differences in groups of people are the result of historical, social, and geographic conditions and that all populations have a complete and equally developed set of cultural traits. The concepts of historical particularism and cultural relativism respectively set the stage for comparative human studies that em-

phasize the "native's point of view."[3] As we will discuss in the next chapter, information about the insider's perspective is necessary to understanding a particular culture.

Boas's work was important for two additional reasons. First, it situated dance research in the social sciences, as a serious academic study. The content of dance "literature" no longer exclusively focused on dance as an art form or entertainment or as a document for historical purposes. Secondly, he introduced the concept that dance was an integral part of human society, woven into the fabric of life. In a lecture presented at a 1942 seminar, directed by Boas's daughter Franziska, he elaborated on ideas in which he observed dance in exactly this type of central role. He wrote that nearly "every aspect of Kwakiutl life is accompanied by some form of dance, from the cradle to the grave."[4] This statement and the seminar in general opened the door to further research about dance as a primary and vital human behavior.

During the 1940s and 1950s, another significant development occurred that influenced the fledging field of dance cultural study. Gertrude Kurath (1903–1992) (fig. 2-2), a dancer, choreographer, teacher, and musician was writing about dance and music traditions in Mexico and in the United States among the Iroquois, Chippewa, and Tewa indigenous people. In 1946 her work about the Los Concheros in the *Journal of American Folklore* marked the beginning of her career as a dance ethnologist.[5] She also was the dance editor of the scholarly journal, *Ethnomusicology,* and published articles in *American Anthropologist, Southwestern Journal of Anthropology,* and *Scientific Monthly.* Kurath coined the term "ethnochoreology," which corresponds to the word "ethnomusicology." These words denote holistic, cross-cultural studies that contextually approach the topics of dance and music.[6] Another key factor informing Kurath's research was the importance she placed on studying relationships between dance and music, working from the perspectives of an ethnochoreologist and ethnomusicologist. This was quite remarkable since few scholars had the ability to conduct both music and dance analyses.[7]

Many people use the term ethnochoreology, most especially those dance researchers who are members of the special section on dance of the International Council on Traditional Music (ICTM). The ICTM is a non-governmental organization (NGO) in formal consultative relations with the United Nations Edu-

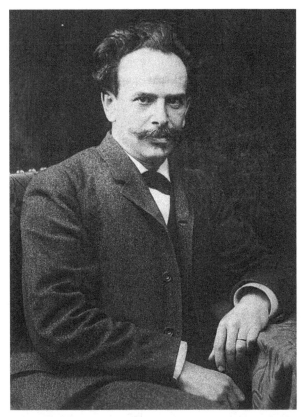

Figure 2-1. Franz Boas, 1906 (Photograph courtesy of Bettmann/Corbis).

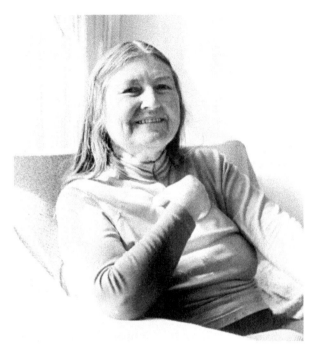

Figure 2-2. Gertrude Kurath Prokosch at home in Ann Arbor, Michigan (Photograph courtesy of Joann Keali'inohomoku, Cross-Cultural Dance Resources, Inc., 1972).

cational, Scientific and Cultural Organization (UNESCO). The aims of the ICTM are to further the study, practice, documentation, preservation, and dissemination of traditional music, including folk, popular, classical, and urban music, and dance of all countries.[8] The word "ethnochoreology" is widely used around the world. One reason for such a global acceptance is because interpretation of the combined terms "etno" and "koreo" in other languages generally refers to people and dance, and "ology" or "ologia" is the study of a particular topic. Therefore the term is understood in most Indo-European languages, such as etnokoreologia in Croatian.[9] However, the phrase "dance ethnology" is most common in the United States. Kurath makes ethnochoreology synonymous with dance ethnology, defining it as "the scientific study of ethnic dances in all their cultural significance, religious function or symbolism, or social place."[10] Another useful definition suggests that dance ethnology, as a field in the social sciences, "brings together aspects of anthropology, history, biology, psychology, sociology, and the arts, which combined help to enrich the study of dance as a cultural indicator, a form of human behavior, and a component of human communication codes."[11] These descriptions help to identify the discipline that frames our study of dance cultures around the world.

DANCE

In addition to situating dance research within humanities, specifically the field of anthropology, it is necessary to define what we mean by dance. Another pioneer in the field of dance ethnology, Joann Keali'inohomoku (fig. 2-3), provides us with the following definition, which we will refer to through our text because of its universal application to all forms of dance. "Dance is a transient mode of expression, performed in a given form and style by the human body moving in space. Dance occurs through purposefully selected and controlled rhythmic movements; the resulting phenomenon is recognized as dance both by the performer and the observing members of a given group."[12]

The first part of the definition identifies dance as a transient or changing mode of expression. Recognizing dance as dynamic is important because, like culture, there are many influences that shape our ways of living and moving. When people process ideas or adapt behaviors to new situations, they

Figure 2-3. Joann Keali'inohomoku (Photograph courtesy of Joann Keali'inohomoku, Cross-Cultural Dance Resources, Inc., 1995).

interact differently. We will discuss in Chapter 5 how context impacts behaviors that may alter a movement, the meaning of the dance, use of props or extensions of the body, and even the entire dance repertoire of a group. The transitory nature of dance also suggests that it is ephemeral, lasting only for the moment. Feelings, images, interactions, and understandings about the dance come together at a particular point in space and time, never to combine in exactly the same way again. The ongoing transformation of dance is important to acknowledge as we investigate dance cultures representing different geographic regions and throughout history.

The second part of Keali'inohomoku's definition of dance focuses on the idea that dance involves purposefully selected movements that are recognized as dance by the performer and observing members of a given group. In Chapter 10, we will be examining how dance selectively represents values and beliefs of a specific culture. This concept positions dance as a transmitter of cultural knowledge. The other critical information stated in Keali'inohomoku's definition, and that supports our previous discussion about culture, is that dance emerges as a result of shared meaning. In other words, the dancer and observers use criteria or information from within a particular cultural knowledge system to determine whether a particular phenomenon is or is not dance. That idea transitions us into the next chapter where we will explore comparative frameworks using perspectives inside and outside cultural systems to study the world of dance.

Summary

There is tremendous rationale for including multicultural dance education within humanities curricula. First, it focuses on understanding dance as human phenomenon, which reveals the human condition. Humanities studies also provide a link to cultural anthropology, emphasizing shared knowledge systems that guide behavior, such as dance. Finally, anthropological theory informs the development of a universal definition that offers a holistic view for understanding all dance.

Notes

1. Keali'inohomoku, Joann W. (1976). *Theory and methods for an anthropological study of dance.* Ph.D. dissertation, Indiana University. *Dissertation Abstracts International 37-04,* #7621511, ProQuest, Ann Arbor, MI, p. 2278. The underline emphasizes differences between the lower case "d" referring to relatively unskilled participants and the upper case "D," which involves highly trained specialists.

2. National Endowment for the Humanities web site. Accessed on January 10, 2004 at http://www.neh.fed.us/whoweare/overview.html.

3. Feleppa, Robert. (1990). Emic analysis and the limits of cognitive diversity. In T. Headland, K. Pike, & M. Harris (Eds.), *Emic and etics: The insider/outsider debate* (pp. 100–119). Newbury Park, CA: Sage Publications.

4. Boas, Franz. (1942). Dance and music in the life of the northwest coast Indians of North America. In F. Boas (Ed.) *The function of dance in human society*, 5–19. Brooklyn, NY: Dance Horizons.

5. Snyder, Allegra F. (1992). Past, Present and Future. *UCLA Journal of Dance Ethnology, 16,* 1–28. Mrs. Snyder is a faculty emerita and co-founder of the dance ethnology graduate program at University of California, Los Angeles.

6. Keali'inohomoku, Joann W. (1986). Honoring Gertrude Kurath. *UCLA Journal of Dance Ethnology, 10,* p. 4.

7. McAllester, David P. (1972). Music and dance of the Tewa pueblos by Gertrude Prokosch Kurath and Antonio Garcia (book review). *Ethnomusicology, 16*(3), 546–547. Ann Arbor, Michigan: Society of Ethnomusicology.

8. International Council on Traditional Music. Accessed on January 16, 2004 at http://www.ethnomusic.ucla.edu/ICTM/.

9. Dunin, Elsie. Personal communication, January 15, 2004. Mrs. Dunin is an independent researcher, faculty emerita, and co-founder of the dance ethnology graduate program at University of California, Los Angeles.

10. Kurath, Gertrude. (1960). Panorama of dance ethnology. *Current Anthropology 1*(3), 235.

11. Snyder, Allegra F. (1992). ibid.

12. Keali'inohomoku, Joann W. (1976). A comparative study of dance as a constellation of motor behaviors among African and United States Negroes (with a new introduction). In A. Kaeppler (Ed.), *CORD Research Annual 7* (pp. 1–13), NY: CORD; Keali'inohomoku, Joann W. (1969–1970). An anthropologist looks at ballet as a form of ethnic dance. In M. Van Tuyl (Ed.), *Impulse* (pp. 24–33). San Francisco, CA: Impulse Publications.

Discussion Questions/Statements

Write your responses to the following questions in the space provided. Collaborate with one or two other students and explore their ideas to the same questions. Examine similarities and differences to the various responses.

1. Do you agree with Keali'inohomoku's statement suggesting that dance is only a human phenomenon? Why or why not?

2. In your own words, how would you describe the field of humanities to an 8th grade student? To a 3rd grade student? To a peer? Compare the words and approach you use to explain what humanities is to these different people.

3. Boas's term "historical particularism" is important because it emphasizes how, in the case of dance, cultural knowledge and respective behaviors are specific to the time period in which they occur. What dance or type of dance can you think of that identifies a particular time in history and why? How would you describe characteristics of the dance (movement style, way people relate to each other, physical setting, clothing, etc.)?

4. Describe changes in your understanding of dance from one point in your life to another. How have certain experiences and information to which you have been exposed (besides reading this book) influenced and transformed how you "see" dance?

5. Is dance an integral part of your life? Why or why not? Do you think that dance is/was a central component in the lives of your parents? Your grandparents? Why or why not?

6. Design your own definition of dance. Compare your ideas with one or two other students and discuss what is or is not dance. Then collectively construct a definition of dance that reveals your shared understanding.

Creative Projects

Role Playing—Imagine yourself as an ethnochoreologist who has received a grant to study dance among one group of people somewhere in the world. However you do not speak their language and will need to hire an interpreter to interview the group's leader. What would be the first question that you ask and why? If you could only ask three questions, what would they be? Explain.

Grant Design—You are submitting a grant proposal to do a humanities project involving dance cultures and world traditions. Provide a brief description of the project including the audience which this project is geared towards, key objectives, a time line, personnel, materials/resources, and budget.

Curriculum Awareness—Access your college/university general catalog and explore what courses constitute humanities education based on the definition discussed at the beginning of this chapter. Investigate what college(s), school(s), department(s), and/or program(s) offers humanities courses. Make a list of these course offerings and compare similarities between them. Identify to what extent dance is included in their content.

Notes

Chapter 3

The Comparative Framework

Introduction

The investigation of multicultural forms of dance, whether it takes place in a traditional Balinese temple, high school festival in Detroit, Michigan, or Yaqui village in Mexico during the 1600s, involves a comparative process. It is interesting to realize that comparative study has its roots in the beginning of human history. As people with different cultural systems come into contact with each other, they automatically respond to one another by comparing information. It is human nature to assess the details of what is happening around us in this way to find meaning. We compare information with what we "know" through our senses of sight, sound, touch, taste, and smell, which we process in order to make sense. This process of knowing or cognition, discussed in Chapter 5, results from our interactions within the environment.

At theatrical concerts or special events, through travel to various geographic regions, during formal classes, in community settings, or other venues, people experience dance representing diverse cultural systems. Even before we enter into these situations, the comparative process begins. You may ask yourself, "Is this going to be like something I have seen, heard, or felt before?" That type of self-questioning occurs at a conscious, as well as a subconscious, level. After arriving in the actual setting, you selectively examine dance information to notice similarities by finding relationships with previous knowledge. If there are extreme differences with your experience, it is more difficult to explore parallels and make sense. This issue is precisely what the field of comparative studies addresses. Multicultural dance education relies on comparative theory to provide a framework for interpreting dance from varied cultural systems. Without a framework, there is no understanding.

Comparative or Cross-Cultural Study

The word "comparative" is relatively easy to understand, which is why it is used to introduce the chapter. However, we will start applying the term "cross-cultural" as a more specific description of multicultural dance study. Cross-cultural study is the comparison of different cultural knowledge systems. Sometimes people confuse this word with multicultural. Individuals may even call themselves cross-cultural dance teachers. Cross-cultural is not a description of someone instructing or doing dances representing diverse cultures.

So much confusion exists over the proper application of the term, "cross-cultural." For instance, you may notice the exchange of words, like inter-cultural, transcultural, and pan-cultural with cross-cultural. Yet, the "attempt to use them synonymously obliterates the value of having terms with differing denotations."[1] "Inter" means between or among, such as the field of intercultural communication, which studies how people from diverse cultural systems communicate. The prefix "trans" means to move across or over, to shift from one to another and implies change, while "pan" indicates a union of several distinct entities sharing something in common. "Cross" denotes a comparative approach that defines and classifies that which is comparable.[2] It also is important to recognize that the comparative method examines correlations and covariations that emerge from studies of similarities and differences.[3]

Emic Perspectives

The notion of comparison suggests a structure within which to frame understanding. This frame involves different perspectives, or points of view. Boas's work sets the foundation for acknowledging one of these perspectives, which underlies all cultural theory. In his research, we observe the emphasis on investigating cultural or shared knowledge of a particular group of people with the purpose of discovering how they understand and act upon those understandings. Based on Boas's theory, researchers recognize that criteria selected by members of a group sharing culture dictate how, why, where, when and what type of dance occurs as well as by whom it is performed.

The term "emic," coined by linguist Kenneth Pike in the late 1940s, became an appropriate word to describe the view of someone "inside" a cultural system. He drew from the concept of phonemics, and specifically phoneme, which is the minimum distinctive sound or the smallest sound unit distinguishing meaning in a particular language.[4] The significance of this idea, which he realized when trying to study languages radically different than his own, was that only those who shared the language knew or understood the phonemes. Criteria for understanding came from within the cultural system. That principle supported the rationale for spending in-depth extended periods of time working and living with a community of people to study in context how behaviors and specifically language use revealed meaning.

This practice of in-depth study, known as fieldwork, is a standard part of cultural research. One of the most important objectives of fieldwork is to learn how people within a discrete cultural system construct and share knowledge. "The art of fieldwork is achieved to the extent a fieldworker is able to render from research-oriented personal experience an account that offers to a discerning audience a level of insight and understanding into human social life that exceeds whatever might be achieved through attention solely to gathering and reporting data."[5] Ethnography is the term applied to that type of rendering. An ethnographic report is a synthesis of various interpretations from multiple sources collected through interviews, observations, and other methods. The ethnographer weaves this information together into a "story" that members of the group under study agree is plausible and valid. Importantly, fieldworkers or ethnographers also must consider their own points of view, which influence many factors determining how the rendering occurs.

PERSONAL EMIC

Each person is unique with different experiences, ideas, and values, affecting how he or she makes sense of the situation. Thus, all understanding is rooted in one's own cultural knowledge or personal emic.[6] The personal emic refers to what is already known to the researcher. That perspective is always a point of departure for comparing what is not known, or outside one's own cultural knowledge system. Comparisons happen constantly, whether you are a researcher doing fieldwork or not. All humans, from the moment they are born to the day they die, comparatively process information using the personal emic as a catalyst to shape how they understand the world around them. This process of finding relationships within existing knowledge structures is highly subjective. No two people share a personal emic. Imagine for a moment the following scenario: Two students attend a local festival featuring dance and music groups representing Africa. They stop and watch a performance by a group of young adult men from Sudan. Student #1 thinks immediately of an experience she had studying dance and drumming with a Ghanaian teacher, although the movements and rhythms are very different from what she learned. Student #2 has no background in dance and drumming from Africa but notices how the men move together in an expression of solidarity. He remembers a step team that performed at his fraternity, which reflected this same type of feeling. Both students have different ways of comparing this experience and finding parallels, guided by their respective views situated within the personal emic.

Importantly, the act of observing a particular event or performance does not by itself constitute cross-cultural study. In the field of comparative studies it is necessary to have more than just basic interactions, involving everyday, automatic comparisons between what one knows and new information. One way to achieve the type of higher level interactions required for cross-cultural investigation is by talking with members of a particular group that share cultural knowledge. However, the suggestion is to go beyond a mere exchange of ideas and move toward a systematic inquiry and recording of responses for later analysis. This describes the ethnographic interview process. Interviewing is a planned activity that incorporates a series of questions, which exam-

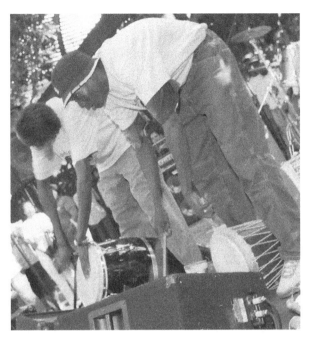

Figure 3-1. Sudanese drummers performing at the City of Phoenix Heritage and Science Park African Festival (Photograph by Vivian Spiegelman, Phoenix, Arizona, 2002).

ine an individual's understanding. More than a "yes" or "no" reply, good interview questions are open-ended enough to prompt a lengthier response, allowing the interviewee to shape and control the direction of his or her answers in a way that is most meaningful.

Questions may explore details about the significance of movements, the dancers and drummers, the time and place the dance occurs, the organization or sequence of movements, and the process by which people learn the dance. The interviewee's response provides an emic or cultural insiders' point of view. It is especially valuable to pay attention to the words and phrases used by "natives" or those members sharing meaning to explain a certain phenomenon. Studying language, which will be discussed further in Chapter 10, provides insight to cognition and how people symbolize ideas. Other considerations for interviewing include selecting the informant, as well as determining where and how long the interview will take. These choices significantly impact how information is interpreted. Interviews involve interaction between two people and two emics, that of the person asking questions and the respondent. This type of activity is fundamental to cross-cultural dance studies.

Etic Perspectives

Another type of interaction that begins with the personal emic involves comparing information by using a framework derived from outside a specific cultural system. This is referred to as an etic approach. From the word, phonetic, it is a strategy that scientists, scholars, and others use that relies on extrinsic concepts and categories for distinguishing and comparing aspects of multiple cultural systems. "Through the etic lens the analyst views the data in tacit reference to a perspective oriented to all comparable events (whether sounds, ceremonies, activities), of all peoples, of all parts of the earth."[7] Etic perspectives emerge from theories and concepts that have a universal application. In other words, it is possible for a researcher or student to use an etic frame to examine any cultural system and draw parallels between different systems. A specific example of an etic approach for language study is the International Phonetic Alphabet, which provides the academic community worldwide with a notational standard for the phonetic representation of all languages in order to correctly reproduce sounds for word pronunciation. Many dictionaries include phonetic descriptions. For instance, the American Heritage Dictionary lists the word, "dance," followed by the phonetic information, *dăns*.

There is a similar system to record and study human movement called Labanotation, developed by Rudolph von Laban (1879–1958). Labanotators around the world use this system, based on graphical representations, to document as well as analyze dance and other movement in space and time. Following is an example of Labanotation (fig. 3-2); Labanotators read the "staff" from the bottom to the top.[8] The symbols refer to Cherkessia movements used in Israeli folk dancing.

It is essential to remember that an etic view is usually a stepping stone for gaining access to emic perspectives or understandings.[9] This reinforces the idea that both positions are necessary for holistic comparisons. Labanotation, for example, is an important tool for studying and comparing movement from different cultural systems. However, critical details about personal motivations for doing the movement, as well as the meaning, history, and other

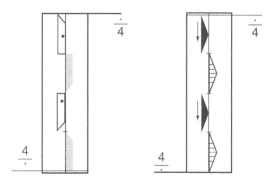

Cherkessia, from Israel.
Holding hands in an open circle,
or in a line following the leader.

Figure 3-2. Labanotation from Ohio State University's LabanLab.

contextual information, also must be obtained. Without that data, any investigation of dance around the world or throughout history will be uni-dimensional and, thus, incomplete. Further, one must remember that the individual's personal emic provides a lens through which he or she interacts and interprets etic perspectives. Simply stated, different people will have different understandings since their background influences how they apply and make sense of a particular etic conceptual or theoretical framework.

One Example of Comparative Dance Study

When students encounter an unfamiliar dance form or situation, it is beneficial for them to select from a variety of strategies to analyze information and make sense. Beyond the first and most natural stage of comparison, which consists of the individual trying to find relationships between new and old experiences, there are basically two roads to travel for cross-cultural dance studies. One path involves interactions with cultural "insiders" through interviews to determine how members of a particular group sharing knowledge understand the dance, in other words by investigating emic views. The other path requires having etic approaches that are created and acknowledged by a community of scholars with the purpose of universally comparing dance in diverse settings. This second strategy is more difficult since the novice student does not possess a well developed background or awareness of etic or theoretical frameworks. The following example provides one specific etic perspective for comparative analysis,

which adds to the repertoire of tools available for multicultural dance study.

Gertrude Kurath contributes an etic model to the field of cross-cultural dance studies described in her 1960 article that compares how dances develop over time and space. Kurath's model offers several possibilities concerning how people adapt their dances to various contexts. By applying Kurath's framework, we will explore two types of "dynamic processes" relative to the movement form, *capoeira* (cop oh aeh' rra).[10]

Capoeira (fig. 3-3) refers to the name of a fight or play that originated in Angola, Southwest Africa (*Jogo de Angola*). African slaves forced to work in the sugar cane plantations by Portuguese colonialists brought this cultural knowledge to Brazil. The movement form was created as a series of defensive movement techniques among the slaves disguised as rhythmic dance-like behavior. Between 1630 and 1695, African slaves and the Portuguese were at war with each other in the area known as Serra da Barriga (se' hah dah ba he' ga) located between the states of Pernambuco and Alagoas, in Northeast Brazil. This was the first account of the existence of *capoeira* in Brazil.

Capoeria could not be openly practiced because law prohibited it into the twentieth century. However, this changed once Master Bimba, often credited for the reformation of *capoeira* in Brazil, developed the movement form into a legitimate sport. In the 1930s, he opened an academy in Salvador, Bahia (bah yee' ah), but only students with good grades and a job could attend. Master Bimba invited President Vargas to Bahia where members of the academy performed *capoeira*. This experience impressed the president so much that he changed his attitude toward *capoeira* and decreed the practice as legal.

Many people around the world resonate with this practice, which have resulted in the establishment of *capoeira* academies and *grupos* in countries around the world. Although there are specific movements and training techniques, every *capoeirista* brings his or her own unique style and defensive strategies to the *roda* (hoh' dah), or circle within which practitioners interact. People of different ages and backgrounds learn *capoeira* in schools, clubs, and community associations.

Kurath suggests that one dynamic process by which dance evolves is diffusion, which implies a

Figure 3-3. *Axé Capoeira*, Tempe, Arizona (Sigrun Saemundsdottir, Photographer, Tempe, Arizona, 2004).

dispersion or transmission of "information" from the source. Dances that originate in one part of the world and shared by a particular group of people "travel" across distances, either in their entirety, or perhaps only specific steps, to become a part of another group's repertoire or integrated within another dance.[11] Often, this will happen through individuals migrating to other geographic areas bringing their dance cultural knowledge with them. A certain degree of adaptation always occurs in the new context. In *capoeira*, diffusion takes place as the movement form travels from its place of origin (Southwest Africa) to Brazil in the 1600s—first to the state of Pernambuco and then to various locales throughout the country. Four hundred years later, the diffusion of *capoeira* is extensive, evidenced by the number of classes taught around the world.

A second dynamic process is enrichment that occurs spontaneously, through internal development, or as a result of contact with external forces.[12] Voluntary changes in *capoeria*, such as the addition, deletion, or alteration of movements, the meaning or purpose of the activity, the type of participants, and the space where it is practiced clearly demonstrate the enrichment process. This is especially true as more individuals possessing diverse cultural knowledge become *capoeiristas*, which shapes their actions and specific strategies used to interact with one another, thereby enriching further development of the movement form over time and space.

The dynamic process model, accepted by scholars or experts in the field of comparative studies, is an excellent tool for multicultural dance education. Students apply this etic framework to explore similarities and differences between different cultural systems, informed by their own personal emic lens. This type of "tested" model also may stimulate the design of new etic frameworks and ways of comparing common aspects of dance.

Summary

At the heart of multicultural dance study is the cross-cultural or comparative process. This process involves using different perspectives by which to interpret information: the personal emic view, emic viewpoints of cultural "insiders," and etic approaches.

The personal emic of individual students or researchers shapes comparisons by interacting with cultural "insiders" through fieldwork and interviews as well as with theories or concepts for universal application and analysis. Importantly, emic and etic interactions provide a multidimensional framework for gaining knowledge about dance cultures around the world.

Notes

1. Keali'inohomoku, Joann W. (1985, Summer/Autumn). Cross-cultural, inter-cultural, pan-cultural, transcultural. *Cross-Cultural Dance Resources Newsletter 2*, 1.
2. Ford, Clellan S. (Ed.) (1967). *Cross-cultural approaches: Readings in comparative research.* New Haven: Human Relations Area Files Press.
3. Lessa, William A., & Vogt, Evon Z. (1979, 4th ed.). *Reader in comparative religion.* New York: Harper & Row.
4. Lett, James. (1996). Emic/etic distinctions. In D. Levison & M. Embers (Eds.), *Encyclopedia of cultural anthropology* (pp. 382–383). New York: Henry Holt and Company.
5. Wolcott, Harry F. (2001). *The art of fieldwork.* Lanham, MD: Rowman & Littlefield Publishers, Inc.
6. Harris, Marvin. (1990). Emics and etics revisited. In T. Headland, K. Pike, & M. Harris (Eds.), *Emics and etics: The insider/outside debate* (pp. 48–61). Newbury Park, CA: Sage Publications.
7. Pike, Kenneth. (1954). *Language in relation to a unified theory of the structure of human behavior* (p. 41), Glendale, CA: Summer of Institute of Linguistics.
8. Ohio State University, Department of Dance, Labanlab. Accessed on March 30, 2004 at http://www.dance.ohio-state.edu/labanlab/index.html.
9. Pike, Kenneth. (1990). On the emics and etics of Pike and Harris. In T. Headland, K. Pike, & M. Harris (Eds.), *Emics and etics: The insider/outsider debate* (pp. 28–47). Newbury Park, CA: Sage Publications.
10. The information about *capoeira* is derived from a series of interviews that took place in 1998 with Mestre Aguinaldo Garcia in São Paulo, Brazil and his *grupo*.
11. Kurath, Gertrude. (1960). Panorama of dance ethnology. *Current Anthropology 1*(3), 239.
12. Kurath, Gertrude. (1960). ibid.

Discussion Questions / Statements

Write your responses to the following questions in the space provided. Collaborate with one or two other students and explore their ideas to the same questions. Examine similarities and differences to the various responses.

1. What are the advantages of comparative dance study? How many reasons can you list that support the value of cross-culturally studying dance? Why would you want to develop this skill as a dance performer? Student? Researcher? Teacher?

2. Think about a novel or unique dance experience that was completely unlike anything you had ever done or seen before and describe your feelings. How did the activity compare to previous dance experiences? What relationships did you make between old and new information?

3. Imagine you are conducting an interview with a member of a group sharing dance knowledge, such as a community association that convenes on Friday nights to practice Eastern European social dances. You have identified one of the regular, principal members with whom you will speak. What questions would you ask to explore cultural knowledge relative to the group? What would be your opening question?

4. Thinking about the interview process, describe some techniques you might use to record responses. What "recording" problems can you envision occurring and how will you resolve those? Also, once you have the interview data, how will you analyze this information? What ways or methods can you use to understand or make sense of the material?

5. Consider the variety of etic frameworks that are useful for comparing dance around the world. Draw from your own academic background to describe theories or concepts that might have interesting implications when applied to dance. Scholars from fields such as psychology, sociology, anthropology, education, and art utilize diverse etic frameworks that also are relevant to multicultural dance study. List as many as you know and compare to those of other students in your class.

6. It is not difficult to find dance examples that demonstrate the dynamic process of diffusion. Besides *capoeira*, think about dances that have a specific origin in history or from one place around the world and have traveled to a new context. What examples can you list? Also ask yourself how the dances "moved" from one time and/or space to another. What "vehicles" transmit dance information? How do these change over time and/or space?

Creative Projects

Critical Viewing—Study a photo (from this textbook or elsewhere) of a dance and write down your interpretation of the information. Consider how your background and cultural knowledge shape the way you make sense. In a small group, compare each member's personal emic for understanding. Discuss similarities and differences. Practice this exercise by studying a short video clip of a dance and follow through with the same activities. How does the medium (photo or video) impact the meaning making process?

Interview (a required assignment to be completed by all students)—Select a particular group of people that share meaning through dance related activities. Find out when and where they regularly meet. Determine if this time works with your schedule and whether you can attend one of their meetings. Contact the group before you arrive so that they are aware of your intentions to interview one of the members. Perhaps someone interested in participating as an interviewee will step forward, otherwise you will need to ask an individual if he or she will take part in a 30-minute interview that you will conduct to examine "what it's like to be a member of that group." Determine where and when the interview will occur and then record your process from beginning to end. Think carefully about your questions and be sensitive to your interviewee. After the interview, study your data and present your "findings" to the class. Highlight important words used, special emphases, patterns or interesting relationship between ideas, and terms or practices that you find unusual.

Internet Resources—Access the Internet and using any search engine, type the key words "cross-cultural." Examine various Web sites to determine which relate most closely to the discussion in our text. Which Web sites present the term improperly? Compare the content or focus of several different Web sites and observe where, when, and by whom these were created. How do various search engines compare? Do the same exercise exploring the term "cross-cultural dance studies."

Notes

2

Dance as Interaction

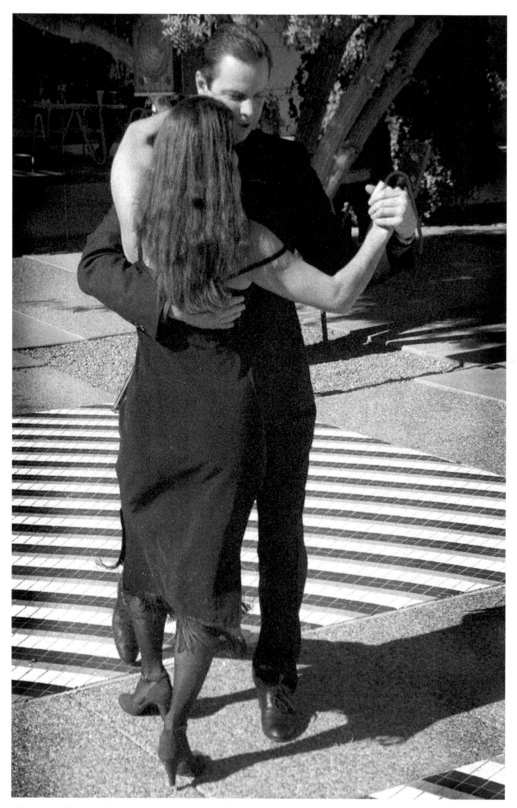

"Tango is like two bodies and four legs moving as one dynamic entity. It is the physical manifestation of the music that is tango. The dance begins with "getting-to-know" your partner (*conocimiento* in Spanish), which happens even before the first step, it's non-verbal. It's within the embrace." Daniela Borgialli and Peter Adang performers (Photograph by Sigrun Saemundsdottir, Glendale, Arizona, 2004).

Chapter 4

The Dynamic World

Introduction

K urath's etic framework of studying the dynamic processes by which dances evolve over time and space provides a perfect introduction to our next discussion. This chapter explores in more detail the scientific theory of dynamism to explain that force or energy is the basic principle of all phenomena throughout the world. Using physics as another etic lens promotes further comparisons between dance and different types of behaviors.

Many people are unaware that physics or other scientific disciplines are useful tools for comparatively studying dance. Yet once we dig deeper and discover ideas about dance not easily visible or common in everyday understanding, we find that there are many underlying surprises. This type of critical viewing also extends one's range of possibilities for making connections between diverse concepts. It is like using a microscope to find out more information than what is obvious to the naked eye.

Physics and Dance

The only constant is change. This adage constitutes our point of departure for examining dynamism, which suggests that everything inherently has energy. The word "energy" comes from the Greek, *energos*, meaning active, at work. Activity implies process, change, or transformation. The study of energy is explored in physics, the scientific discipline concerned with the natural behavior of phenomena in the universe. In physics, energy is a result of subatomic particle activity. As subatomic particles move, they change in reaction to other particles within their immediate environment. Bubble chamber photographs are taken to better understand the movement of these particles by using liquid hydrogen to record particle "tracks" (fig. 4-1).

In the mid-1950s when this technology first appeared, bubble chamber photographs revealed paths of subatomic particle activity that influenced scientists to believe that matter was intrinsically restless. From those early bubble chamber studies, mass was "seen" as energy, which led to a deeper understanding of the dynamic nature of the universe. The ideas of rhythm and dance came to mind as scientists imagined the flow of energy going through patterns that make up the particle world, illustrated in the following quote from *Tao of Physics*.

> All the material objects in our environment are made of atoms which link up with each other in various ways to form an enormous variety of

Figure 4-1. Bubble chamber photograph of subatomic particles (Photography courtesy of Fermilab National Accelerator Laboratory, Batavia, Illinois, 2004).

molecular structures which are not rigid and motionless, but oscillate according to their temperature and in harmony with the thermal vibrations of their environment. Modern physics, then, pictures matter not at all as passive and inert, but as being in a continuous dancing and vibrating motion whose rhythmic patterns are determined by the molecular, atomic, and nuclear structures.[1]

This notion of "dancing" molecules sets the stage for connecting physics with dance. Physics involves investigation of the building blocks upon which our universe is structured. The behavior of elemental particles demonstrates that energy is the fundamental link between all things, all people, and all places. Like the preceding quote, dance becomes a metaphor for particle activity, as well as the movement of all things. Yet, it is not only the metaphor that supports connection between dance and physics. On the most basic level, dance exemplifies the energy of life. It may be for this reason that dance is a part of all societies around the world throughout history and offers a rationale for comparing these two seemingly disparate topics.

It is interesting to investigate other relationships between dance and physics. For example, envision the following scenario. At a festival, a dance ensemble stands off stage before the performance begins. While they are waiting, members of the group are exemplifying potential energy, or stored energy. As soon as they start moving as dancers on stage, they exhibit kinetic energy. In reality all human action, whether it is walking down the street or eating an ice cream cone, is kinetic. Yet a dancer, by nature of his or her purpose or objective, exhibits kinetic energy once the motion of dancing initiates. Prior to that, there exists potential energy as the dancer prepares to realize or embody the dance.

Once on stage, each dancer moves in relation to others and the environment itself. Sensitivity to the organization of time, space, and energy as well as the conditions of the setting is requisite for being a member of a performance group. The dancers are aware of their surroundings and adjust their movements accordingly. Looking through a physics lens, we may consider Isaac Newton's Third Law of Motion, explaining that for every action, there is an equal and opposite reaction. A good example of this concept is illustrated by tango, a male and female couple's dance originating in Buenos Aires, Argentina. Interactions between the man and woman involve the exertion of forces, which move each other through space. They use energy to travel in various directions and/or articulate their bodies while staying in one place that equals the size or amount of the force they exert. The impetus in Argentine Tango comes from the leader's center of gravity, not from the arms or legs. Some movements use centrifugal force so that the action can happen with the leader being the center axis and the follower is the circumference or visa versa (the follower is the center of the circle), or there is an imaginary center between the two bodies as the action takes place on the circumference of the circle.[2]

Physics applies to the execution of every movement in dance. For instance, the force of gravity influences how we stand, walk, roll, and leap. Earth's gravity produces a downward force that acts at the center of gravity of the body while the floor or ground exerts a vertical upward force on the body through the feet.[3] Balance of the body is possible if the center of gravity lies on a vertical line passing through the area of support (our feet) on the floor. Dance usually involves moving from one foot to the other, which means an individual must find a new center of gravity every time he or she shifts weight. This becomes increasingly more complex as the dancer turns, jumps, or changes vertical alignment of the spine. The dancer and the universe as a whole are bound by specific forces that impact movement and that subsequently influence interactions.

Dance and Creation Myths

The study of physics in relation to dance takes us in another direction, besides looking at behavior or motion of the material universe. As we consider origins of the universe, a connection with dance emerges. Physicists continue to develop theories about how the universe was formed. Within the traditions of many people throughout the history of the world, there exists stories to explain the creation of the universe, Earth, people, and other aspects of the natural world. For example, the beliefs of those who practice Hinduism, originating in the area known today as India, directly relate the creation of the universe with dance. According to Hindu beliefs, Shiva, Brahma, and Vishnu form the great triad of Hindu gods. Shiva appears as the King of Dancers or Nataraja, Lord of the Dance, and performs the cosmic dances that typify the ordered movement of the universe (fig. 4-2). He personifies the destructive

Figure 4-2. Sculpture of Shiva Nataraja, Batu Caves, Malaysia (Corbis).

forces of the universe, as the dancing destroyer of the ego. His destruction is not simply negative; it is the elimination of old forms to allow new forms to emerge. Thus, he also represents regeneration. He figures in many legends, where he dances to punish enemies, or in some cases to instruct people in right conduct. Shiva is depicted with four arms standing on one leg, with the body of a demon underneath. The upper right hand of the god holds an hour-glass drum to symbolize the primal sound of creation. It beats the pulse of the universe, accompanying Shiva's dance. The upper left bears a tongue of flame, the element of destruction, while the ring of fire and light, which circumscribes the entire image, identifies the field of the dance with the entire universe. The lotus pedestal on which the image rests locates this universe in the heart or consciousness of each person.[4]

Other stories depicting the origins of the universe share a common theme of creation and destruction. Dance is not always directly mentioned; however, the focus is consistently about change, process, and transformation, an inherent characteristic of dance. Dance is ephemeral, or transitory, like all aspects of life and the universe, existing in a particular time and space for the moment. Each subsequent moment of the dance is slightly different than the preceding one. The series of dance moments is like a ceremonial procession, taking the dance and nondance participants into the future. No one moment is the same, and since each preceding moment influences or impacts the next, there is a transformational quality as one "moves" through the dance activity.

Life and dance are synonyms of each other and reflect a linear transformation. In physics, a linear or one-way transformation is explained by the Second Law of Thermodynamics, which states that all things evolve toward disorder or energy dispersion. This is often referred to as entropy. Dance demonstrates this law of physics if one considers the beginning of a dance as having a particular ordering of energy, which progresses until the end when the energy finally disperses. In nature, weather conditions carved the Earth to form the "arches" in Moab, Utah and they also exemplify the same entropic process.

Movement, change, process, and transformation are motifs found in almost every myth related to creation. For example, the Navajo or *Diné* of the Southwestern United States tell a story about Changing Woman (the *Diné* call her by many names such as *Isanakleshe, 'Asdzá · nádle · hé, Asdzáá Nádleehé, Esdzânádle,* and *Estsan-ah-tlehay*). She interacted with Spider Woman, an important figure who helped the *Diné* emerge from the first of four worlds. Today, we are said to live in the fourth or glittering world. In some Navajo sacred narratives, Changing Woman dwells as Whiteshell Woman in her hogan (the name of a traditional Navajo dwelling) in the eastern skies, while her sister in the west, Turquoise Woman, lives in her own hogan. Together, the sisters hold the east-west solar pathway across the heavens. In other sacred stories, Whiteshell Woman and Turquoise Woman, instead of being two different deities, represent different stages, or cycles (youth and maturity), of the same creatress. She lives on earth, but moves freely through time/space. In the skies, she dances out thirty-two spiraling paths through the stars, and in the depths of the ocean, she dances out thirty-two spiraling paths through the waters. There, in a hogan made of whiteshell, turquoise, abalone shell, black jet, and clear quartz, she continues to live. For her, it is a place of dance. Dance is Changing Woman's primary activity in her house, and through dance she manifests blessings, abundance, protection, wisdom, compassion, and ever-changing transformations.[5]

Changing Woman also figures prominently in creation stories of the Apache people, another tribe from the Southwestern United States. The *Na'ii'ees* or the Apache Woman's Puberty Ceremony, also known as the Sunrise Ceremony, is a female coming of age communal ritual, reenacting an Apache origin myth based on Changing Woman. Preparations, which are costly and require an enormous amount of time, include the making of ritual paraphernalia and food exchanges. The four-day event involves many ceremonies, dances, and songs as the young girl becomes imbued with the physical and spiritual power of White Painted Woman, and embraces her role as a woman of the Apache nation. For most of the four days and nights, she dances to songs and prayers, as well as runs in the four directions. During this time, she also participates in and conducts sacred rituals, receiving and giving both gifts and blessings, and experiencing her own capacity to heal.[6]

Similar rites of passage ceremonies occur among many American Indian tribes throughout North and South America. Dance is a requisite component of these activities that highlights and heightens the metamorphosis from youth to adulthood. There are dance activities marking other significant moments in life, such as birth, marriage, and death, as well Earth's orbit or travel around the sun.

Rites of passage depend on the events of a particular person, for instance, a young man's bar mitzvah or a child's first communion. They happen because of an occasion that takes place during an individual's life cycle. However, rites of passage differ from rites of intensification, which are intended to reaffirm the society's commitment to a particular set of values and beliefs. For example, activities during rites of intensification like Ramadan, Kwanzaa, St. George's Day, and the summer or winter solstices have no necessary relationship to an individual.[7] Rituals discussed throughout this text include both rites of passage and rites of intensification.

Summary

Dynamism, which explains the universe in terms of force or energy, is a fundamental concept of physics. In other words, the basis of all things is energy, and dance is no exception. Energy also implies activity and change. Therefore, dance, or rather the activity of dancing, more clearly illustrates a process rather than a tangible product. Among different people around the world, dance is thought to be the catalyst for cosmic change, like the beginning of the universe or other creations. It is a metaphor for the life force and heightens events that are significant to human and Earth's cycles while furthering social values and beliefs.

Notes

1. Capra, Fritjof. (1975). *The tao of physics*. New York: Bantam Books.
2. Borgialli, Daniela. (2004). Personal communication. Ms. Borgialli is an independent Tango performer and teacher working in metropolitan Phoenix, AZ.
3. Laws, Kenneth. (1984). *The physics of dance*. New York: Schirmer Books.
4. Kumar, Nitin. Accessed on March 17, 2004 at http://www.exoticindia.com.
5. Jenks, Kathleen. (2003). Autumn greetings, customs, and lore. Accessed March 15, 2004 at http://www.mythinglinks.org/autumnequinox~archived2001.html.
6. Cody, Ernestine. (1998). The children of changing woman. Accessed March 20, 2004 at http://www.peabody.harvard.edu/maria/Sunrisedance.html.
7. Keali'inohomoku, Joann. (2004). Personal communication.

Discussion Questions/Statements

Write your responses to the following questions in the space provided. Collaborate with one or two other students and explore their ideas to the same questions. Examine similarities and differences to the various responses.

1. Do you think applying physics concepts to learning about dance in a traditional classroom is useful? Why or why not?

2. Go to the Particle Adventure Web site created by the Lawrence Berkeley National Laboratory and selectively read through the information presented (http://particleadventure.org/particleadventure/). Based on that material, what other comparisons can you make between dance and physics?

3. Choose one particular concept in physics and think about how you would demonstrate it to other students using movement or dance. Next, describe it on paper and then verbally explain to a partner what the concept is and how he or she can explore it through movement or dance. Have the other student actually follow the instruction then discuss the outcome of this exercise. Was it clearly explained? How well did the movement or dance activity illustrate the physics concept?

4. The word "dance" is often used as a metaphor for movement as in "the leaf danced with the wind." A metaphor is a figure of speech in which an expression is used to refer to something that it does not literally denote in order to suggest a similarity. How have you heard the word "dance" to refer to movement by other than human activity? What new metaphors can you create using dance?

5. In the stories describing Shiva and Changing Woman, what is the role of nature? How are elements of nature incorporated in the creation myths? Compare similarities and differences between both stories.

6. Think of how dance accents specific rites of passage, either in your own life or that of someone you know. Describe to another person one particular experience that you had or witnessed in which dance was a significant part of the transformation from one stage or situation in life to another.

Creative Projects

Art Application—Work in a small group to design a trademark or logo to represent a dance company using a "physics" theme. Create this visual icon for company letterhead or T-shirts but do not use words/text. Explore color, line, patterns, shape, and size as you develop your ideas. A final rendering will be produced and submitted on white 8½" x 11", 20lb. paper.

Internet Resources—Surf the Internet and locate one Web site that has information about a myth or reference in religious literature that involves dance. Write a one-page composition that identifies the source you accessed (full bibliographic citation), explains why you chose that particular source, and describes how the themes of movement or transformation are incorporated within the story or sacred text.

Literary Activity—Work in a small group to write a myth in which dance is a tool for creation. Decide how the myth will incorporate values and beliefs of a specific group of people from a particular region of the world or a fictional group of people. Include at least one color illustration. The story should be between 1–2 pages in length (250–500 words).

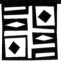

Notes

Chapter 5

Human Interaction

Introduction

The topic of interaction, explored in the previous chapter, provides a bridge between this exploration of the physical and social worlds. One thing that all the natural sciences have in common is an interest in breaking down "matter" or material aspects of the universe into its various component parts to analyze the relationship of those parts. The study of interaction between components not only helps scientists understand the way interlocking pieces fit together, but also provides insight about the nature of physical reality. In the human sciences, the study of interaction among people promotes awareness about the nature of social reality.

This section examines several social theories to create a foundation for investigating what, why, where, when, and how individuals dance, as well as who dances. The theoretical foundation also situates dance as social behavior that is shaped by the context or environment in which it exists. Interaction in a specific context further impacts cognition, the process of knowing. All aspects of our social world influence knowledge construction and, thus, the way we learn dance culture and examine dance around the world.

Social Life

Philosopher Wilhelm Dilthey (1833–1911) contributes to social theory the idea that all human interaction is social action, requiring meaningful orientation to others in any setting. As we explored in Chapter 3, it is natural for people to analyze information about objects within the environment in order to make sense of them. Once we process that

information, we take action toward those objects in response to the way we interpret or find meaning.[1] All data including sights, sounds, tastes, smells, textures, and intuition guide our understanding and subsequent behavior. How we act has everything to do with what we know, since prior experience informs the present and future.

Think about the following scenario. It is the beginning of the semester and a group of university students, who registered for an introductory dance course, enter a "classroom space" on campus for the first time. This room has a smooth, wood surface, large floor-to-ceiling mirror on one wall, and no other furniture except for a stereo system on a cart in the corner. The teacher is not present and no instructions are available to offer direction. Even though the students have never been in this space before, they act by observing objects in the room, the room configuration itself, and each other's behavior. One person sits down against the wall opposite the mirror. Everyone else similarly positions themselves along the edges of the room. It does not seem to make sense to sit in the middle of the floor, nor stand and wait. Individuals casually talk with each other, which provides information and influences the sense-making process. Someone enters the room; everyone looks up to see a person walk over to the stereo system, place personal items on the cart, and turn to address the group. The students recognize that this must be the teacher and the class is about to begin.

Each action impacts the next in a continual process that occurs seamlessly from moment to moment. The process of meaning making is mostly subconscious; we do not necessarily calculate each step to decide what action to take. Yet, people usually reflect on what they have done to orient themselves in

a particular situation. We have discussed that experience serves to guide understanding. Often the choices of how to act, whether they are based on previous knowledge or not, take into account the individual's sense of what is correct or acceptable and/or feelings of comfort or discomfort in that particular situation.

All interactions between people require a reciprocal exchange or negotiation of information in which individuals fit their own actions to the ongoing actions of one another, shaping each other's behavior. This communication creates a feedback loop in which individuals act in response to how they "read" one's behavior and vice versa. While dancing, people constantly interact through physical or eye contact to negotiate space and time relative to one another. If the goal is to present a certain level of uniformity and one person changes positions, tempo, and/or movements, everyone else must adjust their performance. Conversely, if one person is moving differently, he/she may be forced by the group to move within the pattern, and conform willingly or not. This is seen commonly among line and/or figure dancing in which the odd ball is not tolerated. The person must modify the movement to fit with everyone else, or he/she may be ostracized and/or no longer permitted to dance with the group.

The same type of negotiation process happens between performers and non-dance participants such as musicians, singers, and audience members. For example, in many traditional dances from Ghana, West Africa, the dancers listen to the drum language to execute the correct movements in the proper sequence. The drummers reciprocate by studying the dancers' actions and preparing them with signals to begin new patterns. Realization of an ideal performance usually happens when all those involved with the activity successfully negotiate and share meaning.

SOCIAL ORGANIZATION

Every human being is born into social organization. Organization implies order or patterns that develop among people over time. Sociological study focuses on these patterns, how they are created, and how they come to influence, direct, or control interactions among people. The process by which individuals learn the rules to become members of a specific organization is known as socialization. This may be defined as the means by which an individual is integrated into society.[2] It differs from enculturation, the process whereby a person adjusts and adapts to his or her total environment, which we discuss further in Chapter 6.

Social organizations shape the characteristics of interactions that take place as an individual learns appropriate, as well as inappropriate, behaviors within that structure. Sociologist Georg Simmel (1858–1918) states that there are various forms of social organization ranging from dyads, groups, formal organizations, communities, and societies.[3] Dyad patterns come into play when two people interact. In dance, these dyads are usually called duets. Groups refer to interactions between three or more individuals and can last from a few minutes to any duration. Trios, quartets, and quintets are some of the different types of groups in which dancers interact. Larger groups are more complex, which is why it is necessary to devise specific rules that govern behavior. In some group settings, like during an Irish *ceilí* (kay lee) (fig. 5-1), a caller is necessary to announce which movement will be performed next. *Ceilís*, which are a type of party or gathering, usually involves set or figure dances that follow a systematic pattern. However when many people come together for a *ceilí*, the caller ensures organization, an otherwise difficult task for a large group.

Two other types of social organizations are communities and societies. Studying these group formations gives us another tool for comparing dance cultures around the world. Community comes from the Latin word *communis*, meaning common; this also is the origin for the word communication. Community involves more than shared characteristics or affiliations. It implies common activities and sense of purpose that emerge from people whose lives are bound together in symbolic and concrete ways.[4] Family, which includes the nuclear unit (mother, father, and children), as well as extended members (grandparents, uncles, aunts, cousins, etc.), resides at the heart of community and communal relationships. Sociologist Ferdinand Tönnies (1855–1936) explains that community, or *gemeinschaft*, is an essential human will that has an underlying, organic, or instinctive driving force. There is mutual dependence hinging on the group as a whole, and not its individual parts.[5] Membership in *gemeinschaft* is self-propelled, in contrast to *gesellschaft*, or society, where membership is sustained by some definite end, such as remuneration through money or other reward for work or service.[6] Communal, or *gemeinschaft*, groups are usually closed to participation by those

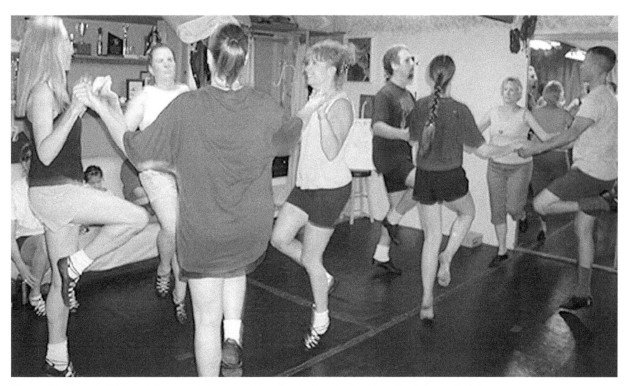

Figure 5-1. Phoenix Irish *Ceilí* Dancers (Photograph by Sarah Houghtelin, Phoenix, Arizona 2003).

who do not share kinship, traditions, geographic space, and/or socio-economic status.[7]

Dance exists in both communal and societal structures. From a community perspective, there are numerous instances in which dance occurs for the benefit of the whole. Family gatherings consisting of dance activities, like at weddings, births, anniversaries, and deaths, as well as religious ceremonies and other events, are community oriented. They promote values of unity and solidarity, strengthening familial bonds and customs. People who share dance

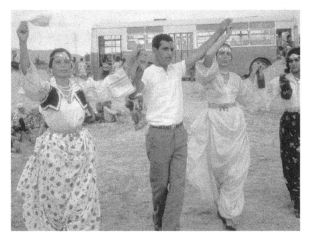

Figure 5-2. Romani (Gypsy) family during their *sunet* (circumcision) celebration, Skopje, Macedonia (Photograph by Elsie I. Dunin, Skopje, Macedonia, 1971).

traditions, not necessarily related through kinship, also reveal communal organization. Folk dance clubs, where a regular set of participants actively meet, usually are communities. People living in close proximity to one another share common activities and goals promote community through dance events that take place in neighborhoods, at schools, and in churches. Additionally, there are special populations consisting of individuals that come together for a variety of socio-economic and political reasons. Elderly or retirement-age people, groups, children, and adults with physical disabilities, and asylum seekers/refugees are forming dance communities to adapt and/or cope to their unique situations.[8]

Dance in societal organizations (*gesellschaft*) are much different than communities since they are sometimes larger, involve diverse people from many backgrounds and areas of the world, and have open membership, meaning that anyone in the position to do so may join.[9] These organizations, also referred to as associative groups, often are built on relationships developed through one's profession, educational situation, and/or special interest. Illustrating this type of group is the Royal Scottish Country Dance Society (fig. 5-3), established in 1923, with the purpose to protect and promote the standards of Scottish country dancing. It is an international organization with over 21,000 members. Society

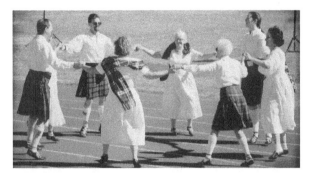

Figure 5-3. Royal Scottish Country Dance Society, Phoenix, Arizona (Photograph by Sigrun Saemundsdottir, Mesa, Arizona, 2004).

membership is available on an annual basis and is usually obtained through local branches, located in many countries around the world.[10] Another example of associative groups is the Society of Dance History Scholars (SDHS), a not-for-profit organization dedicated to promoting study, research, discussion, performance, and publication in dance history and related fields. Organized in 1978 as a professional network, the society was incorporated in 1983 and has individual and institutional members in the United States and abroad, committed to the (inter)discipline of dance studies.[11] Both the Royal Scottish Country Dance Society and the Society of Dance History Scholars demonstrate *gesellschaft* characteristics because, according to Tönnies, they are artificially contrived or constructed by an "arbitrary will" that is deliberative, purposeful, and goal oriented, instead of being self-fulfilling like the *gemeinschaft* groups.

Cognition

The word cognition comes from the Latin *cognitio*, for knowledge. Historically, investigation of cognition begins in the discipline of psychology to understand knowledge acquisition and processing in search of a theory of learning. Early theories of cognition acknowledge the existence of cognitive structures that consist of sets of ideas that are hierarchically arranged.[12] Study of these structures, or schemata, reveals how people organize and retain meaningful materials. Schemata incorporate general knowledge and facilitate interpretation and representation of events and phenomena. Most critically, schemata provide a framework for categorizing "data" and operate as information-processing mechanisms.[13]

As individuals negotiate meaning to interact, they use the appropriate schema to interpret and process information within an environment. The total environment may include people, aspects of nature, and/or human-made objects. In the following example, consider how specific schema organize knowledge about spatial orientation and direct particular actions.

A man and woman visiting Brazil from another country enter a club in the state of Sao Paulo, where couples are dancing *forró* (foh hoh') (fig. 5-4). This dance and music form, which has many different styles, is popular throughout the country and is performed by people of all ages, socio-economic backgrounds, and ethnicities. Sometimes women will dance as a couple, but most often the duet consists of a male and female. It originated with the *caboclos* (ka bow' klos), individuals with European and indigenous ancestries that worked the sugar cane fields in northeast Brazil. The music, based on Portuguese, Dutch, French, and indigenous Brazilian rhythms, has four beats to a measure. Couples hold hands and torsos, and move together by mirroring each other's

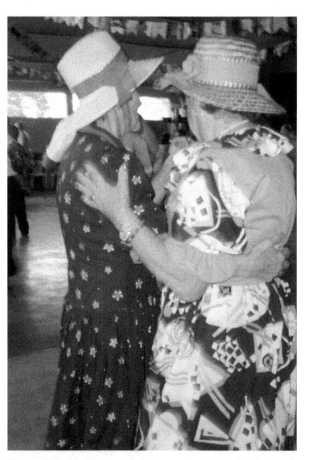

Figure 5-4. Dancing *forró* during *Festa Juninas* in Guaraná, Espírito Santo, Brazil (Photograph by Pegge Vissicaro, Guaraná, Espírito Santo, Brazil, 2003).

steps. They place their weight on one foot opening to the side on the first count, change weight to the other foot in the center for the second count, rock back to the side on count three, and hold the last count to repeat starting with the opposite foot opening to the other side. After observing the dance, the non-Brazilian couple begins moving, but discovers shortly that they are continually bumping into other couples on the dance floor. They stop to reassess their movements, talk about the problems they are having, and then study more carefully the situation as it is happening. They eventually recognize that *forró* is not necessarily a couple's dance. Rather it is a group or collective experience in which everyone moves more or less harmoniously in a counterclockwise direction around the room. Among these people, schemata pertaining to spatial orientation operate to unify and provide order, guiding actions to form a circular pattern. For the non-Brazilian couple, their spatial schemata categorized dance as movement through space that was not group oriented with an arbitrary design and direction.

In the previous example, the non-Brazilian couple interacted with objects in the environment using automatic cognition, a kind of routine or everyday cognition that is implicit, unverbalized, and rapid. When they stopped to analyze their dilemma, their mechanism for information organizing and processing shifted to deliberative cognition, which is more explicit, verbalized, and slow, happening when attention is shifted to a problem or issue.[14] This shift, requiring one to think critically and reflexively, involves the motivation to override existing schemata, and allows variability of time for information processing to occur. Deliberative cognition makes one stop and think about a dissonance or inconsistency between the new and stored information.[15] The same idea is explained by the theory of cognitive dissonance, in which forced or accidental exposure to new information may create cognitive elements that are dissonant with expectations.[16] Often people seek situations to experience cognitive consonance or agreement with what they know. However, during cross-cultural dance study, information does not always fit into our dance schemata pertaining to who dances and when, where, why, and how people dance. Since that may vary radically from one's understanding, it is necessary to develop tools and have opportunities that promote deliberative cognition, a requisite skill for multicultural dance education. This discussion will surface again in Chapter 6, Chapter 9—when we examine authenticity—as well as in Chapter 11.

SOCIAL CONTEXT

The single greatest influence upon cognitive operations is context. Beginning in the twentieth century, psychologist Lev Vygotsky (1896–1934) suggested that cognitive skills and patterns of thinking are not necessarily prescribed by innate facts, but are determined mostly by the sociocultural context in which the individual interacts. This interaction leads to continuous step-by-step changes in a person's thought and behavior, which may vary greatly from one cultural knowledge system to another.[17] Higher mental functions evolve from social interactions and the negotiation of meaning with others becomes the vehicle through which learning occurs. Thus, knowledge acquisition, information processing, and learning are socially embedded.[18]

The social learning theory of constructivism is based on the idea that people construct knowledge by interacting with their world in order to seek meaning. Interaction with others in the environment encourages an exchange of different interpretations and promotes multiple ways for the sense making to occur, an important aspect of cognitive development.[19] This theory is fundamental to our investigation of dance cultures, as knowledge systems that people socially construct. Constructivism also emphasizes the impact of context and how the environment shapes meaning. In comparative dance study, we may observe that the way individuals or groups understand dance culture is relative to the context, such as where they live or what religious beliefs they practice, and will differ from setting to setting. Interpretation of dance culture changes throughout people's lives, as they continually negotiate meaning and interact with the dynamic world.

Summary

Human life is social life that involves interpreting "data" about people and other things within the environment and subsequently interacting in ways that make sense. Experience, as well as context, informs all actions. As humans interact, they organize themselves in different ways to provide meaning and structure. Socialization allows individuals to learn rules that guide behaviors in various types of organizations. Influencing information processing and knowledge acquisition are cognitive operations,

specifically schemata, which facilitate interpretation and representation of events and phenomena. The social context in which people interact shapes these operations to influence how they learn. Interaction that encourages an exchange of multiple perspectives enables comparative dance study of cognitively diverse information.

Notes

1. Erickson, Frederick. (1986). Qualitative methods in research on teaching. In M. Wittrock (Ed.), *The handbook of research on teaching* (3rd ed., pp. 119–161). New York: MacMillan.

2. Herskovits, Melville. (1948). *Man and his works.* New York: A. A. Knopf.

3. Simmel, Georg. (1908). The isolated individual and the dyad. In K. Wolff (Ed.), *The sociology of Georg Simmel* (pp. 118–144). Glencoe, IL: Free Press.

4. Holtzman, Jon D. (2000). *Nuer journeys, Nuer lives.* Boston: Allyn & Bacon.

5. Tönnies, Ferdinand. (1925). The concept of gemeinschaft. In W. J. Cahnman & R. Herberle (Eds.), *Ferdinand Tönnies on sociology: Pure, applied and empirical selected writings* (pp. 62–72). Chicago: University of Chicago Press.

6. Nisbet, Robert. (1966). *The sociological tradition.* New York: Basics Books, Inc.; Truzzi, Marcello. (1971). *Sociology: The classic statements.* New York: Oxford University Press.

7. Weber, Max. (1947). *The theory of social and economic organization.* (A.M. Henderson & T. Parsons, Trans.). New York: Oxford University Press. (Original work published 1921).

8. Vissicaro, Pegge & Godfrey, Danielle C. (2004, winter). The making of refugee dance communities. *Animated,* 20-23; Vissicaro, Pegge & Godfrey, Danielle C. (2003a). Immigration and refugees: Dance community as healing among East Central Africans in Phoenix, Arizona. *Ethnic Studies Review, 25/2,* 43–56.

9. Weber, Max. (1947). *The theory of social and economic organization.* (A.M. Henderson & T. Parsons, Trans.). New York: Oxford University Press. (Original work published 1921).

10. The Royal Scottish Country Dance Society Web site. Accessed on March 24, 2004 at http://www.scottishdance.org/.

11. Society for Dance History Scholars Web site. (2002). Accessed on February 12, 2004 at http://www.sdhs.org/.

12. Ausubel, David P. (1963). Cognitive structure and the facilitation of meaningful verbal learning. *Journal of Teacher Education, 14,* 217–221.

13. Rumelhart, David E. (1980). Schemata: The building blocks of cognition. In R.J. Spiro, B.C. Bruce, & W.F. Brewer (Eds.), *Theoretical issues in reading comprehension.* Hillsdale, NJ: Erlbaum; Sewell, William H. (1992). A theory of structure: Duality, agency, and transformation. *American Journal of Sociology, 98,* 1–29.

14. D'Andrade, Roy G. (1995). *The development of cognitive anthropology.* New York: Cambridge University Press.

15. Vissicaro, Pegge. (2003b). *Emic etic interaction: Processes of cross-cultural dance study in an online learning environment.* Ph.D. dissertation, Arizona State University. *Dissertation Abstracts International, 64-10,* #AAT3109623, ProQuest, Ann Arbor, MI, p. 3588.

16. Festinger, Leon. (1962). *A theory of cognitive dissonance.* Stanford, CA: Stanford University Press.

17. Woolfolk, Anita. (1998). *Educational psychology* (7th ed.). Boston: Allyn & Bacon.

18. Vygotsky, Lev. (1978). *Mind and society: The development of higher psychological processes.* Cambridge, MA: Harvard University Press.

19. Black, John & McClintock, Robbie. (1996). An interpretation construction approach to constructivist design. In B. Wilson (Ed.), *Constructivist learning environments: Case studies in instructional design* (pp. 25–32). Englewood Cliffs, NJ: Educational Technology Publications.

20. Dils, Ann. (2001). Personal communication. Mapping as a classroom activity and instructional tool has been developed extensively by Ann Dils and discussed in her paper, *Mapping: A personal dialogue with culture.*

Discussion Questions/Statements

Write your responses to the following questions in the space provided. Collaborate with one or two other students and explore their ideas to the same questions. Examine similarities and differences to the various responses.

1. When you enter a theatrical performance space, how does the information you derive from the setting impact the way you interact? Your home? An exercise facility? A dance club? Give examples of the type of "data" you might find in these places and discuss how your interpretation of this information might direct you to act in a certain way.

2. Watch a short video clip (less than 5 minutes) of a person dancing. Write down in as much detail as possible how the individual interacts within the setting. Remember that each action, informed by the previous one, reveals how he or she makes sense in that environment. Discuss your recording of information with another student's observations to compare how you negotiated meaning while watching the video.

3. Do the same exercise watching several video clips, each representing a different group of dancers interacting. Observe carefully the "rules" for appropriate behavior. What happens if someone breaks the "rules?" How do people act similarly or differently in these various configurations?

4. With a partner, take turns teaching each other a short movement phrase. First, create the phrase by using everyday gestures, like washing your face, putting on clothes, and sweeping the floor, or invent your own movements, such as articulating your arms, hands, legs, feet, and torso. After you have developed the sequence, teach your partner non-verbally how to perform the pattern exactly as you did. However, this must be done without words. Explore how both of you must read the other's interpretation to negotiate meaning and understanding. Discuss this process of constructing knowledge after both partners have had a turn to present their phrase.

5. Reflect on situations in which you engaged in or attended a dance activity, but acted differently than the rest of the participants because you were not socialized as a member of that group. Or else, discuss an instance of cognitive dissonance where what you saw, heard, or felt did not agree with your understanding of dance. In either circumstance, explain your feelings about the experience.

6. Watch two video clips of dance performance that take place in different contexts and compare the ways people negotiate meaning. Begin by studying the number of dance and non-dance participants, sex and relative age of all participants, the type of performance environment, and the size of the movement space. How do these factors impact understanding? What other factors can you observe that significantly influence the process of making sense in these settings?

Creative Projects

Internet Resources—Surf the Internet and locate at least three different Web sites that have information about dance and community. Compare similarities and differences between the various sites. How do they reflect characteristics of community discussed in this chapter?

Critical Design and Artistic Application—Invent a dance society with an explicit purpose. Determine a name and then construct a mission statement, outlining long-term goals. Clearly articulate membership rules and guidelines. For example, who can join and how much does it cost? Also design a logo for a letterhead on 8½" x 11" paper and submit this along with the other information about your dance organization.

Cognitive/Knowledge Maps[20] (a required assignment to be completed by all students)—Ask students to make individual cognitive/knowledge maps outlining their concept of dance. Have them begin by writing the word "dance" in the center of a piece of paper. As they think of other words that represent their understanding of dance, they will write those on the paper. Suggest that they group similar ideas together and explore relationships. Compare these maps with other students and with the class as a whole. Examine the way the class works to construct a group knowledge map, representing their collective dance schemata.

Notes

Chapter 6

The Dynamic Individual

Introduction

This chapter continues our journey exploring the notion of dynamism, fundamental to human social life and all behavior in the universe. We recognize that people interact for survival and adaptation to every situation in order to make meaning, a necessary and inherent human trait. In the total environment, interaction occurs among people, elements of nature, and/or human-made objects. Those factors are external, influencing how people make sense and act. Yet each individual brings into the setting internal factors that also affect understanding and interactions.

Two internal factors are world view and culture. As we examine these concepts, it is not surprising to find that dynamism, and specifically interaction, impact how internal factors function to guide behaviors. One objective of this section is to question existing ideas about world view and culture. It also is our aim to situate this discussion within a twenty-first century perspective, an important goal for advancing multicultural dance education as a scholarly discipline.

World View

World view is hard to measure and even more difficult to define because it encompasses the intangible. Yet, it is a critical part of how we describe ourselves. It is the way we know what is real and what is not, and includes individual as well as group understandings. World view is more than seeing the environment around us, or putting on a pair of glasses to explain the way things appear. As a highly generalized structure containing ideas, images, and assumptions about reality, it resides at the deepest, gut-level core of who we are. World view has to do with basic attitudes, values, beliefs about things, including the ultimate questions with which a person is confronted. Issues, such as what is life and death, are examples of concepts that our world view helps us to understand and that are culturally informed.

Philosopher Immanuel Kant (1724–1804) coined the term "world view" or *Weltanschauung* in 1790. *Welt* in German means world and *anschauung* means view. World view describes a consistent (to a varying degree) and integral sense of how people understand reality, although this may vary greatly from person to person and group to group. Importantly, we carry this "baggage" inside of us from one context to the next. Its roots are in human sensory processes, which act as a portal through which our brain receives information to influence interpretation and action.[1]

World view impacts cognitive operations, involving mental structures or schemata that incorporate general knowledge to facilitate processing and interpretation of information. Studying schemata specific to morality and moral codes reveals what a person or group believes is right and wrong. Morality, like other aspects of world view, involves a comprehensive interpretation that does not usually adapt to changing circumstances. This differs from cultural knowledge systems, which may accommodate different meanings and even conflicting constructs depending on the context.[2]

One moral code that guides behavior and ethical conduct among people practicing many of the major organized world religions is the idea of doing unto

others as you would have them do unto you. World view informs adherence to this principle and other laws of governance. Failure to abide by moral codes throws one's world view off balance, upsetting cognitive operations. The disruption explains the notion of cognitive dissonance, exemplified by the breaking of taboos or social restrictions on actions that are considered morally wrong by a particular set of people. When this happens, a group's understanding of reality turns inside out, and serious ramifications, including severe punishment, may result.

For instance, among people in most nations where Islam is practiced, dances that involve men and women together in public are usually forbidden. Iranian law, which is largely influenced by Islamic beliefs, does not support the mingling of unrelated men and women. In December 2003 one of Iran's best-known dancers, Farzaneh Kaobli, and 24 of her students were detained as they were performing dances in Tehran, the capital of Iran. Iran's hardline clerics banned the activity, which they considered morally corrupt. The previous year, a court in Tehran barred male dancer, Mohammad Khordadian, for life from giving dance classes and he was forbidden to leave Iran for 10 years. Sweeping social restrictions imposed after the 1979 Islamic revolution have gradually eased since the 1997 election of reformist President Mohammad Khatami. However, the judiciary, controlled by unelected hardliners, does punish anyone who breaks the longtime taboos.[3]

Fundamental to studying world view is religion, a system that represents and orders ideas, feelings, beliefs, and practices, which develop in response to experiencing the sacred, the supernatural, and the spiritual. Religious beliefs significantly influence perceptions of dance throughout history and the world. These understandings of reality form a continuum ranging from one extreme to another, suggesting that dance brings one closer to sacredness or sin as it activates bodily senses. This last idea underlies the motivation by Christian missionaries to restrict certain types of dance activity in the South Pacific and elsewhere, beginning as early as the 1770s with the arrival of Captain Cook. In the Hawaiian Islands, *hula* (fig. 6-1), a part of ancient religious practices, declined significantly due to Christian attitudes. However, King Kalākaua (1836–1891) reinstated the public performance of hula as a key aspect of Hawaiian cultural knowledge at his coronation

where he is honored today by the annual spring Merry Monarch Festival.[4] In Kalākaua's court, the dancers wore Victorian high necked, long gowns (*holoku*) which were stylish at that time in addition to other types of skirts.[5]

As we explore dance cultures around the world, it is good to keep in mind how our personal world view impacts interpretation. For example, among some people influenced by Western European civilization, dance is an individual expression or art. On the other hand, these ideas about dance are not shared by the Hopi, an American Indian tribe located in Arizona. Hopis do not consider themselves dance artists, nor dance for personal satisfaction. Instead, the dances, which strengthen social solidarity of the group, as well as the feeling of clan identity and pride, are done to bring moisture.[6] A Western European perspective may promote the idea that dance represents freedom or reaching up to the sky, in contrast to movement that connects to the Earth or relating down towards the ground. World view always frames our understanding, which is why we must examine our own views in relation to those we are studying. When we peel back personal beliefs, we will find under the surface our world view staring back at us.

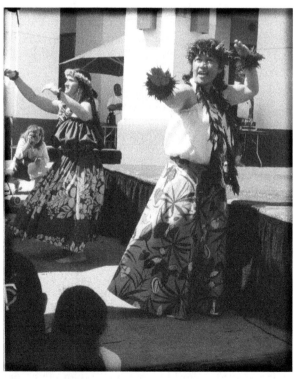

Figure 6-I. Hula dancers, City of Phoenix Heritage and Science Park Aloha Festival (Photograph by Sigrun Saemundsdottir, Phoenix, Arizona, 2004).

Cultural Knowledge Systems

The previous discussion of world view sets the stage for studying cultures, or cultural knowledge systems. The concept of culture is confusing and hard to grasp since, like all processes of interpretation and sense making, it is embedded within the social world and changes over time and space. Certain understandings about culture parallel cognitive theory, which suggests that information is input, processed, stored, and output in the form of some learned capability.[7] This idea promotes culture as a cumulative deposit of knowledge, experience, beliefs, values, and assumptions about life that is widely shared among people who have a common heritage.[8] However, a product orientation implies that culture and cognition are a bound collection of shared information resources. That idea reifies culture, by treating it as a structured object about which stereotypes, generalizations, and ethnocentric views may develop.

A focus on process described by anthropologist ___ Herskovits (1895–1963) explains culture as ___, manifesting continuous and constant ___ The study of cultural processes explores the ___ of personal as well as shared knowledge ___ that function by organizing information. ___ess the information to construct meaning ___de behaviors.[10] From this idea, we may lo___lture within cognitive operations in which world view is a consequence.

Each individual has a unique cultural system consisting of negotiated understandings with others, obtained through personal experience in family, work, education, and other social settings. This system is like a tool kit consisting of strategies and techniques that are utilized depending on the context to inform individual interpretations and subsequent interactions.[11] The construction of new knowledge through interactions with various people increases the system's repertoire and broadens the individual's response to different scenarios. Exposure to information presented through media, such as television, radio, newspapers, and the Internet, also contributes to the formation and development of cultural systems. That idea provides rationale for promoting multicultural dance education and the development of comparative skills requisite for living in an increasingly diverse nation, such as the United States.

As a person negotiates meaning in an environment, his or her cultural system provides the individual with appropriate tools to make sense within that particular setting. This concept supports a dynamic constructivist approach to understanding culture as domain specific knowledge structures. It also explains the capacity of individuals to participate in multiple cultural traditions, as well as share and construct new knowledge in varied contexts.[12] For example, the experience of frame switching suggests that individuals shift between interpretive codes rooted in different cultural knowledge systems, responding to cues in the social environment. In the United States, students who speak Spanish as their primary language switch to English and interact using the English language in most public schools. Likewise, learning traditional dance and music of Mexico may be one part of a person's background growing up in the American Southwest and which they continue to experience during family gatherings. That individual also can shift interpretive codes to participate with school friends in line dancing at a club or a mosh pit at a rock and roll concert (fig. 6-2). This dynamic constructivist approach to culture establishes the ability of each person to have unique interpretations and actions that are situationally cued.

Each context has patterns of behaviors that people who share meaning follow. For example, an individual dancing in a school dance setting adheres to different patterns or ways of behaving than in a family gathering. The patterns are not usually visible or recognizable, but those interacting within the context must learn these in order to adapt to the situation. This process of learning, which every human experiences, is called enculturation.[13] It is through enculturation that we learn dance culture.

DANCE CULTURE

Keali'inohomoku coined the term "dance culture" in 1972, which refers to an entire configuration rather than just a single performance. This includes the implicit and the explicit aspects of the dance, its reasons for being, as well as the entire conception of the dance within the larger culture.[14] Dance culture is a component of the total cultural knowledge system. Members of dance cultures share knowledge which inform their actions about what constitutes appropriate dance behavior. Because context is ever changing, knowledge construction is an ongoing process, and dance culture, like all cultural knowledge, is dynamic.

Among dance cultures of the world, there are many differences and similarities in terms of how context informs knowledge construction. In some

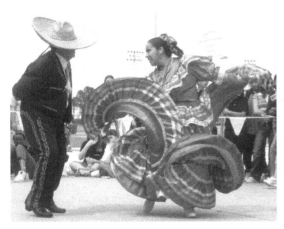 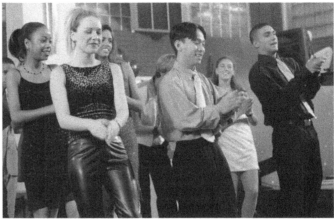

Figure 6-2. Traditional dance of Mexico performed by Primavera Folklorico Dance Company, Phoenix, Arizona (Photograph by Sigrun Saemundsdottir, Tempe, Arizona, 2004); line dancing at a party, 2001 (© by Chuck Savage/Corbis).

areas, dance culture is a highly structured and integral part of people's lives, such as among the Kaluli speaking people of Papua New Guinea. Anthropologist Edward Schieffelin spent more than four years studying a group identified as the Bosavi *kalu*, who reside in the Bosavi rain forest. He categorized six discrete types of dance and ceremonies, which comprised their dance culture. The Gisaro is the oldest and most widely known, described by Schieffelin in his 1976 monograph. All dances and ceremonies have certain similarities, including social giving and exchanging, which is basic to the Kaluli way of life. Also, songs are made up for each occasion to evoke emotions. These songs project the members of the audience back along their lives, through images of places they have known in the past. The Kaluli do not regard their ceremonies as expressing hostility; instead they are seen as "grand and exciting, deeply affecting, beautiful and sad, but not antagonistic."[15] The anger that motivates an audience member to take a burning torch and plunge it into the body of a dancer is an effect of the songs. This is a measure of the ceremony's efficacy, a drama of opposition in which the actions and feelings of all dance and non-dance participants are brought into mutual relations and understanding with one another.

Dance culture of the Kaluli, a more or less culturally homogenous group, exists as a part of their entire cultural network. We will focus on that concept further in Chapter 10 to study how dance culture is a microcosm of the total culture. Among the Kaluli, dance culture seems relatively easy to define, but this is changing through contact with the outside world. Dance culture of an American, particularly one who does not have tribal affiliations, is much more difficult to describe. The variations and

range of experiences that comprise a person's dance culture can be extremely complex. Through rapid dissemination of information and interaction with different types of people, dance cultures are evolving at light speed.

THE LANGUAGE OF CULTURE

The study of dance as a component of shared or cultural knowledge systems must include an awareness of how to use the words "culture" and "cultural." Unfortunately, there is tremendous misunderstanding about the usage of these terms. Much of the perplexity relates to the increasingly dynamic world in which we live. One hundred years ago, it was simple to look at a specific set of individuals to observe similar values and beliefs. Today, media, as well as population shifts, promote greater exposure to diverse ideas, which in turn stimulates cultural heterogeneity. Research on shared knowledge systems continues to reach new dimensions and levels of investigation. Being conscious of these changes is important since it ultimately impacts how we relate to one another.

The proper application of language describing culture also helps us to avoid forming generalizations that stratify groups of people based on special abilities or criteria, discussed further in Chapters 7 and 8. This may happen when we incorrectly personify culture, suggesting that it is a concrete material object, which acts or behaves in certain ways. As explained earlier in the chapter, reifying culture is a common mistake, illustrated by the phrase "that culture does very theatrical dances." However, culture is not something that takes action. Instead this dynamic process frames interpretation and conse-

quently influences a person's or group's action. It is correct to use the word "culture" if it can be easily replaced by the term "shared knowledge system."

Summary

It is important to recognize the total environment as an external factor shaping interactions. Additionally, internal factors of world view and cultural knowledge systems, which each individual brings into the setting, also influence interpretation, understanding, and behaviors. These internal factors are located within socio-cognitive operations. Culture involves the ongoing construction of knowledge which people strategically employ to adapt to changing contexts. Together, the study of external and internal factors provides a comprehensive framework for comparing dance cultures worldwide.

Notes

1. Kearney, Michael. (1984). *World view*. Novato, CA: Chandler & Sharp Publishers.
2. Hong, Ying-yi, Morris, Michael W., Chiu, Chi-yue, & Benet-Martinez, Veronica. (2000). Multicultural minds: A dynamic constructivist approach to culture and cognition. *American Psychologist, 55*(7), 709–720.
3. Dareini, Ali Akbar. Iran's best-known dancer detained after dancing in public. Accessed on March 22, 2004 at http://cnews.canoe.ca/CNEWS/World/2003/12/25/296739-ap.html.
4. Keali'inohomoku, Joann W. (2004). Personal communication.
5. Ka 'Imi Na'auao O Hawaii Nei, (2004). The history of hula. Accessed on March 24, 2004 at http://www.kaimi.org/history_of_hula.htm.
6. Keali'inohomoku, Joann W. (1974). Dance culture as a microcosm of holistic culture. In T. Comstock (Ed.), *CORD Research Annual 6,* (pp. 99–106).
7. Driscoll, Marcy. (1994). *Psychology of learning for instruction*. Boston: Allyn & Bacon.
8. Brislin, Richard. (1993). *Understanding culture's influence on behavior.* New York: Harcourt Brace College Publishers; Samovar, Larry A. & Porter, Richard E. (1997). An introduction to intercultural communication. In L. Samovar & R. Porter (Ed.), *Intercultural communication*. Belmont, CA: Wadsworth Publishing Company.
9. Herskovits, Melville. (1948). ibid.
10. Goodenough, William H. (1957). Cultural anthropology and linguistics. In P. Garvin (Ed.), *Report of the seventh annual round table meeting on linguistics and language study*. Washington, D.C.: Georgetown University Monograph Series on Language and Linguistics 9.
11. DiMaggio, Paul. (1997). Culture and cognition. *Annual Review of Sociology, 23*, 263–287.
12. Hong, Ying-yi, Morris, Michael W., Chiu, Chi-yue, & Benet-Martinez, Veronica. (2000). ibid.
13. Herskovits, Melville. (1948). ibid.
14. Keali'inohomoku, Joann W. (1974). ibid.
15. Schieffelin, Edward. (1974). *The sorrow of the lonely and the burning of the dancers.* New York: St. Martin's Press.

Discussion Questions/Statements

Write your responses to the following questions in the space provided. Collaborate with one or two other students and explore their ideas to the same questions. Examine similarities and differences to the various responses.

1. How do you understand the relationship between dance and the sacred, the spiritual, and/or the supernatural? Use your response as a point of departure in defining your personal world view.

2. From your perspective, what constitutes taboo behavior in terms of dance? Why? How does your world view impact the way you understand dance taboos?

3. Envision yourself doing fieldwork among Kaluli in Papua New Guinea. You experience the ceremony, Gisaro, and observe the activity of burning the dancers. Would this promote cognitive dissonance? Why or why not?

4. Watch one or two video clips representing dance cultures in diverse contexts. Observe how shared knowledge among the group also reveals individual cultural knowledge systems within the total environment. Even though information is similarly understood, what differences emerge in terms of where the dancing occurs, when it occurs, how it is done, and who dances?

5. Think about how switching interpretive frames may apply to your personal life. Is your primary language (what you first learned) different than the one you use in school or at work? Do you have certain traditions and customs that you practice with your family/relatives that are vastly different than what you do when you are away from that environment? How do you shift from understanding and interaction from one situation to the next?

6. Describe your individual dance culture in as much detail as possible. What type of dance experiences have you had or do you have? Where do you dance? When? With whom? Why and how?

Creative Projects

Art Application—Imagine you are giving a Powerpoint presentation and must provide a visual diagram to illustrate the dynamic constructivist approach to culture to support your explanation of this concept. How do you visualize the idea of a personal cultural knowledge tool kit? How might you portray the process of negotiating and sharing meaning in changing contexts? What types of shapes, colors, and lines will you use? What relationships will you emphasize? Render your image on 8½" x 11" paper. Then discuss and compare your design with two other people to discover similarities and/or differences between diagrams.

Internet Resources—Use a search engine to explore "dance culture" Web sites. Study at least three different resources to determine the extent to which the authors of the sites understand culture as a dynamic knowledge system. How do they connect dance and culture? What similarities and differences occur between the sites? Why? Write your response to these questions in a 250-word essay.

Critical Thinking—In small groups discuss the usage of the words culture and cultural in the following sentences. Explain how and why the words are correctly or incorrectly used. As you examine each application, think about whether the idea implied reifies culture.

1. His culture is completely different than hers.

2. Many cultures in North America came from Western Europe.

3. Dance cultures are universal in societies throughout the world and history.

4. Cultural study pertaining to dance in Brazil reveals influences by West African, European, and American Indian traditions.

5. The dances presented at the festival demonstrate great cultural diversity.

6. His dance culture is influenced primarily by the customs of his ancestors.

7. He studied modern dance and ballet but did not know any cultural dances.

8. Dance is not a part of her culture.

9. I'm going to get some culture by attending this event.

10. Her dancing style is culturally informed.

Notes

3

Dance as Representation

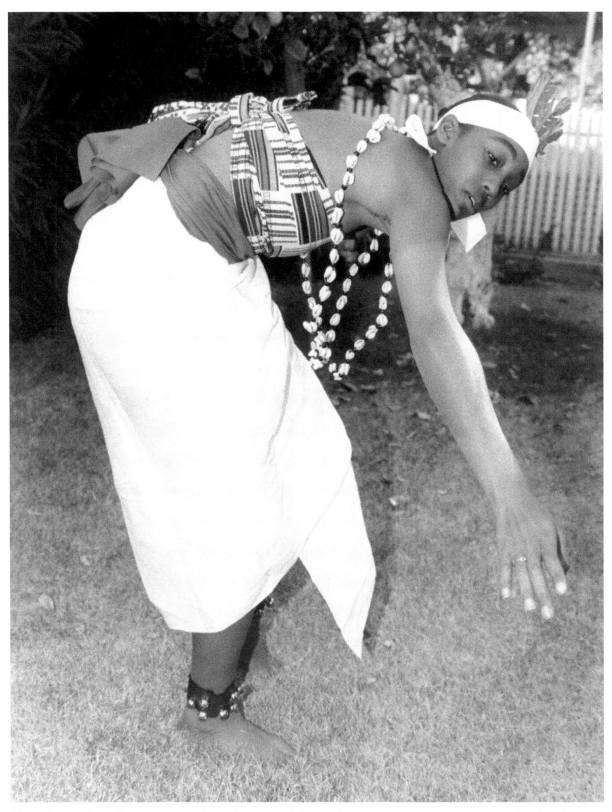

"From the Ewe dance Sowu, or Dance of Life, the waving of the arm is a reverent gesture to show respect for those in whose footsteps we follow. We stand on the shoulders of the great people who have gone before us, who have made our lives better because of their contributions. We bow forward to the Earth and humble ourselves in their honor." Performer with Adzido West African Folkloric Ensemble, Phoenix, Arizona (Photograph courtesy of Florence 'Awonye' Ganyo, 2004).

Chapter 7

Identity

Introduction

Renowned master drummer and dancer, Cornelius Kweku Ganyo (fig. 7-1), or "Uncle C.K." as many knew him, traveled around the world sharing cultural knowledge about the traditions of his people, the Ewe of Ghana, Togo, Benin, and Nigeria, as well as other ethnic groups with whom he lived and researched in West Africa. His motto was "We are all ONE in music and dance." This notion of unity was an attempt to deemphasize separation and segregation between people. C.K.'s lifelong mission in teaching dance and music highlighted positive human virtues by which to live in harmony as citizens of the world. He recognized similarities as a way to open doors that spread peace through increased awareness.

The concept of unity affirms our identity as *homo sapiens*, inhabiting planet Earth. Beyond this idea, there may be many other identities, both individual and collective. An individual identity is like a fingerprint, since no two are alike. When several people have certain types of similarities, they may form a collective identity. One of the most common types of collective identities is culture, in which a set of people shares knowledge and acts upon how they make sense of that information. As we will continue discussing throughout this text, dance reveals cultural identity by demonstrating the shared knowledge that people use to define themselves in relation to others. Preservation, dissemination, and/or creation of cultural identity occur through dance cultural processes. People maintain dance culture with current shared knowledge, bring past shared knowledge to the present, and encourage the production of future or new shared knowledge.

Race

Collective identities may promote accord within a group while at other times they become divisive and produce situations of inequity. In past centuries, race has been considered a type of collective identity based on membership to a particular group. Caucasian, Mongoloid, and Negroid were terms used to describe three large categories by which to classify humans and relate to each other. Popular conceptualizations of race are rooted in nineteenth and early twentieth century scientific thought in

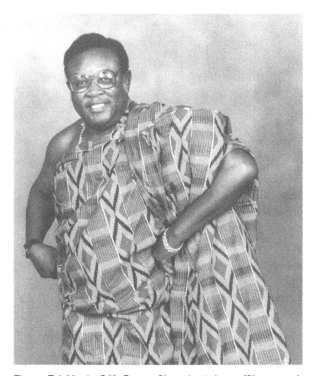

Figure 7-1. Uncle C.K. Ganyo. Phoenix, Arizona (Photograph courtesy of Florence 'Awonye' Ganyo, 2004).

which scientists used observations of racial differences to support racist doctrines. Racism, stemming from the erroneous concept of biological racial superiority, has had and continues to have a tremendous effect on how people interact with one another. Race in the United States is a social and political construct and has no basis in science.

The biological concept of race is now believed by many to be untenable. Research by the International Human Genome Sequencing Consortium shows that any two people are 99.9 percent identical at the genetic level. However, the 0.1 percent difference is important only because it helps explain why one person is more susceptible to a specific disease.[1] By studying the patterns of these genetic differences, or genetic variations, in many people, researchers expect to identify which differences are related to disease.[2] This concept is irrelevant, however, for the purpose of multicultural dance education.

Deep-seated beliefs about race are difficult to change even with current scientific understandings about the human genome. This insight about the relatedness of all humankind may strengthen the concept of one race, the human race, which aims to fill the trenches isolating people and discouraging interaction. Among the *Diné*, or Navajo, there exists the notion of one race, "the five-fingered people" as told in creation stories.[3] The Miwok, an indigenous group located in California, also have a creation myth explaining how *Os-sā'-le*, the Coyote-man, and *Pe-tā'-le*, the Lizard-man, who are the first people, made humans with five fingers so they could eat and hold things.[4]

World dynamics further complicate and make more ambiguous the notion of race, since more and more children are born of parents with various types of skin color and other physical features. The mixture of these characteristics generates even greater diversity, making so-called racial classification next to impossible. This is quite obvious in countries such as Brazil. More than half of the population has a varied ancestral background that includes some combination of African, European, Asian, and/or indigenous American descent. Unlike the United States, Brazil has not had the same type of emphasis in educational or government applications that require data based on race, although discrimination is clearly evident in terms of advantages provided for "lighter skinned" people, particularly in higher levels of administration.

Race may be understood as an artificially contrived tool of power and has become a cultural construct, promoting racial differentiation. The notion of race influences how people share information and understand themselves in relation to others. This understanding leads to various actions and behaviors, including those that promote group identity as well as discrimination. Dance classified by so-called racial distinctions is not instructive. By attempting to identify traits that differentiate dances on this basis, we propagate the construct of race, leading to appropriation of power. Any terms that endorse racial classification are insignificant for comparative study, implying extreme ambiguity and generality, which lead to misinformation and stereotyping.

Nationality

Nationality is another collective identity that connects people in terms of birthplace. Individuals may have more than one nationality or change nationality through a process of naturalization, which requires prolonged stay in a particular nation. Nations have physical, empirical delineation such that the people within those boundaries are controlled by the jurisdiction of a specific government. Since these geographic borders are negotiated, they may change over time. Negotiations occur through economic trade and/or war. Japan, Cambodia, Vietnam, and Afghanistan are all countries in the continent of Asia. People born in these countries are respectively Japanese, Cambodian, Vietnamese, and Afghan. If travel occurs from one country to another, they are required to have a passport or other official document demonstrating their national identity.

National dances are becoming more and more difficult to categorize. A century ago, there was greater emphasis on the study of dance of a particular nation. Much of this interest was fueled by feelings of nationalism or patriotism through which people demonstrated their devotion to their birth nation. However, today's national qualities or characteristics may not adequately describe dances. This is due in large part to dissemination of information through media and immigration influencing shared knowledge systems. American dance is diverse and nearly impossible to define. This same statement is true in relation to many other nations around the world. Therefore, nationality, like race, as a category to describe dance, may become inconsequential.

One example where nationality is an identity marker for dance culture is among refugee groups. This is particularly true among the Dinka and Nuer people from Sudan, Africa's largest country. In Sudan, intermittent periods of civil war have existed for decades between different groups. Two groups in the southern portion of this country are the Dinka and Nuer, influenced by Christianity but faithful to traditional ways. Both groups subsist as cattle, sheep, and goat herders and are generally nomadic, following their herds' migrations. On the other hand, they have distinct languages, and similarly, distinct dance and music.

Many of these people have fled as refugees from their homeland, leaving established ways of life behind. In some instances, social service intervention has helped to relocate the refugees to host countries. In the U.S., Dinka and Nuer, who have come to be known as the Lost Boys of the Sudan, interact with other refugees and share certain cultural knowledge, like the English language, food choices, dress, and popular music. In Phoenix, Arizona, they have formed the group Sudanese Voices United as a community organization through which they reaffirm national identity (fig. 7-2). Although Dinka and Nuer maintain traditional dance cultures distinct from each other, they collectively participate in special events and perform dance and music traditions under the auspice of Sudanese Voices United.[5]

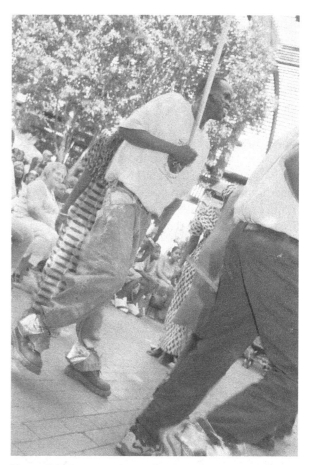

Figure 7-2. Sudanese Voices United performing at the City of Phoenix Heritage and Science Park African Festival (Photograph by Vivian Spiegelman, Phoenix, Arizona, 2002).

Ethnicity

A third type of collective identity that connects people is ethnicity. *Ethnos*, a Greek term, from which the word "ethnic" derives, refers to a group of people that has in common biological and cultural ties, with a special emphasis on tradition.[6] Biological similarities may be physical size and shape, hair and eye color, and skin tone. Cultural characteristics, or shared knowledge among people sharing ethnic ties, may include language, world view, religious beliefs, political values, social organization, dress and food/eating customs, music, and dance. Examples of ethnic groups are Celt (United Kingdom), Hmong (China, Laos, Myanmar, Thailand, and Vietnam), Arara (Brazil), Basque (Spain/France), Inuit (Canada/Alaska), and Ibo (Nigeria). Sometimes a particular ethnic group constitutes the nation of its origin, such as ethnic Slovakians in the nation of Slovakia. In contrast, several different ethnic groups exist simultaneously in one area, like the Ga, Akan, Ewe, and Twi people within the national boundaries of Ghana.

The explicitness of ethnic identity varies significantly depending on the time and place of study. For example, one hundred years ago, ethnic groups in Europe were more easily observed than today. Interethnic marriages, immigration, nationalism, and globalism have diffused or placed less emphasis on ethnic group identities. In some cases, ethnic identity is no longer distinguishable. Keali'inohomoku raises further questions about whether ethnic dance is identified by the style, the ethnicity of the performer, or the context in which it is presented.[7]

The United States, as a multiethnic society, is complicated in terms of studying ethnic identity. Sometimes ethnic groups are not clearly defined because people have adapted to new settings and lost or consciously relinquished their traditional ways. In fact, not long ago, there was a fear that the U.S., as a melting pot of many different types of people, might lead to homogenization, where all ethnic

identities would blend together. Renewed interest in diversity issues, especially in the 1980s, led to increased ethnic awareness and pride. This became a focal point in education and civic activities. Today most major cities in the U.S. have annual festivals and are developing community centers to promote various ethnic groups.

In some cases around the world, ethnic identity is as clear in the twenty-first century as it was hundreds of years ago. Regardless of external influences, specific languages and ways of life persist. For the Yaqui or Yoeme, indigenous people of the American Southwest, *pascola* dances are a treasured part of their heritage (fig. 7-3). Their traditional homeland is in the state of Sonora, Mexico, although socioeconomic persecution forced some of them to relocate and establish communities in and around Tucson and Phoenix, Arizona.

The word *pascola* means "old man of the fiesta or ceremony" and is a Spanish version of the Yaqui word *pahko'ola*. Taught through oral and movement traditions and passed down through the generations, the *pascola* learns the dances by apprenticing with another *pascola*. Much of their inspiration to dance comes through visions, usually in a dream. The *pascola*, a unique part of Yaqui dance culture, performs at all major occasions, including feasts, weddings, and sacred occasions. Sometimes, he is the host of the event and, in addition to dancing, will pantomime, clown, and tell stories to the crowds. A harpist, a violinist, and a drummer-flutist usually accompany the *pascola*, who wears a large blanket tied around his waist, a belt of metal bells, and cocoon rattles around his ankles. The *pascola* also carries a wooden rattle and wears a mask, carved of wood and usually painted black or brown. The mask is made to resemble the face of either a human, a goat, or other animals, with a beard and eyebrows made of either hair or fibers. The tradition of mask making also is passed through generations and taught through apprenticeship.[8]

Ethnicity is a subcategory within the larger classification of culture. Although members of a specific ethnic group have biological similarities, this information is only one component pertaining to their shared or cultural knowledge system, which influences how they make sense of themselves in relation to others and informs their actions. The study of ethnic dances, as dances from ethnically distinct groups of people, is still possible and important. Dances of the Yaqui reveal ethnic identity. However, a shift in perspective is taking place that no longer focuses exclusively on ethnic dance as a category of study. Instead, emphasis on dance as a cultural knowledge system begins to "even the field" since universally ethnicity is becoming less and less an identifying factor worldwide.

One such example is popular dances, such as hip-hop, which are complex and difficult to understand ethnically. This also is true for studying ballet or modern dance as ethnic dances, especially today, when each dance form borrows heavily from other dance traditions around the world. By examining the origin of ballet, it is possible to discover common ethnic roots, as Keali'inohomoku observed in her well-known article on that topic.[9] She explains how the language, performance space, customs reenacted on stage, choreographic themes, roles, aesthetic values, and scenic elements reveal a Western European civilization heritage. However, if some dances are considered ethnic and others are not, there emerges

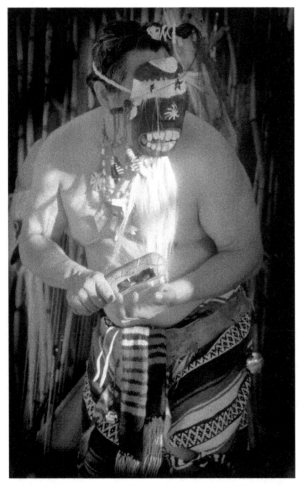

Figure 7-3. Merced Maldonado, Yaqui Pascola, Guadalupe, Arizona (Photograph by Sigrun Saemundsdottir, Guadalupe, Arizona, 2003).

a type of hierarchy in which ethnic dance may be more or less valued. This attitude powerfully impacts how people look at and understand dance around the world.

Summary

Dance reveals unique characteristics by which people identify themselves. These characteristics also make it possible to recognize a particular person or group through their dance culture. Dance, a form of self-identity, is as diverse as the number of people in the world. Individuals with common traits form collective identities. Yet, categories based on race and national identity (in some cases) are not beneficial to the philosophy underlying multicultural dance education, since this type of identification often leads to generalizations about dance behaviors that are stereotyped and promote misinformation. Worldwide, there are many examples of dance cultures illustrating ethnic identity. Nonetheless, ethnicity does not provide a universal framework for comparative study of dance. Diffusion of dance cultural knowledge due to intermarriage and population shifts is making ethnic identification increasingly more difficult.

Notes

1. National Human Genome Research Institute. (2002). International consortium launches genetic variation mapping project. Accessed August 21, 2002 at http://www.genome.gov/10005336.
2. Bamshad, Michael, & Olson, Steve E. (2003, December). Does race exist? *Scientific American, 289/6*, 78–85.
3. Zah, Peterson. (2003). Personal communication. Mr. Zah is the Former Chair of the Navajo Nation.
4. Judson, Katharine B. (Ed.) (1994). Myths & legends of California and the old Southwest. Lincoln, NE: University of Nebraska Press.
5. Vissicaro, Pegge, & Godfrey, Danielle C. (2004, winter). The making of refugee dance communities. *Animated*, 20–23.
6. Keali'inohomoku, Joann W. (1969–1970). An anthropologist looks at ballet as a form of ethnic dance. In M. Van Tuyl (Ed.), *Impulse* (pp. 24–33). San Francisco, CA: Impulse Publications.
7. Keali'inohomoku, Joann W. (1990, Summer). Angst over ethnic dance. *Cross-Cultural Dance Resources Newsletter, 10*, 1–6.
8. Maldonaldo, Merced. (2004). Personal communication. Mr. Maldonaldo is a Yaqui Pascola and artist living in Guadalupe, AZ; The Yaqui today. Heard Museum. Accessed March 23, 2004 at http://www.heard.org/rain/cultura5/raincu11.html.

Discussion Questions/Statements

Write your responses to the following questions in the space provided. Collaborate with one or two other students and explore their ideas to the same questions. Examine similarities and differences to the various responses.

1. In what ways does dance reflect your cultural identity? To what extent do you share dance cultural knowledge with your family? Peers? With another group of people?

2. Think about how many times you have seen job or school applications that ask for information regarding race. White, Black, Hispanic, Indian may be some of the terms listed, however, none of the words accurately describe race. The term white is not an appropriate label for describing a group of people, nor is the term black. The words Hispanic and American Indian also do not accurately refer to a race of people. Without a scientific basis by which to understand significant variables, why does the concept of race continue to exist as a criterion to assess someone for an application? As humans heighten their awareness about the political construct of racial distinction, how will that change the way people relate to one another? What action should be taken now, as we move forward in the twenty-first century?

3. What value does ethnic identity have in your own life? How has interethnic marriage, immigration, nationalism, and/or globalism impacted your ethnic identity? Which ways does dance reveal your ethnic identity?

4. How do you think people interpret, understand, and take action toward dance performance groups that identify themselves on the basis of racial, national, and/or ethnic characteristics? What examples can you provide, both positive and negative, that may relate to your own experience or observations?

5. What is your nationality? How does this identity impact the way you make sense of dance as a part of your cultural knowledge system?

6. Name one specific ethnic group to which you may belong and discuss whether or not that identity influences your dance culture.

Creative Projects

Family Genealogy (a required assignment to be completed by all students)—With the help of family members, list as many ethnic groups to which your family is associated in the form of a genealogical chart or tree (principally your mother's and father's parents, grandparents, and great-grandparents). You may have to dig deep to locate specific areas from where your ancestors originated to determine their ethnicities. If it is absolutely impossible to identify specific ethnic groups, you may refer more generally to nations or regions (for example, Ireland or Andalusia). After researching this information, write a short essay (250 words) describing the extent to which your share cultural characteristics (language, food, dance, dress, religion, etc.) with other members of each ethnic group you listed. After each individual has designed their chart, compare the information with two or three other students. Finally, develop a class tree that visually illustrates similarities as well as the range of different ethnicities among the group.

Literary Application—Develop a short story for children between the ages of 2–4 using a reference to dance, which is new or expands on an existing story that pertains to the notion of one race or one people. The objective is to promote peace through unity. Include a title and at least one color illustration.

Critical Viewing—Observe two video clips of groups of people interacting through dance. Study which characteristics the individuals in each group share. What type of identity or identities do you think or know that these characteristics demonstrate? How are the groups similar or different? Discuss your ideas with one or two people.

Notes

Chapter 8

Labels and Categorization

Introduction

People recognize their own particular national, ethnic, and/or cultural identities based on certain shared characteristics, which dance exemplifies and strengthens. As we explore dance cultures around the world, it is natural to process information by labeling and categorizing. Schemata facilitate organization and interpretation of this information. Knowledge construction begins by making relationships between previous ideas and continues as we negotiate meaning through interaction in specific contexts. Language is a vehicle for communicating our knowledge, and the terms we use become identification tags or markers representing how we understand.

Sometimes, the terms and concepts we disseminate about dance are not entirely correct, but through popular usage, we become comfortable with the language and the labels "stick." This chapter begins by examining how our words and attitudes may situate some movement forms in higher positions of power. Throughout the discussion, it is important to critically examine the impact of our own and others' world views and cultural systems on labeling and categorizing dance.

Issues of Power

We have explored the idea that collective identities, such as culture, race, nationality, and ethnicity promote differentiation. Unfortunately, comparison by differences creates hierarchy, ranking groups and appropriating power accordingly. Groups that have a larger membership and demonstrate greater authority or control become dominant, such as government,

corporate, and institutionally sanctioned organizations. When these groups exercise power to their advantage, they are hegemonic. The word hegemony comes from the Greek, *hegemonikos*, pertaining to leadership. In critical theory, hegemony refers more specifically to oppressive aspects of power and promotion of ideology to mold consciousness.

Ideology, from the Greek words *idea* and *logia*, meaning "to speak ideas," is often understood as a set of doctrines, opinions, ideas, and ways of thinking of a particular group. Importantly, ideologies reveal assumptions that take for granted, or legitimize, certain practices, beliefs, and behaviors. Hegemony occurs when these practices, beliefs, and behaviors are used coercively to manipulate citizens to adopt oppressive meanings.[1] For example, over the past 100 years, many texts have focused largely on the study of dance from a European perspective. These texts were legitimized by the dominant or hegemonic ideology through continued adoption in university courses. However, toward the mid-twentieth century, scholars began resisting this Eurocentric perspective by producing literature that more equally represented diverse dance cultures of the world.[2]

Ethnocentrism

The term "Eurocentric" implies that Western European cultural knowledge systems are the center of emphasis. Likewise, ethnocentric suggests that the ethnic or cultural group to which one associates is considered more favorable or more highly valued than another. Ethnocentric practices advance ideological assumptions that legitimize certain ways of thinking and acting. In the case of evaluating two dances originating from two different ethnic groups

or cultural systems, it is highly ethnocentric to suggest one may be of greater importance because of its history, types of dancers, music, apparel, space and time in which the dance occurs, movement technique, or reason it is performed. Some individuals believe that ballet is superior to dances of indigenous people living in the Amazon basin because the former requires rigorous training and development of technique. This example demonstrates how people impose their values in ways that motivate ethnocentric, as well as Eurocentric attitudes, which creates a polarized view of "we" versus "they."[3]

All people are ethnocentric because they possess a value system that is specific to their world view and cultural knowledge system. Every individual exists in the center of his or her own universe, using various interpretive frames to process what is happening around that person. This influences how they "see" themselves in relation to others, or their world view. Ethnocentric behavior becomes pejorative when a person's values promote judgments that diminish another's way of life or attitudes in favor of one's own.

Media representations of dance encourage ethnocentric attitudes, which produce generalizations and stereotypes. Generalizations are vague representations that group people, ideas, and behaviors together by abstracting common properties or qualities to form larger, more general concepts. Stereotypes conform to set, oversimplified images that are difficult to change. Both generalizations and stereotypes legitimize the way we think and act in relation to dance. Visual information mediated by print materials, television, radio, and the Internet further ideological assumptions. The notion of African dance is a generalization and stereotype propagated by media representations. Using this term, which appears in textbooks, newspapers, television or radio shows, and/or Web sites, reduces an entire body of dances from Africa into a continental category and reveals a hegemonic ideology that is largely oppressive. Asian dance, European dance, North American dance, South American dance, and Australian dance are equally manipulative. Although these terms are convenient and easy to use, they sometimes promote an inaccurate view that all dance from these areas are similar.

Looking at each of the six continents individually, we may find it appropriate to organize information about dance culture by geographic location, such as north, south, east, and west. Discussing dance of West Africa, for example, is better than using the term "African dance" alone. There are many similarities of traditions among the people of West Africa, even though languages are widely dissimilar. In contrast, there are vast differences between West and North Africa. Within the countries of West Africa, there may be several hundred different ethnic groups with each ethnic group having unique subgroups of culturally unique people. Therefore, the best labels, or descriptors, of dance from any part of the world are the most specific. This task is often harder to achieve, yet educationally it provides more significant information.

Historically, all media perpetuates cultural, ethnic, national, and racial stereotypes. Many examples, as innocent as they may seem, are found in children's programming, such as cartoons. Although misrepresentations have been much worse in the past than the present, they still exist today. Naturally, people are influenced by what they see and hear and may find generalizations useful because of the simplicity with which information can be categorized. Unfortunately, this type of classification creates an unvarying form, pattern, expression, opinion, or character that is void of individuality. All forms of media must be carefully examined for promoting generalized or stereotypical information. Without precise or in-depth analysis, media representations of dance from a particular area of the world often lead to an ambiguous and sometimes misguided impression, by reasons of this very lack of specificity.

Primitive, Folk, and Ethnic Dance

Definitions of dance forms change depending on the context. In the late 1800s and early 1900s, one accepted view of understanding human societies proposed that people evolved through different stages of development. Among primitive groups, dance was essential and included elements of possession and ritual.[4] This idea represented a hegemonic ideology, describing certain groups as being more advanced (in terms of evolution) than others. Today, "primitive dance" classes are taught around the world and in universities. This "form" is believed to have distinctive features appealing to something that is exotic and basic, often involving African-like dance movements. However, the word "primitive" in this usage is both a generalization and stereotype.

Anthropologically speaking, the concept of primitive suggests "an autonomous and self-contained system with its own set of customs and institutions, that may be isolated or have more or less contact with other systems but is usually economically independent and the people are often, if not always, non-literate."[5] Non-literate implies that members of primitive systems do not have a written form of communication. Conversely, the people, who cannot read and who reside in a social system with a written form of communication, are referred to as illiterate.

Sometimes dance is considered primal because it is primordial human behavior. To classify dance as primal is not a valuable category for cross-cultural study since this behavior already is a fundamental aspect of being human. People also attempt to describe dance of the "primevals," although no evidence exists to verify that our prehistoric ancestors actually danced. There are strong inferences about the presence of dance, but we do not have any records validating dance behavior by early humans. We can, however, accurately state that there are dances performed by primitives, or those living in primitive societies.

Folk or peasant societies differ from primitive ones, which are not autonomous or independently governed. Instead, people in folk societies interact and have a symbiotic relationship with the larger society since they live together geographically, relate economically, and share certain aspects of cultural knowledge. Folk dance embodies traditional values of folk societies and is a dimension of the total society within which it exists. Following that idea, Keali'inohomoku, informed by anthropologist Robert Redfield's work, suggests that folk dance is commonly performed as a part of the little tradition within the great tradition of a given society.[6]

In Brazil, *quadrilha* is a folk dance common to most people throughout the country that represents shared traditions and values. Brought to Brazil by European immigrants, *quadrilha* originated in the French courts during the eighteenth century as the quadrille, which consists of four couples creating square-like patterns (fig 8-1).

In Brazil, *quadrilhas* occur in large open areas, such as the community center or village plaza, performed by children and sometimes adults exclusively during the harvest festivals in June and July, known

Figure 8-1. Quadrille formation.

as *Festa Juninas.* These festivals celebrate the days of St. Anthony (June 13th), St. John (June 24th), and St. Peter and St. Paul (June 29th). Much more than the original four sets, *quadrilha* involves an unlimited number of couples moving counterclockwise in a circle, in two rows facing each other, and/or a single line moving in serpentine and spiral patterns. Couples consist of boys/men and girls/women; however, either role may be played by a member of the opposite sex. The dress is *caipira* or hillbilly style, which emphasizes a farm or rural environment. There is a caller who directs the participants' action. Some of the popular movements are *grande roda* (fig. 8-2) (dancers travel holding hands in a big circle), *forró* (couples dance together), and *costura inglesa* (participants hold hands and create a line that weaves in between each other like sewing). This folk dance is a smaller tradition within the larger tradition underlying Brazilian society, promoting an agricultural lifestyle, community, and family values, as well as

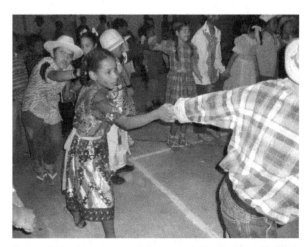

Figure 8-2. A *grande roda* during a *quadrilha* Guaraná, Espírito Santo, Brazil. (Photograph by Pegge Vissicaro, Guaraná, Espírito Santo, Brazil, 2003).

Catholic religious beliefs. Today many schools around the country promote curriculum that includes learning folk traditions, such as *quadrilha*.

A single point needs to be made about using the term "ethnic dance." All dance has ethnic roots from which it developed, as Keali'inohomoku discusses. For some dances, it is very difficult to determine precise origins, or there may be several origins that blend together to create the movement form. Conversely, there are dances that clearly reflect a particular ethnic group. Yet when most people refer to ethnic dance, they usually do not mean ballet, modern, or anything else based on Western European civilization values and beliefs. The implication is that other dances are lumped together into the vague "ethnic" category, producing differentiation. This difference engenders levels of authority and control. Words are influential tools, so we must be aware how labels or classification appropriates power as we describe dance cultures around the world.

Traditional and Classical Dance

Kurath used the term "continuity" to refer to the process of promoting traditions through dance.[7] Due to social conservatism, certain dances remain relatively unchanged throughout the centuries. Since the twentieth century, Labanotation (previously discussed on pages 25 and 26) and/or video recording movement have facilitated this process. Archives of dances are an important source for accurate reconstruction of traditional dances. Standardization or the implementation of a codified technique for teaching dances becomes another strategy for preserving tradition. This is evident in ballet, where teachers abide by specific methodologies, such as Vaganova and Cechetti, to rigorously uphold the standards for evaluating and sustaining excellence in ballet technique.

Another way to promote tradition is through the repetition of ceremonies or special events that occur more or less regularly year after year. The indigenous people of Taiwan, Republic of China, have many traditional dances. With a total of nine distinct tribes, there are over 500,000 total indigenous people living in Taiwan alone. On Orchid Island, about 40 miles southeast of Taiwan, live approximately 3,000 members of the Yami tribe (the younger generation prefer the term Tao, which means "man" in Bashiic, a Malayo-Polynesian language).[8] From March to June, they paddle into the ocean with decorated wooden canoes to catch flying-fish, a time-honored activity,

crucial to the subsistence economy of the tribe. The Yami observe many taboos while catching and eating these fish because they are sacred. During *pyafuan* or "the month of the beautiful moon" when food is in abundance, the Yami (Tao) womenfolk gather in an open space in the village to sing and dance. Characteristic is the swinging of their hair while dancing. The dance also is performed to celebrate the completion of building canoes and houses, a communal activity, as well as for tourists throughout the year.

Classical dances also are traditional but place special emphasis on an important historical era. Often pedagogy is explicit and detailed, having developed over a long period of time. The term "classical" is culturally specific since various areas of the world throughout history refer to classical dances differently. Authority promoted by dominant ideologies dictates what is considered classical. For instance, in much of Europe and North America, classical dance training infers study of ballet, the epitome of Western European civilization's values and beliefs. Although modern approaches to ballet education are popular, the stereotypical image of ballet is classically based, focusing on orthodox or conservative views of the body, technique, choreographic themes, attire, and musical accompaniment.

In India, perhaps the best known and most popular classical dance is *Bharatanatyam* (fig. 8-3), which originated from Tamilnadu or the state of Madras in the southern part of the country. Prior to the 1930s, it was known as *Sadir Nac* or *Dasi Attam*, the dance of the temple *devadasis* (servants of God).[9] The word "*bharatanatyam*" consists of "bha" for "bhava" or expression, "ra" for "raga" or musical mode, and "ta" for "tala" or rhythm. Natyam means the art of dance.

As India struggled for independence from the British, urban *literati* or scholars sought to revive ancient traditions in an effort to promote national consciousness and develop forms of pan-Indian identity. "Pan" derives from the Greek meaning all. The venue for performance shifted from the temple or palace to Western European styled theatres, with a proscenium arch (creates a picture-like frame that positions audience members in front of the dance), raised stage, curtains, and fixed tiered seats with aisles.

Students train in *Bharatanatyam* using codified techniques to express Hindu texts through intricately detailed movements of the entire body. Culminating intensive training is the *arangetram*

not. All dance is social and cultural since it reveals socially constructed (shared) knowledge.

It is possible to categorize dances as social, in which the primary objective is meeting and interacting with people, particularly those of the opposite sex. There are numerous examples of dances around the world that fulfill this purpose, exhibiting a variety of movement styles. In the United States, folk dancing at community center clubs, participating in underground raves and house dancing, and/or swing dancing at a bar or ballroom are only a few of the dance types and contexts in which people develop social relations through dance. Social dance shapes, informs, and influences social patterns, triggering transformation of the self or promoting adherence to the group.[10]

One such dance that impacted social attitudes in Europe during the late 1700s was the waltz (fig. 8-4), originating in Austria. As its popularity grew, guardians of public morality complained that the "motion was dizzying, exhilarating, even intoxicating; the more energetic couples seemed constantly

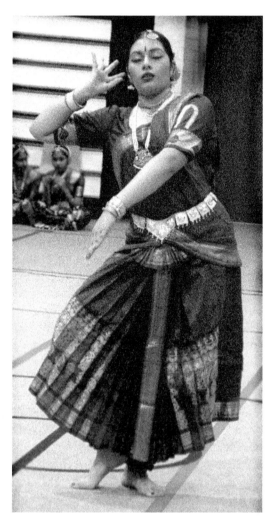

Figure 8-3. *Bharatanatyam* performer with Asha Gopal's Arathi School of India Dance, Phoenix, Arizona (Photograph by Sigrun Saemundsdottir, Tempe, Arizona, 2004).

(ah rrhen gay' tram), which means ascending the stage, and is a type of graduation ceremony that requires elaborate preparation, sometimes lasting over a year. This is the first formal presentation of the student (*shishya*) to an audience by her teacher (*guru*).

Social and Popular Dance

A review of sociological theory reminds us that human life is social life in which we meaningfully orient ourselves to the environment. From this perspective, it may be redundant to delineate a special category for social dance, since inherently all dance behavior is social. The same concept applies to the term "cultural dance," which is confusing, suggesting that some dance is cultural and other dance is

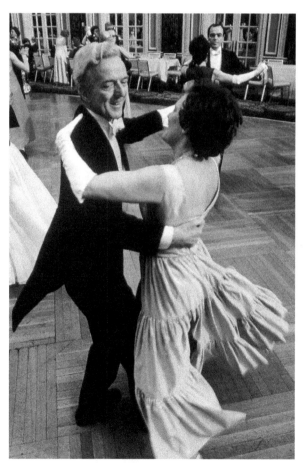

Figure 8-4. Waltzing, Boston, MA, 1980s–1990s (© Ted Spiegel / Corbis).

on the verge of losing control."[11] However, by 1815, the revolutionary waltz, which allowed couples to dance by holding each other tightly, became socially acceptable. Although the initial craze diminished significantly, media facilitated the popularization of waltzing in the twentieth century, particularly in film by stars such as Fred Astaire and Ginger Rogers. Ballroom studios sprung up everywhere to accommodate interest in learning to waltz, providing standardized teaching techniques. Today competition ballroom dancing includes waltz as one of the many categories by which couples are judged.

The popularization of any dance form involves a widespread interest that builds on current trends. Some dances emerge and become popular immediately while others move in and out of popularity. Dances that go through any type of resurgence, another of Kurath's dynamic processes, involve a renewed enthusiasm for tradition.[12]

Today, swing dance is one such movement genre that has been revived and popularized in many parts of the world (fig. 8-5). Swing dancing encompasses a range of different dances such as the Lindy Hop, named after Charles Lindbergh's flight to Paris in

1927, and jitterbug. As a couple dance, its roots are in Harlem, New York and the opening of the Savoy Ballroom in 1926 along with the big band sound of jazz musicians and singers like Benny Goodman, Glenn Miller, Duke Ellington, and Cab Calloway. Some of the many swing dance styles include West Coast Swing, East Coast Swing, Cajun Swing, and Country Western Swing.

Popular dances, like swing, have a general appeal, are frequently encountered, easily accessed, and/or widely accepted by the public at large. Promotion of classes in private studios and public schools as well as through formal and informal competitions increase interest by developing new recruits and strengthening the skills of those already involved. Media also stimulate exposure and generate awareness. Importantly, popular dance is context specific, meaning that its popularity exists within a particular time and place. For example, *forró* is only popular in Brazil and is gaining greater strength as a dance style because of rising national pride and rural to urban population shifts. As with all aspects of the universe, each environment stimulates different types of interactions. Changes that popularize certain dances are interesting to study since they reveal how social, economic, political, and other factors impact knowledge construction.

Summary

Just as we have multiple identities to which we relate, there also are multiple ways to label and categorize dance. Depending on one's perspective, different identification tags may be used to help us organize and manage dance information. A danger in classifying dances is the possibility of situating our own value system in a position of power, leading to derogatory views toward other people's dances. It is also valuable to critically assess media representations which often encourage sweeping generalizations and stereotypes. In every case, the best formula is to study dance cultures around the world by using labels and categories that are context specific, creating equality for all dances, dancers, and dancing.

Notes

1. Keali'inohomoku, Joann W. (1969–1970). ibid.
2. Clarke, John, Hall, Stuart, Jefferson, Tony, & Roberts, Brian. (1981). Sub cultures, cultures and class. In T. Bennet, G. Martin, D. Mercer, & J. Woollacott

Figure 8-5. Swinging with the Lindy at the Savoy Ballroom, New York, 1947 (© Bettmann/Corbis).

(Eds.), *Culture, ideology, and social process* (pp. 219–234). London: Batsford Academic and Educational.

3. Theories and methods of dance research developed by Kurath, Keali'inohomoku, and other scholars (see selected bibliography) significantly influenced the shift towards a more inclusive approach to studying dance cultures around the world, which impacted dance literature.

4. Keali'inohomoku, Joann W. (1990, Summer). ibid.

5. Royce, Anya P. (1977). *The anthropology of dance.* Bloomington, IN: Indiana University Press.

6. Keali'inohomoku, Joann W. (1969–1970). ibid.

7. Keali'inohomoku, Joann W. (1972). Folk dance. In R. M. Dorson (Ed.), *Folklore and folklife: An intro-duction,* (pp. 381–404); Redfield, Robert. (1956). *Peasant society and culture.* Chicago: University of Chicago Press.

8. Kurath, Gertrude. (1960). ibid.

9. Tapei Journal. (July 21, 2000). Autonomy for orchid island. Accessed on March 29, 2004 at http://www.taiwanheadlines.gov.tw/20000728/20000725f1.html.

10. Puri, Rajika. (2004). Bharatanatyam performed: A typical recital. *Visual Anthropology, 17*(1), 45–68.

11. Malnig, Julie. (2001). Introduction. *Dance Research Journal, 33*(2), 7–10.

12. Jonas, Gerald. (1992). *Dancing.* New York: Harry N. Abrams, Inc., p. 171.

13. Kurath, Gertrude. (1960). ibid.

Discussion Questions/Statements

Write your responses to the following questions in the space provided. Collaborate with one or two other students and explore their ideas to the same questions. Examine similarities and differences to the various responses.

1. Make a list of labels and categories that you have heard or are typical for describing dance around the world. On what basis do you think these labels and categories are selected? In what ways do they reveal hegemonic ideologies?

2. Take a moment to explore your own ethnocentric perspectives and how they influence understanding dance. Try to provide at least one example in which your world view and cultural knowledge system limited your ability to equally appreciate dances different from those with which you are familiar.

3. Some people might claim that dance is more significant (and highly valued) in non-literate societies than in societies that have a written system of communication. List reasons to support both sides of the argument. Then in small groups, debate your ideas. Have one or two judges to evaluate which group provided the most convincing arguments.

4. Describe a folk dance in which you have participated or observed. What was the purpose of doing this dance? Who were the dancers? Where did it take place and when? How did you move? What types of steps or movement patterns did you do?

5. Describe a tradition that you practice or know about in which dance is always present. Why is dance important to preserving this tradition? Who participates? Where? When? How?

6. Choose one dance that is very popular among people in your general age group. Do you like this dance? Why or why not? What reasons do you think the selected dance is so popular?

Creative Projects

Internet Resources—Surf the Internet and find Web sites in which the authors/Web designers use specific labels or categories to describe dance from any place or time around the world. Choose one site and provide references to labels and categories that promote generalizations or stereotypes. In contrast, select another site that does not promote generalizations or stereotypes, with examples from the actual text. Critically examine the differences between both Web sites. Discuss your findings in a 250-word essay that includes the Web addresses (URL) of each site.

Large Group Activity—Form groups of five or six people and then make a list of the six continents/ geographic areas: North America, South America, Africa, Europe, Asia, Australia/Pacific Islands (you may wish to refer to the maps located on pages 164–171). Next discuss individual dances or characteristics of dances that you think represent people living within these larger world regions. For example, what comes to your mind when you envision dance culture of Asia? What dances have you heard about from South America? Ask yourself to what extent media representations inform your understanding of these dances or characteristics of dances. Provide examples of media influences.

Movement Activity—Choose a tradition that you share with family members, your peers, or a special interest group. Then design a dance activity by determining when, where, and how it should be performed. You may think of a series of movements that help you to remember the tradition and which can be repeated to create a pattern. Select music, special attire, and any other aspects. These choices must be meaningful and representative of the tradition.

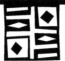

Notes

Chapter 9

Movement, Perception, and Values

Introduction

In this chapter, we explore how the dancing body shapes our perceptions. Perception involves interpreting sensory data to create mental representations of the world. The senses, which respond to different types of stimuli from outside and inside the body, affect the way we move and react to others moving.[1] Sensory processing also may influence the formation of relationships by which we identify, categorize, and label dance. From these ideas, it is possible to recognize that cognition or knowledge construction is bio-basic, rooted in biological activities.[2]

Each of us has unique sensory perceptions that we experience during the physical activity of dance as well as while observing others dance. Our individual perceptions are culturally informed and vary between people and groups. By using criteria from our particular cultural knowledge system, we assess sensory information and respond appropriately. These criteria also provide a rating scale by which we hierarchically rank and thereby determine value of importance, reflecting cultural ideals about issues such as what is aesthetic or authentic. Evaluation is context-specific, so whether we are appraising our own dancing or that of another person, the total environment, which includes all external and internal factors, has an effect upon our interpretation and understanding.

The Movement Experience

Dance cannot exist without human bodies. This physicality is what we notice most; we feel it. Some dances heighten our physical awareness since the activity of movement creates sensations in the body. The heart and pulse beat more quickly as blood circulates. The respiratory system works harder and faster to accommodate these changes. Endorphins also are released in the body, producing chemical reactions that intensify the movement experience. Through the senses, our bodies know that we are dancing.

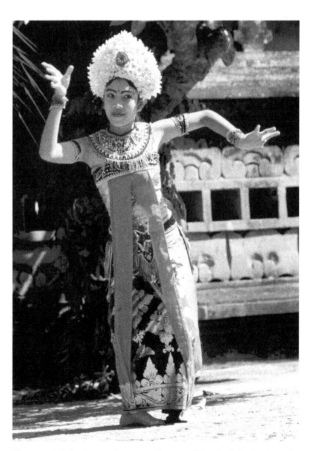

Figure 9-1. Balinese Legong dancer, Ubud, Bali, Indonesia (Photograph by Nora Taylor, Ubud, Bali, Indonesia, 1992).

From the moment an individual begins dancing, changes happen as he or she embodies experiences and ideas. Embodiment is a way of providing material form to abstract or intangible concepts. Through dance, the physical space of a human body gives shape or structure to concepts, like world view and cultural knowledge. In the same way, dance may embody spiritual beliefs or a choreographer's vision as well as national and ethnic identities. Dance makes the invisible, visible.

The process of transforming experience and ideas into the dancing body involves numerous factors influenced by external and internal conditions. Externally, the space in which the activity occurs affects the transformation. As dancers move on the stage of a theatre or specially designed performance area, they interact and react with the environment. From their perspective, there is a clear difference between "offstage" and "onstage." On one side of the "curtain," they are getting ready to dance by switching from everyday clothing to specific apparel, applying make-up, warming-up the body, and/or mentally preparing themselves. The transformation is complete by the time the dancer enters the performance area. Elements, such as a distinctive surface to enable movement, theatrical lighting, and scenery, provide greater focus on the dance. This space serves as a catalyst or enticement, facilitating the change from doing basic, common activities to dancing.

Envision a setting in which colored strobe lights create a unique ambience alluring people to dance or a formal ballroom with an area designated by parquet flooring, which highlight the dance space as separate from the rest of the room. These special places "call" to the dancer. Most communities have particular areas for dance events. Consideration for where dancing takes place may be determined by the number of people, accessibility, and the desired affect for a special or themed event such as prom, wedding, or quinceñera, an occasion marking the transition from child to woman. Theoretically, all spaces may accommodate dance, but dance does not happen just anywhere. Certain conditions need to be present that impact the environment and generate information, triggering the senses and a dance response.

There are all types of situations in which people have an effect on an individual's sensory perception and the way he or she dances. In cities around the world, dance clubs and discotheques are purpose-fully designed for men and women to come together to meet one another. The desire to connect with others influences how one dances. A person's movement style and/or that of others may be attractive, engaging certain types of feelings and actions.

The amount of people in a setting also impacts the senses and subsequent dance behavior. For example, during Carnival, large crowds of people often gather to celebrate life and the beginning of Lent. Carnival, which means farewell to flesh in Latin, concludes on Ash Wednesday, determined to be precisely 40 days before Easter. That time of year also coincides with an important point marking the Earth's orbit around the sun. In Europe and the rest of the Northern Hemisphere, Carnival happens during the vernal (spring) equinox, while in Brazil and the Southern Hemisphere, it corresponds with the autumnal (fall) equinox. This impacts what people wear, the types of activities that occur, and the places where celebrations take place, such as on the beach versus indoors.

Some of the most renowned Carnival celebrations are in Italy, Croatia, Germany, Trinidad, Tobago, Columbia, and Brazil. In the United States, Mardi Gras, which means fat Tuesday in French, also is a Carnival festival. *Carnaval* in Rio de Janeiro, Brazil attracts tourists from all over the world. The *Sambódromo* (fig. 9-2), built in 1984 for the parade of Rio's professional samba schools, holds 100,000 spectators each night during the four days prior to Ash Wednesday. Samba schools (*escolas de samba*) are not actually teaching institutions. Instead, a samba school is an association of people from the same neighborhood, usually a working class community (*favela*) in a suburban area. They get together on a regular basis for rehearsals and provide jobs by employing people year-round in the production of costumes and floats. Each school has approximately 3,000 to 5,000 members and 6 to 8 floats that take from 60 to 75 minutes to make it through length of the *Sambódromo*.[3] The drum corps (*bateria*) of each school also consists of hundreds of people playing percussion instruments. With so many people moving close together for an extended period of time, the sensory experience is powerful. It resembles a colorful moving tapestry of energy and pulsating rhythm that stimulates observer and participant alike.

Besides dance and music, Carnival includes feasting, revelry, and a perceived change of identity through use of masks and costume. Masks and special attire used in dance and other types of ceremo-

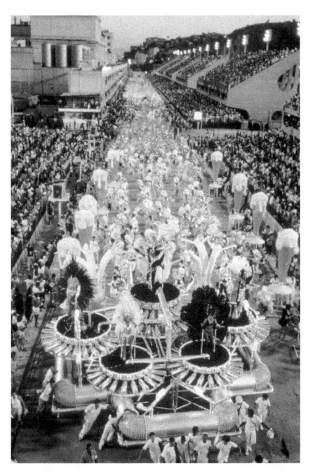

Figure 9-2. Sambódromo during Carnaval, Rio de Janeiro, Brazil (© Maze/Corbis).

nies impact movement and transform the individual externally and internally. It is not difficult to understand how dancing while wearing something out of the ordinary, like a large headdress or long cape, impacts one's physical sensitivity, most specifically balance. Psychologically, these items may influence emotions and personality traits, making a person that is normally shy feel more outgoing. Other internal effects on the moving body may happen as a result of fasting, using mind altering substances, eating certain foods, and/or drinking specific beverages. For example, Hopi men restrain from eating and doing specific types of behaviors several days prior to participating in *katsina* ceremonies (fig. 9-3). That, in addition to wearing heavy masks and doing repetitive movements all day long, with only half hour intervals to rest, is a necessary part of the transformation to become a *katsina*.[4]

During *katsina* ceremonies, Carnival festivities, and various dance events around the world, drumming or percussive sounds using gourds and items found in nature are a significant component. These instruments usually have a central purpose by providing rhythm that people feel and to which they respond. The drum, like a heartbeat, represents the pulse of life. For some groups of people, drums symbolize the center of the universe, and may be considered the medium through which contact between the spiritual world and dancers occurs. When the Malpeque people of Lennox Bay, Prince Edward Island, Canada hear the drum, they remember their sorrows and joys. It also increases awareness to all creation, since without Mother Earth, animals, trees, and humans, they believe no one could survive. Each beat of the drum, along with the dances and songs, are prayers to the Creator.[5]

For most people from Burundi, East Central Africa, the drum promotes feelings of national identity. For many years, it was featured on the country's flag. Drums are made of a specific wood called *umuvugangoma*, literally "the wood that makes the drum resonate," and cow skins. These vibrations are data that the senses process and to which people react through movement. Drums transmit information using specific language and were traditionally played as an announcement for someone of high rank. It also is a way to establish communications between isolated places. When battles were fought, the drum was the equivalent of the battle flag, and its capture by the enemy was equal to defeat. Drums also are a strong symbol of fertility: one of the most important

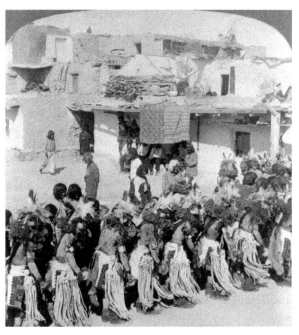

Figure 9-3. Hopi *Katsina* Ceremony, Shungopavi, Arizona, 1903 (© Corbis).

uses of the drum was to accompany the benediction of the crop seeds by the ruler or chief.[6]

Kinesthetic and Aesthetic

The drum material resonates or vibrates when it is struck with a stick or hands. These vibrations produce sound waves that travel through the air, which externally impact auditory perception. Internally, those sounds may stimulate a reaction to move in culturally patterned ways. Sensory stimulation that influences movement may be described as a kinesthetic response. Kinesthetic involves the root word "kinetic" from the Greek *kinein*, to move. Many different types of sound impact dance behavior besides music or rhythmic accompaniment. One example is shouting words of encouragement for the dancer, like the *jaleo* (ha ley' o) in Flamenco. The vocal expression from the audience or non-dance participants generates kinesthetic feedback that may cause the dancer to feel a heightened sense of energy. Flamenco, a movement, music, and singing form originating in the region of Andalusia, Spain is a dialogue between the singer, guitarist, and dancer. Through percussive footwork and intricate hand, arm, and body movements, the dancer kinesthetically interprets the words and emotion of the singer. This interpretation is individually perceived and culturally informed by views toward appropriate and inappropriate behaviors.

There are many other sensory stimuli besides sound. Affects on perception include color, temperature, clothing, the architecture of a space, and the time of day dance occurs. Texture is also an important factor influencing kinesthetic response. Imagine dancing with shoes on a smooth surface as opposed to moving barefoot on sand. A completely different experience results from the way the foot contacts the floor, which impacts friction, or movement resistance and balance.

Kinesthetic response on the part of the dancer and/or observer is one way to study processes of sensory perception and compare dance cultures around the world. Another perspective considers aesthetics, from the Greek word, *aisthetikos*, meaning perceptive, especially by feeling. The concept of aesthetic involves an evaluation of perceptions.[7] Aesthetics also refers to the branch of philosophy dealing with notions of beauty, perfection, and/or other culturally defined qualities. Value judgments of sensory information based on shared understandings determine

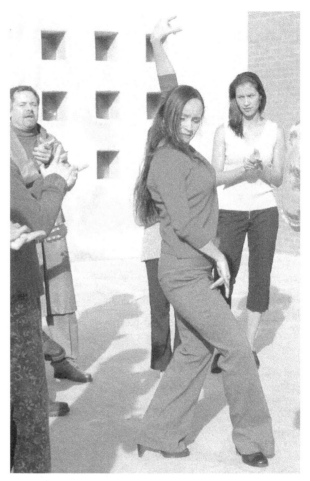

Figure 9-4. Flamenco dancer, Bernadette Gaxiola, Calo Flamenco: Ballet de Martín Gaxiola, Phoenix, Arizona (Photograph by Martín Gaxiola, Tempe, Arizona, 2004).

what constitutes cultural ideals. A positive aesthetic response occurs when elements such as body shape, movements, spatial design, and/or costuming meet or exceed expectations. For example, a person aesthetically conditioned to seeing thin dancers may have a negative aesthetic response to dances in which the performers are heavy. This response may come from cultural values, suggesting that large means ugly. It is important to clarify that even for those who share meaning the dancer may have a different set of criteria by which to evaluate the aesthetics of a performance than the audience. An individual may strive for an ideal feeling or kinesthetic response while dancing; while the observers desire a specific visual configuration.[8]

ART AND NON-ART

These same values influence how people may label or categorize certain dance forms as art. What we mean by art is relative to our shared understand-

ings. For some, art is the demonstration of exemplary technique. Artistry may be a term applied to extraordinary high levels of control or skill. However, classifying dance as art usually prompts ethnocentric evaluations that appropriate certain dance forms and empower specific people sharing cultural knowledge. Keali'inohomoku points out that using the term "art" to describe dance from a society different than one's own is really describing one's own tastes, so whether dance is art or not depends upon the intent of the performers.[9] She also explains how art requires selectivity and therefore makes a distinction between Dancers and dancers. The term "Dancer" implies a trained specialist or artist whose product (Dance) is artistic. Conversely, a dancer is someone who dances but is not necessarily an artist. Examples in this text where the terms "dancers" and "dance" are not synonymous with "artist" and "art" refer to dance cultures of the Hopi, Yaqui, Kaluli, and Yami, as well as those who get together for *quadrilhas*, *forrós*, and *ceilís*. These individuals are more or less ordinary folks with the minimum required talent and skill to realize the dance. Most highly valued for these groups of people is the process and affect of the dancing upon the dancer and/or observer rather than the end result and creation of Dance.

Authenticity

Our discussion about aesthetics and art naturally leads to examining the topic of authenticity. Cultural values define what makes sense or is cognitively consonant. That determination powerfully influences assessment pertaining to validity and credibility of the dance experience or presentation. The word "authentic" derives from the Greek *authentikos*, from *authentês*, meaning author. Authentic suggests a claimed and verifiable origin or authorship; not counterfeit or copied. The question of how one knows whether dance is authentic or not is difficult to answer. This issue also is highly contested since there are so many ways to interpret the word "authentic."

From an individual's perspective, the activity of dancing is real, not imagined. It exists within an actual time and space. Through dance, we extend thought to represent understandings that are credibly our own. Moving validates and legitimizes the embodiment of these ideas, which reflects the author's or dancer's personal knowledge system and world view. When we "try on" another person's

movement, we translate that "data" into ways that make sense. Our bodies move to produce what we believe is a true, sincere representation of the information. We may not look the same while doing the movement; however, the experience is genuine or authentic.

The question of authenticity becomes important with the presentation of dances that embody a group's cultural knowledge. In this case, validation by the people from whom the dance originated is one measure to determine whether it is a legitimate representation of the shared knowledge system. Guidelines pertaining to movement quality, design, organization of movement patterns, musical accompaniment, apparel, and props must adhere to culturally defined criteria of the group to meet aesthetic expectations. Often the elders and/or other individuals sanctioned by the community are entrusted with the responsibility to carefully critique all aspects, thereby maintaining integrity of the dance culture. Dance that promotes continuity of traditions from generation to generation are especially susceptible to scrutiny, and innovation is not usually encouraged.

All over the world where issues of identity play a major role, dance as an authentic representation of cultural knowledge is a significant factor. Dance preserves and disseminates shared information with which people identify and distinguish themselves from others, empowering them as a group. Once authenticity diminishes, they become weakened, and compromise identity. The aspect of identity also pertains to dances that authentically represent shared knowledge of individuals living in a specific geographic area. Association of the dance to a physical location strengthens connection between the people and that space. Authenticity then becomes a political tool demonstrating a type of territorial claim. With such high stakes, it is requisite for the survival of the group that dance culture remains authentic. A third perspective for discussing identity and authenticity relates to the commercialization of cultural knowledge. The importance of maintaining and promoting cultural knowledge becomes a matter of economic productivity for groups that rely on tourist dollars. Often people want to experience local dance cultures when they visit foreign countries. Agencies or organizations fulfill this expectation by offering shows and classes featuring native groups and teachers. From a positive viewpoint, this helps to support the development of dance cultural knowledge in that area by providing money for costumes,

instruments, and dance or music specialists to work with individuals in the group.

On the negative side, people may exploit dance cultural knowledge by stereotyping certain elements (movement, costume, music, etc.) and presenting information that is not authentic. The victims are usually schools and communities looking to promote diversity and hire dance and music performance groups or teachers that state they represent specific areas of the world. Sometimes the institutions are limited to a small pool of applicants, which is further constrained by availability and budget. Fortunately, this is changing since criteria for selecting culturally responsible groups and individuals are being established as the field of multicultural education matures.

Some people suggest that globalism is to blame for the lack of clarity or generalized dance and music performances promoting various world regions. Globalism may be considered a melding of systems on a planet-wide level where financial, military, legal, governmental, educational, scientific, and technological infrastructures cooperate as integrated, consolidated units. This leads to the formation of a global identity, which is essentially homogenized or blended to create a uniform composition. However, global dance or world dance does not exist, nor can it happen since cultural knowledge is and always will be context specific. There are too many variables that impact the negotiation and agreement of meaning. For everyone in the world to share understanding about a particular dance is simply not possible. For the same reason, the terms "global dance" and "world dance" are not correct and only serve to confuse people. These labels are marketing ploys that require critical evaluation and should be viewed with suspicion.

Summary

The way we experience and evaluate movement involves processing information on a biological, sensory level. Cultural or shared knowledge systems influence these individual perceptions that are context specific. Many internal and external factors shape our interpretation and understanding. Sensory stimuli also trigger kinesthetic responses and aesthetic perceptions. These understandings promote the formation of values, which determine how we employ culturally defined criteria for judging levels of artistry and authenticity pertaining to dance.

Notes

1. Keali'inohomoku, Joann W. (1976). ibid.
2. Hall, Edward T. (1959). *The silent language*. Garden City, NY: Doubleday & Company.
3. Insider's Guide to Rio de Janeiro, Brazil Web site. Carnival in Rio de Janeiro. Accessed on April 4, 2004 at http://www.ipanema.com/carnival/parade.htm.
4. Keali'inohomoku, Joann W. (1976). ibid.
5. Malpeque People of a Sacred Bay Web site. (1999). The drum. Accessed on April 6, 2004 at http://collections.ic.gc.ca/malpeque/drum.html.
6. Maclouf, Malika. (August 8, 1998). Actualités 67: Encadré tambours Burundi le tambour, tout un symbole. Journal L'Alsace. Accessed on April 7, 2004 at http://www.alsapresse.com/jdj/98/08/21/ST/article_3.html.
7. Keali'inohomoku, Joann W. (1976). ibid.
8. Keali'inohomoku, Joann W. (1976). ibid.
9. Keali'inohomoku, Joann W. (1976). ibid.

Discussion Questions/Statements

Write your responses to the following questions in the space provided. Collaborate with one or two other students and explore their ideas to the same questions. Examine similarities and differences to the various responses.

1. Describe the type of music that stimulates you to dance. Why? How does it make you move?

2. Watch a short video clip in which dance occurs and describe how elements in the space focus the observer's attention on the dance.

3. How do you describe your dance style when you are in a club with other people your age? Besides the music, what motivates you to move?

4. Describe various internal and external factors that may impact the way you dance (what you wear, eat, drink, etc.).

5. When you hear drumming, how does it make you feel? Describe how your body responds.

6. What type of dance is aesthetically pleasing to you? Why?

Creative Projects

Movement Activity (a required assignment to be completed by all students)—Students will begin by casually walking around a large, unobstructed space in their own unique ways. After one minute, the teacher or class facilitator will ask them to increase their speed slightly. This process will be repeated again after two minutes, three minutes, and four minutes. During the last minute, participants should be moving as quickly as possible. At the end of five minutes, the teacher will tell the students to prepare to freeze when they hear a clap of the hands. Once the teacher claps and students stop, they will be asked to close their eyes for one minute in order to concentrate on the sensations in their bodies and their awareness of the total environment. After they open their eyes, the teacher will ask students to discuss in small groups how the physical experience impacted their sensory perceptions. Also the class as a whole should be encouraged to discuss similarities and differences between their experiences.

Internet Resources—Surf the Internet and find Web sites that you think authentically describe a particular dance culture. What methods or strategies do you use to authenticate the information? Also identify another Web site that does not present an authentic representation of dance culture. Why did you choose the site? Discuss similarities and differences between both types of Web sites.

Critical Viewing—View a video clip of dance. Write down those aspects of dance information that do (positive reaction) and do not (negative reaction) make sense. How does the dance meet your aesthetic standards as a member of the cultural knowledge system from which the dance originates or as a member outside the system, whose expectations are framed by external sources? Respond to the question, is this dance authentic? What assumptions do you make to come to this conclusion? Discuss your reactions in small groups.

Notes

4

Dance as
Transmission

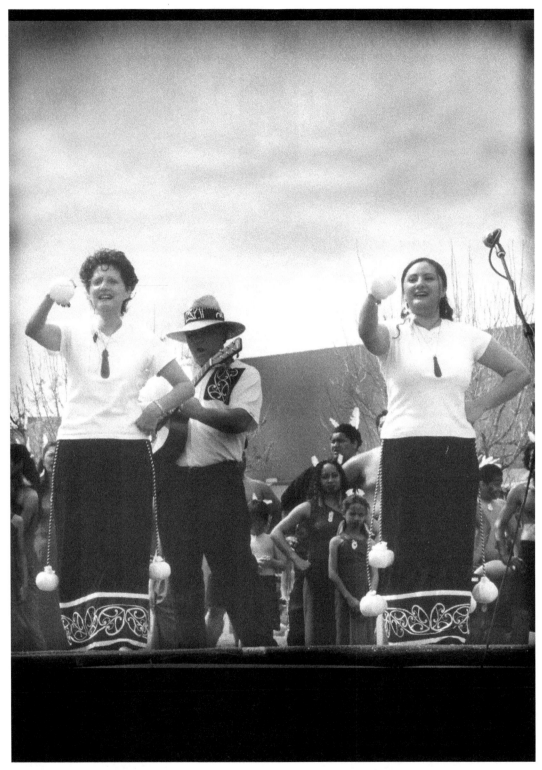

"Among the Maori of New Zealand, poi have many meanings. In our dances or *hakas*, we swing these soft balls, originally derived from a traditional weapon, to suggest forces of nature such as waterfalls, summer rain, and birds in flight. The sound keeps rhythm for the dancing, and may be used during ritual ceremonies, welcoming guests, and celebrating important events. They connect us to our past, focus us in the present, and direct our future paths." *Hiona* from Salt Lake City, Utah performing at the City of Phoenix Heritage and Science Park Aloha Festival (Photograph by Sigrun Saemundsdottir, Phoenix, Arizona, 2004).

Chapter 10

Dance Communication

Introduction

Humans, as social beings, meaningfully orient themselves to people and other objects within the environment. Orientation involves the senses, which process data affecting our body. In various settings, our personal cultural knowledge system guides our interpretations and strategically informs a response. These responses consciously or unconsciously transmit information that convey meaning and communicate.

This chapter explores the operation of cultural systems as a primary means for transmitting information.[1] People generate meaning about dance verbally using words and nonverbally using movement and other behaviors in order to construct knowledge. Words and movement are symbols that represent ideas and experiences. Each context requires different ways to communicate since the circumstances impacting interactions are constantly changing.

The Language of Dance

Language, as a component of cultural knowledge systems, is one way people extend thought. Spoken and written languages employ words to which people attach meaning, shaped by cultural or shared understandings. There are thousands of languages worldwide and many more regional dialects of each specific tongue. Since all people do not share one language, intercultural communication is often difficult and sometimes unfeasible. The same idea holds true for dance, another component of cultural knowledge systems. No individual dance exists that everyone around the world interprets similarly. Even among those that share cultural knowledge, individual perceptions about dance differ. Due to the specificity of culture, it is impossible for dance to transmit the same information to everyone. We cannot communicate universally through one single language of dance.

For this reason, there is no generic word to describe "dance." The English word dance comes from the Old High German, *danson* or *dinsan*, meaning to draw, drag, or trail. That definition automatically frames and limits an individual's perspective about movement phenomenon. More confusion develops since the word dance in the English language is both a noun and a verb. The word form does not change, but a person must know the word usage to determine meaning appropriately.

A compilation of definitions taken from several dictionaries describe the noun dance as:

- rhythmic movement of the feet or body, ordinarily to music
- a particular kind of dance, such as the waltz, tango, etc.
- the art of dancing
- one round of a dance
- a party to which people come to dance
- a piece of music for dancing
- rapid, lively movement

Likewise, definitions of dance as a verb are:

- to move the body, especially the feet, in rhythm, ordinarily to music
- to move lightly and gaily about; to caper (to leap, skip, or spring as in the frolic of a goat or lamb)

- ◆ to bob up and down
- ◆ to be stirred into rapid movement, as a leaf in a wind
- ◆ to take part in (a dance); or perform (a dance)

By looking at the variety of meanings that pertain to the subject and activity of dance, we may examine how misunderstandings and misinterpretations arise when discussing dance cultures around the world. In addition, ideologies regulate the meaning-making process. For example, all dictionaries reveal a dominant ideology controlling definitions of words in English or any other language. This ideology influences how each individual translates and makes meaning. It is always important to critically analyze when, where, why, and how people use the word "dance" to observe appropriation of power and the positioning of hegemonic ideologies. Awareness of that issue strengthens the justification for developing a cross-cultural definition of dance. Cited on page 15, Keali'inohomoku provides us with this important tool for studying dance phenomenon in any context, which is not constrained by culturally-defined constructions of meaning.

We may find ourselves using the word "dance" to describe or discuss an activity that is not considered dance by those sharing the cultural knowledge system from which the movement phenomenon originates. Conversely, people who share meaning may understand a movement form as dance, while those outside that system do not. For example, ice dancing and water ballet may be termed "dance" by practitioners of these activities. Others may not be able to accept that classification. Despite the controversy, dance is "dance" when there is common understanding among those from whom the activity derives. People sharing cultural knowledge agree whether the movement form is dance or not and how labels are used. Individuals who do not share cultural knowledge and use the term "dance" to describe an activity impose their understanding and world view, as discussed in Chapter 8. Attaching labels and interpretations without being aware of our biases leads to ethnocentric attitudes favoring some forms and diminishing others because they do not meet our expectations as to what constitutes dance.

Perhaps one of the most important points pertaining to dance and language is that the word "dance" is not universal due to the variety of ways people interpret movement phenomena. Some groups of people have no single word for dance. Others have a variety of specific terms for dance but not a general word. For example, the Australian Aborigines of northeastern Arnhem Land use the word "*bongol*," which addresses dance-like behavior but also includes music. This same word may similarly be used to describe movement that excludes patterned steps of some sacred ceremonies and of certain activities of children's age groups.[2] In Portuguese, two words classify dance but refer to different contexts. A *dancarina* refers to a female dancer in a non-theatrical setting, while *bailarina* suggests a professionally trained specialist. Many dances have a unique label, which communicates specific information. For example, a *capoeirista* is one who does *capoeira*, and a *sambista* is a fanatic samba dancer.

In Japanese, two words refer to dance but are not synonymous: *mai* and *odori*. "*Mai* refers to quiet dance, with emphasis on the hands, and *odori* refers to swift dance with emphasis on the feet."[3] There are many types of *mai* and *odori*, which characterize specific prefectures, which are townships or regions. The *Kamigata-mai* is at times called *jiuta-mai*, because it is performed to the accompaniment of *jiuta*, a popular song sung by the Kamigata people of Osaka, Kyoto, and Kobe. It is performed as a chamber art, in *zashiki*, a Japanese-style room with *tatami* mats, to entertain special guests. The *Awa Odori* of the Tokushimi prefecture on Shikoku Island is over 400 years old (fig. 10-1). From August 12–15, close to one and a half million people of all ages gather on the streets and move to rhythms of the *shamisen* (a musical instrument similar to a banjo), drums, wooden flutes, and gongs. Originally, this dance emerged to celebrate completion of the Awa castle in 1585 and may also pertain to welcoming ancestral spirits during the *bon* season, which also is in mid-summer.[4]

Symbolization

Dance, like language, is a complex system of symbols used to represent and communicate meaning. The word "symbol" comes from the Latin *sym*, the prefix meaning "together" and *ballein*, which means "to throw." Combined, they suggest a comparison, or something that stands for another thing. Symbols do not exist in isolation but instead relate to one another and are a part of a total symbol system. Because dance symbols also are culturally derived, their meaning is shared, communicated, and understood between people who share cultural

Figure 10-1. An assembly of Awa Odori teams dance together to open the spring festival "Hana Haru Festa." Tokushima Prefecture (Photograph by Claire Kinder, 2004).

knowledge from which the dance originated. Cultural outsiders most likely understand the symbols differently, so symbolic meaning is not universal. One movement may have a variety of interpretations. Costume, music, and a variety of other elements relative to dance also have diverse meanings depending on the situation. For example, dance events that involve the color red may represent good fortune, death, violence, or the blood that unites all living creatures on the Earth. The study of symbol systems is always culturally relevant and must include examining relationships among different symbolic information to appropriately contextualize understanding. In other words, symbols are emic representations of a world view.

The Maori, indigenous people of New Zealand, have much symbolism in their dances. Maori are classified as Polynesians, related to the inhabitants of Hawaii, Tonga, Samoa, and Tahiti. There are many types of dances or *haka*; however, some are specifically intended for battle. These *hakas* are performed by men and serve to physically condition the Maori warrior. One particular gesture involves rolling the eyes and sticking out the tongue. This movement symbolizes the fierceness and strength of the Maori. Today *hakas* (fig. 10-2) are important aspects of Maori culture that express New Zealand identity. The word *haka* is made up of two parts: *ha* means breath and *ka* means to ignite or energize. The *haka* is sim-

ply a way to ignite the breath, energize the body, and inspire the spirit.[5]

Symbols are tools that extend ideas or thought and must be consciously distinguished from that which they symbolize. It is important to recognize that there is no clear relationship between the symbol and what it symbolizes, because without this understanding sometimes the symbols take on a life of their own and become confused with the reality they represent. In dance, both the dancer and the dance are symbols representing specific cultural knowledge. *Bharatanatyam* dancers that venerate a particular deity are not the actual deity, nor is the dance, which retells a story from a religious scripture, the text itself or the information it explains. This idea is somewhat more complex when discussing

Figure 10-2. *Te Whanau*, Mesa, Arizona performing a haka at the City of Phoenix Heritage and Science Park Aloha Festival (Photograph by Sigrun Saemundsdottir, Phoenix, Arizona, 2004).

transformations in which the dancer must "become" something else, as in Hopi *katsina* ceremonies. This is not simply an impersonation, since the dancer "must feel within himself, must be convinced himself, that he is more than himself, or other than himself."[6] The transformation, connecting the physical reality and conceptual reality, enables the symbolization process.

We may observe symbolization through that type of transformative experience in many places around the world where people "become" other than themselves through changes in sensory processes. During the Christmas-New Year holiday season, most often on Boxing Day (December 26th) and New Year's Day, there is a celebratory street parade in Jamaica called Jonkonnu or Jonkunnu. This also happens in the Bahamas as Junkanoo, in Belize as John Canoe or Jankanu, and in other parts of the British Caribbean and North America. That time of year was traditionally when slaves were free from work and could enjoy themselves. Forming bands and/or dressing up in costumes, they roamed the land, entertaining both Great House and slave quarters and gaining some small payment for their trouble, usually money, food, or liquor. The Jonkonnu characters, typically played by men in costume, included Pitchy Patchy (fig. 10-3), Horse, Cow, the Devil, Bellywoman (pregnant woman), Policeman, and Actor Boy. They danced to the sound of a square drum called a gumba box or gumbay (gombay) drums, as well as other drums and instruments, like the triangle, fife, and kitchen grater. Today the cost of assembling these

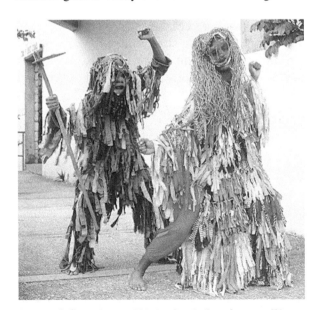

Figure 10-3. Jonkonnu "Pitchy Patchy" performers (Photograph courtesy of Jamaica Tourist Board, 2004).

groups is prohibitive but there are some special occasions in which Jonkonnu groups perform.

The event may have originated to recognize John Conny, believed to be a legendary early eighteenth century West African chief, or John Canoe, also known as John Cooner, a slave trader on the coast of Africa.[7] In Ewe, a language native to Ghana, Togo, Benin, and Nigeria, one interpretation of the words "*dzono kunu*" is deadly magician sorcerer; *dzon'ku* is a sorcerer's name for himself, and the *nu* means man.[8] *Dzo* also implies fire, charm, sorcery; *ku* is death; *kunu* suggests a death related issue.[9] Presence of this language demonstrates the dispersion of traditional knowledge by the slaves from West Africa to Jamaica. The character of the Devil, who pokes people with his pitchfork, promotes the element of supernatural. Transformation occurs to a greater or lesser extent through the use of masks and costumes to change identity, creating a magical, supernatural atmosphere. In the African Diaspora, numerous cases exist in which the slaves, as an oppressed group, disguised traditions by combining them with customs of the dominant class. Jonkonnu may have incorporated West African beliefs involving possession and magic with European cultural knowledge, such as the use of Shakespearean monologues and masquerade parades like Carnival. One idea explaining this adaptation strategy is that it eased retraumatization issues of forced migration in addition to making the slaves, as outsiders, appear less threatening.

Dance Culture as a Microcosm

For the person studying dance from an unfamiliar cultural knowledge system, it may seem impossible to understand meaning or interpret what the dance symbolizes. Yet because dance reveals behaviors, selected by the group or individual to represent specific ideas and information, the outsider may look at dance data for clues about the choices of people sharing culture. It is for this reason that anthropologists refer to all components of culture, dance being no exception, as microcosms of the total culture knowledge system. Microcosm is a little world, or epitome of the larger world. Epitome from the Latin, *epitome*, is an abridgment, or a part that is representative or typical of the characteristics or general quality of the whole. Dance ideally symbolizes or represents ideas and is characteristically typical of the larger cultural system.[10] Therefore, the study of dance reflects values and communicates information about the whole culture.

The Ewe of Ghana, Togo, Benin, and Nigeria have a dance, Sowu, that exemplifies this idea. Sowu, also called the Dance of Life, is taught to young boys and girls because the meaning of movements instructs them how to grow and become proper members of the Ewe community.[11] For example, the intent of one phrase in which the dancer steps to his or her right and left, simultaneous with rhythmic articulations of the upper body, is to show respect to one's mother and father. Another phrase illustrates that there are seven days of the week so every step taken each day must be precise. This means that people should do as they say and not be led off their path. The gourd shaker or *axatse* (fig. 10-4), used to accompany the dance *Sowu* as well as many other dances, also is symbolic. The method of playing, which involves rocking the gourd right and left, indicates the value of balancing between give and take. A person who takes from others is greedy and self-serving; one who always gives is usually taken advantage of, which also depletes personal energy resources. Among the Ewe, ideal behavior is always reciprocal, and equally involves giving and receiving.

Figure 10-4. *Axatse* (Photograph by Sigrun Saemundsdottir, Glendale, Arizona, 2004).

Summary

The dance symbol represents meaning that is culturally specific. This complex of symbols that includes the body, apparel, and other aspects of the dance operate as a unified network to transmit information that ideally characterizes the total cultural system. The language of dance is not universal, but all dance communicates. It is important for the multicultural dance education student to explore understandings by those who share cultural knowledge from which the dance originated. The study of dance cultures around the world also includes examining how, why, where, when, and by whom the terms describing dance are used.

Notes

1. Hall, Edward T. (1969). ibid.
2. Waterman, Richard. (1962). Role of dancing in human society: Address and Communication. *Focus on Dance, 3*, 46–55.
3. Keali'inohomoku, Joann W. (1976). ibid.
4. Ito, Sayuri. (1978). Some characteristics of Japanese expression as they appear in dance. In P. A. Rowe & E. Stodelle (Eds.) *CORD Dance Research Annual 10*, (pp. 267–277).
5. Reedy, Hirini. (2003). Tu Strategies. "From the earliest times, the haka has inspired and energized generations of Maori in both peace and war…" Accessed on April 15, 2004 at http://www.tu.co.nz/haka.htm.
6. Snyder, Allegra F. (1972). The dance symbol. In T. Comstock (Ed.) *CORD Research Annual, 6*, 213–224. New York: Committee on Research in Dance. (p. 221). Mrs. Snyder is a faculty emerita and co-founder of the Dance Ethnology graduate program at University of California, Los Angeles.
7. Metzner, Jim. (2002). Jonkonnu Origins. Jim Metzner Productions & National Geographic Society. Accessed on April 15, 2004 at http://pulseplanet.nationalgeographic.com/ax/ archives/01_culture template.cfm?programnumber=2555.
8. Long, Edward. (1774). *History of Jamaica II*. (New edition: Frank Cass, London 1970). London: Lowndes. London: 424–25.
9. Amegago, Modesto. (2004). Personal communication. Dr. Amegago is a scholar and Ewe master drummer dancer.
10. Keali'inohomoku, Joann W. (1972). ibid.
11. Vissicaro, Pegge. (1995). Sowu, the dance of life: Ideal representation of Ewe society. Paper presented at the Society of Ethnomusicology regional conference. Tempe, AZ.

Discussion Questions/Statements

Write your responses to the following questions in the space provided. Collaborate with one or two other students and explore their ideas to the same questions. Examine similarities and differences to the various responses.

1. In your primary language, make a list of as many words as you can think of that mean dance or dance-like behavior. Decide whether the words refer to specific dances or dance in general. Compare similarities and differences between how you interpret each word.

2. Explore how you extend thought or understanding using the word dance by writing down five meanings that you think of when you hear or see the word "dance." Then share your ideas with two or three others. Discuss the similarities and differences between your respective understandings of dance. Next, study the dictionary definitions of dance provided on pages 113–114 and compare these to your personal thoughts. In a small group, discuss the variety of ideas that emerge in relation to the word "dance." Also examine why, as well as how, language and other ways by which to control meaning are tools of power.

3. Do you agree or disagree with the idea that ice dancing is dance? Why or why not? What about water ballet? Pom lines?

4. Choose one dance photograph from this textbook and identify the various symbols that represent meaning. List the symbols in categories such as movement, personnel, apparel, paraphernalia, and external environment. After listing the symbols, briefly describe each one. Then examine relationships between the different symbols and discuss with others how these support one another to create a total dance symbol system.

5. Select a dance described in the textbook and discuss how it reveals ideal behavior of the people from which it originated.

6. Make a list of what you most highly value in your life and what you consider ideal behavior. How would you represent these values and ideals through movement? Based on your personal cultural knowledge system, what dance do you do that exemplifies your concept of ideal behavior?

Creative Projects

Movement Activity—Think about the following concepts: family, work, understanding, and Earth. Then design a specific movement to represent each one. Share these with others in class and compare how interpretation is similar and/or different. Combine the four movements in any order to create a movement phrase. Perform the phrase while remaining in one space and then explore ways of traveling while doing the same phrase.

Interviewing—Ask four or five people that speak a language different than your own to explain the words they use to mean dance. First, write these exactly as they are spelled in their respective languages (provide a phonetic version to remember how to correctly say each term and do not forget to identify the language). Second, write the definition or interpretation of what these words mean. Compare the various terms and definitions by discussing the similarities and differences between how the various people understand dance in a 250-word paper.

Art Application—Working in small groups, imagine you have been hired by an advertising agency to design a symbol to market a new line of dance clothing. The symbol must represent dance and incorporate at least some words, letters, and/or characters representing multiple languages. The goal is to promote widespread appeal as well as suggest the universality by which dance occurs in societies around the world. Explore font, size, shading, color and/or black and white and design as you develop your ideas. A final rendering will be produced and submitted on white 8½" x 11", 20lb. paper.

Notes

Chapter 11

Learning Dance

Introduction

We learn through a process of knowledge construction in which we interact with people and other objects in the environment. Learning is acquired or achieved over time as a dynamic activity influenced by individual experience. Different from ascribed and innate characteristics like ancestral heritage and physical reflex, learning involves a reciprocal exchange of information, which requires negotiation of meaning. This suggests that we develop our personal world view and cultural knowledge system through the activity of learning. Perhaps the most significant factor impacting the way people learn is context.[1] Each situation and the conditions surrounding it shape how we interact and construct knowledge to determine what we learn.

The examination of learning processes often leads to a discussion about teaching methodologies. There are a variety of methods by which information is disseminated. These are culturally derived and appropriate for the group sharing a particular knowledge system. Methods for transmitting information may include direct, general, explicit, implicit, verbal, nonverbal, didactic, collaborative, and other techniques depending on the setting. It is critical to remember that ideologies affect teaching, as well as learning, and must be evaluated as to whether the methods used and the content of information presented privileges certain people while disadvantaging others.

Repetition

One of the primary ways we learn is through repetition. Repeated exposure to specific sensory infor-

mation may produce similar results, which forms a pattern. If a baby is crying, someone usually responds by picking up and feeding him or her. The infant soon expects the same outcome each time he or she cries, relating specific actions and effects. In another situation, a baby hears the mother's voice and looks up to see her face. Eventually through association, a pattern emerges so that the child recognizes auditory data even without visual confirmation. The ability to conceptualize the mother's image, connecting the sound to a person, is an important skill for cognitive development. These examples demonstrate how our senses influence perceptions to form patterns of understanding.

Patterns facilitate cognitive consonance or meaning agreement among those that share knowledge. Cognitive dissonance occurs when what we are experiencing does not adhere to a recognizable pattern and therefore does not make sense. Dissonance is inevitable as we interact with people and in settings where differences exist. At these times we may find ourselves drawing similarities between information to produce patterns of meaning, which creates structure and stability. For example, while watching an unfamiliar dance event, a person may suggest that the group looks or is moving the same when in fact there are huge individual differences. This blending or blurring of participant anomalies by the cultural outsider promotes coherence and serves as a cognitive strategy to provide balance and understanding in an otherwise disordered situation.

People share knowledge about dance by acquiring through repetition an understanding of how specific patterns transmit information. This acquisition process is like learning grammar and syntax of spoken and written languages. Rules of language

provide systemization, which enables communication. In dance, these rules dictate the correct way to perform movements as well as when, where, why, and by whom the movements occur. Other rules govern what dancers and observers wear, what instruments if any are played and by whom, how accompaniment is structured if it happens at all, how properties or other paraphernalia are utilized with the movements, and what activities take place before, during, and after dancing. Learning the rules empowers people by giving them the ability to interact and communicate meaning, fulfilling one of the most basic needs for humans as social beings.

Repetition promotes the formation of patterns that enable us to acquire skills for communicating. It also is a value that people learn as ideal behavior, which may be observed in many dance cultures around the world. Performing repetitive movement for extended amounts of time heightens sensory stimulation, influencing knowledge construction. The *Mevlevis*, *Semazen*, or Whirling Dervishes of Turkey (fig. 11-1) exemplify this idea. These dervishes are devotees of Sufism also known as Tasawwuf, founded by Mevlâna Jalâluddîn Rumi in the thirteenth century, who was born in Afghanistan and buried in Turkey.[2] This practice contains elements of Hinduism and Islam developed primarily in Central Asia. Sufis practice many Islamic beliefs; however, they differ in that dance and music is encouraged during religious practice. They learn techniques that allow them to spin, approximately 20–30 times a minute in intervals ranging from 10–30 minutes. Rotating counterclockwise, the dervishes maintain their physical axis while contemplating the sheikh in the center of the circle.[3] The sheikh represents their link to Rumi and their love of Allah or God. Among Sufi's, the *zikr* is the Divine Ceremony of Remembrance and plays a central role in the practice of Sufism. In this ritual, acknowledging the moment of universal creation, nine members of the *Mevlevi* order spin with arms outstretched, signifying planets revolving around the sun. "They hold their right hands palm-up to receive the blessings of heaven. They hold their left hands palm-down to transfer the blessings to earth."[4] This configuration is also the Arabic glyph for Allah. The sheikh is a mediator between the spiritual and everyday worlds and stands in the center, symbolizing the sun. These 700-year-old whirling ceremonies, also known as *semâs*, are typically open to observers, even non-Muslims.

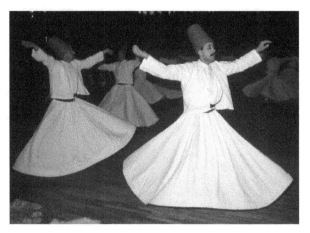

Figure 11-1. Whirling Dervishes, Konya, Turkey, 1990–1996 (© Chris Hellier/Corbis).

Synchronization

Repetition facilitates synchronization of movements, which strengthens transmission of information and promotes communication of meaning. Synchrony involves a mutual organization of time between the dancer and accompaniment and/or a group of people moving at the same time in relatively the same way. Sometimes personal variations occur through differences in body size, which influences timing. Among a group of people sharing cultural knowledge there is more or less flexibility regarding individuality. However, synchronization becomes increasingly more difficult as repetition decreases, thereby diminishing communication.

Synchronized dance movements also reflect cultural knowledge furthering religious, political, and/or social ideals. In Java, Indonesia, *Bedoyo* epitomizes synchronicity. *Bedoyo* is a 300-year-old sacred court dance performed by nine girls. Nine is considered a perfect number, symbolizing nine orifices of the human body, nine human desires, nine constellations, or the nine ceremonial gates of the palace.[5] This dance depicts the mythological meeting between Panembahan Senopati, the first ruler of the Mataram Kingdom II, with Kanjeng Ratu Kidul, the goddess Queen of the South Sea. Traditions in Java are a unique blend of Hinduism, Buddhism, and Islamic beliefs.[6] The dance is accompanied by a gamelan orchestra, which includes gongs, drums, xylophones (*gambang kayu*), bamboo flutes (*suling*), and string instruments (*rebab*) that creates sounds symbolizing the voices of sea wind and other natural voices.[7] At the center of the Sultan's palace is a specially built structure where the *Bedoyo* takes

place. The essence of *Bedoyo* is balance and unison in which the dancers represent a single person, concept, or theme.[8] By moving slowly and calmly, the dancers achieve an ideal state of equilibrium that is so highly valued in Javanese society.

Contexting

Contexting is one of the biggest factors that impacts symbolization and information transference, which subsequently affects the way people learn, as well as teach. Anthropologist Edward Hall coined the term "contexting" to describe the perceptual and cognitive process of recognizing, giving significance to, and incorporating contextual cues in order to interpret the meaning of a situation.[9] How, why, where, when, and with whom communication occurs impact levels of contexting, which range along a continuum from low to high in terms of the capacity to effectively communicate. A low context situation happens when people who do not share cultural knowledge interact and try to communicate. They require a high amount information exchange, which is often explicit and detailed.

Low levels of contexting may occur at multicultural dance and music festivals in which groups representing different areas of the world perform dances to a wide range of people. Sometimes, as presenters realize the diversity of their audience, they will begin by verbally explaining the meaning of movements and symbolism of other aspects of the dance to the audience to promote transfer of information and effectively communicate ideas. That leads to a more satisfying experience, which is especially important if the goal is to promote understanding diverse ways of life. In high context situations, information transference is more implicit, operating on the basis of personal networks and other communal relationships.[10] For example, dance events that revolve around rites of passage or intensification ceremonies, and which emphasize interactions with families and friends are always highly contexted. A low level of information transfer takes place because there is a greater amount of mutually understood information. Spoken directions are seldom necessary since communication patterns are predictable.

For the individual learning or teaching dance in an environment where others, at least initially, do not share cultural knowledge, the obvious progression is to transition from low to high contexted communication. Rich descriptions of the history,

performance setting, and costuming help to deepen meaning about the dance. The study of other aspects, such as individual movements, rhythm, instrumentation, and spatial design, further the meaning-making process. As the group collectively stores or shares knowledge, less information needs to be transmitted to understand the dance. This always requires a substantial investment of time and cannot happen without numerous opportunities to interact, develop relationships, and collaboratively construct knowledge.

In every situation, communication is more or less contexted due to particular conditions surrounding the situation. It is crucial to understand that information, context, and meaning must form a balanced, functional relationship for effective communication to occur. The following diagram (fig. 11-2) of Hall's contexting theory illustrates that greater amounts of stored information (high context) require less transmitted information (low context) and vice versa.

Learning Modes

Dance cultural knowledge systems are dynamic and consist of negotiated understandings. These systems develop through specific interactions or ways of behaving with other people and the total environment. The three basic types of behavioral modes by which we construct knowledge are informal, formal, and technical.[12] All modes are present and usually happen simultaneously; however, usually one type is dominant. How we employ each mode depends greatly on levels of contexting to transfer information and communicate meaning. Study of behavioral modes also reveals values and ideals significant to the people from whom the dance originated.

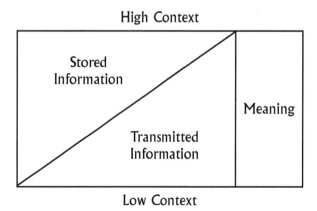

Figure 11-2. Hall's theory of contexting demonstrating the relationship between transmitted information, stored information, and the subsequent meaning.[11]

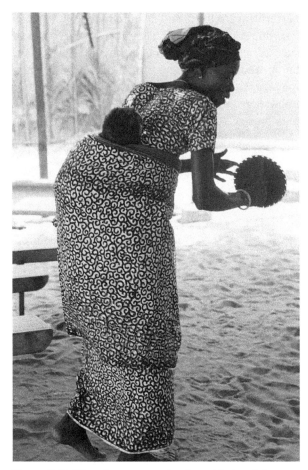

Figure 11-3. Ghanaian woman dancing with her baby at a Christmas celebration, Ada, Ghana 1973 (© Owen Franken / Corbis).

In an informal mode, there is a model used as an object of imitation. Nobody articulates the rules for what is happening, which can only be described in vague terms. Informal modes operate unconsciously or out-of-awareness and demonstrate behaviors that are most naturally acquired, like how kids learn to play and speak. This also is the most common way people around the world learn dance culture. In family and communal gatherings, as well as with our peers, such as in dance clubs, informal behavior guides our actions. Transmission of information travels in one direction to a specific recipient without immediate feedback. Through observation, we acquire new information that also may serve as a model by which others follow. Informal learning often happens in settings where people perform dances socially. As a child, informal learning about dance culture also may happen while being carried on his or her mother's back. From that perspective, they experience their mother's kinesthetic response,

as well as their own sensory perceptions to process information and share meaning.

Formal behaviors often are taught by precepts. These rules or principles prescribe a particular course of action or conduct that structures interactions to take place in specific ways. If the interaction is not appropriate, then there will be some type of admonition or cautionary advice. This warning usually comes from a teacher or person with authority of dance cultural knowledge and may be suffused with emotion, a particular tone of voice, and/or body language. We observe formal learning when a mistake is made. It is a two-way process so that if a person errors, he or she is corrected. In Bali, Indonesia, a *guru* of classical dances trains children using both informal and formal behavioral modes. Lessons begin, without any type of warm-up, as the teacher performs the dances in front of the child, who follows his or her movements. After showing the basic sequence, the teacher moves behind the student, takes the individual's wrists, and forces him or her to bend and undulate the body into desired positions; the

Figure 11-4. Balinese Legong dancer, Ubud, Bali, Indonesia (Photograph by Nora Taylor, Ubud, Bali, Indonesia, 1992).

teacher and student become one.[13] This physical or tactile manipulation of the body transmits the correct information in a most explicit manner, limiting misinterpretation that might result from verbal directions. After many hours of repeating movement demonstrations and manipulations, the movements are said to have "entered" the student. He or she then dances alone, with the teacher correcting from behind as needed. Only after completely memorizing a dance will the student practice with a full *gamelan* orchestra.[14]

The third type of behavior is technical and involves information transmitted in definitive terms from teacher to student, often preceded by a logical analysis. The knowledge rests with the teacher whose skill is a function of what he or she knows and one's analytic ability. Technical learning also happens through the technological transmission of information without the presence of a human teacher. Videos, books, and Internet sites are examples of media that disseminate information to promote technical behavior.[15] Using video images, photos, diagrams, descriptions, and music that systematically analyzes each aspect of the dance, as well as demonstrates relationships between all parts, one may be able to learn or teach the dance. The following diagram visually illustrates the correct foot pattern for waltzing (fig. 11-5). However, one major problem does emerge if there is no one with whom a student may interact to receive feedback or collaboratively construct knowledge. When that happens, instructional methods become didactic or excessively emphasize a particular point of view to the exclusion of others. This may be appropriate for codified techniques in which the intent is to remain unchanged over time, providing standardization as well as uniformity in performance.

As noted, all three types of behaviors exist in cultural systems and may operate together at the same time. Because context impacts interactions, it is interesting to compare how conditions influence and favor certain behavior modes. For example, traditional West African dance instructors in the United States may accommodate differences in lifestyles by developing methods that are appropriate in the United States but not in West Africa.[16] Among the Ewe for example, meaning develops informally as participants in communities interact and information is passed from generation to generation. Dance culture exists within a total complex in which dance, music,

The Basic Waltz Step

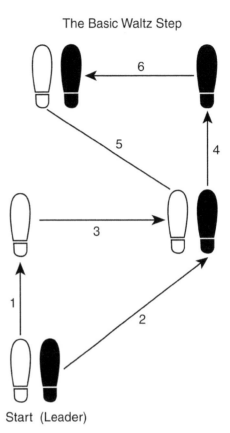

Start (Leader)

Figure 11-5. Diagram of basic waltz step.

and song are integrated. Each component of the trinity has equal weight so that learning one reinforces the other (fig. 11-6).[17] However in the United States, this is not always true. Often at the expense of the other, a greater emphasis on dance movements takes precedence over learning the songs. Understanding the music is even further marginalized. Pedagogy is more formal, following specific rules or precepts customary in American classrooms. Schedules constrain and compartmentalize the learning experience into a regular, ordered structure that exists apart from the context of daily life.

Summary

From the moment of birth, we interact within the environment to construct knowledge and communicate meaning. How we interact depends greatly on the surrounding conditions. People learn to adapt to new situations by discovering patterns, which promotes cognitive development and understanding. Repetition encourages understanding by providing a type of systemization with rules that govern behaviors. Informal, formal, and technical modes of

Figure 11-6. Diagram by Pegge Vissicaro, illustrating the trinity of West African traditional dance culture.

learning operate simultaneously. Context determines which type is dominant and valued for transmitting information.

Notes

1. Vissicaro, Pegge. (2003b). ibid.
2. Tasawwuf.org Web site. (2000). What is tasawwuf? Accessed on April 17, 2004 at http://www.tasawwuf.org/what_tasawwuf.htm.
3. Seidel, Miriam. *Philadelphia Inquirer*, Sunday, February 2, 1997.
4. Shira. (2000). The art of middle eastern dance. Scenes from Turkey: Whirling dervishes. Accessed on April 3, 2004 at http://www.shira.net/dervturk.htm.
5. Jonas, Gerald. (1998). *Dancing*. New York: Harry N. Abrams, Inc.
6. Geertz, Clifford. (1960). *The religion of Java*. Chicago: University of Chicago Press.
7. Persada, Sangga S. (1998). Joglosemar online. Javanese traditional dance. Accessed on April 17, 2004 at http://www.joglosemar.co.id/trad_dance.html.
8. Jonas, Gerald. (1998). *Dancing*. New York: Harry N. Abrams, Inc.
9. Hall, Edward T. (1977). *Beyond culture*. Garden City, NY: Anchor Press/Doubleday.
10. Korac-Kakabadse, Nada, Kouzmin, Alexander, Korac-Kakabadse, Andrew, & Savery, Lawson. (2001). Low- and high-context communication patterns: Towards mapping cross-cultural encounters. *Cross Cultural Management—An International Journal, 8*(2), 3–24.
11. Hall, Edward T. (1977). ibid.
12. Hall, Edward T. (1959). ibid.
13. Holt, Claire, & Bateson, Gregory. (1944). Form and function of the dance of Bali. In F. Boas (Ed.) *The function of dance in human society*, 55–63. Brooklyn, NY: Dance Horizons.
14. Bali and Indonesia on the Net Web site. (2004). Dance, music, and theatres of Bali. Accessed on April 27, 2004 at http://www.indo.com/culture/dance_music.html.
15. Since the first university dance courses (Introduction to Dance, DAH100 and Dance in World Cultures, DAH201) were offered online by Pegge Vissicaro through Arizona State University in 1996, the Internet has developed into a powerful venue for instructional delivery. Today courses provide networked environments that use dynamic discussions, multimedia databases, and telematics to promote social learning. Institutional collaborations and partnerships are increasing through recognition of the benefits of online education and research.
16. Vissicaro, Pegge. (2001). Cross-cultural dance pedagogy. Paper presented at the Congress on Research in Dance Annual Conference, New York University.
17. Ganyo, Cornelius K. (1987–2002). Personal communication.

Discussion Questions/Statements

Write your responses to the following questions in the space provided. Collaborate with one or two other students and explore their ideas to the same questions. Examine similarities and differences to the various responses.

1. Describe the most recent situation in which you learned a specific dance. What was your motivation to learn and how was information transmitted? Where and when did this take place?

2. Reflecting on your daily life, what patterns of behavior do you follow that provide structure? In what ways do those patterns translate to your dance culture? How does that information communicate meaning?

3. Watch a short video clip of a group that shares dance culture with which you are not familiar. Write down in as much detail as possible any movement patterns you notice. What is the structure? How does the pattern begin? End? What other patterns besides movement do you observe?

4. What is your attitude toward repetition in dance? How is this a strategy you employ to construct knowledge?

5. Provide an example in which you experienced informal learning of dance culture. When, where, why, and how did it occur? Who was your "model of imitation?" In what way was communication contexted?

6. Provide another example in which you experienced formal learning of dance culture. When, where, why, and how did it occur? What rules or principles structured interactions?

Creative Projects

Movement Activity (a required assignment to be completed by all students)—Divide the class into evenly distributed rows of 6–8 people each. The first person will be the leader who will perform a movement phrase and teach it to the next individual in the row. The others in the row may not watch the learning process until it is their turn. The phrase may be created by the leader, or the classroom facilitator may provide one phrase that everyone teaches. After the first individual has learned the movement sequence, he or she will disseminate that information to the next person until everyone in the row has gone through the process. The only rule is that the teaching must not involve verbalization or touching. At the end, the last person will perform the phrase for others in the group. Discuss to what extent the movement changed. Also describe the learning process. Compare the strategies used by the person transmitting data with those of the receiver.

Critical Viewing—Compare two video segments of groups sharing dance culture. One example should involve significant movement repetition and synchronicity, while the other example does not. Pay attention to specific rules that may dictate correct behaviors for communicating meaning. Discuss what similarities and differences occur between how the groups transmit information.

Teaching Application—In a small group, create a two minute movement phrase in which everyone contributes a gesture or idea. Then write a "manual" from which another group will learn how to accurately perform this phrase. Consider words, pictures, diagrams, and any other tools you can employ that successfully transmit information to teach this dance. Exchange and read another group's manual, then begin learning the new phrase. Perform the movements to the group with whom you exchanged manuals. They will assess how well you translated the lesson with written feedback.

Notes

Chapter 12

Dance Descriptors

Introduction

Over the course of our journey studying dance cultures around the world, we have constructed a broad theoretical framework, which establishes a basic foundation for the field of multicultural dance education. Our point of departure provides an integrated network of concepts that we may build upon as we explore new ways by which to compare dance cultures. Resources and examples presented in the text serve as an introduction and are designed to trigger more ideas based on one's personal experiences and through increased awareness and exposure to dance in diverse contexts.

The last chapter offers a analysis that most closely follows the technical learning mode previously discussed in Chapter 11. This approach for describing dance cultures incorporates methods for gathering and organizing data that considers the dancer's emic views (intrinsic) and etic perspectives of the dance scholarly community (extrinsic).[1] Discussion begins by exploring the concept of the dance event to situate it within the holistic setting. Then we organize information by examining macro features of the dance event, such as participants and location. Finally, we identify micro features to study the actual dancing and related aspects. This process may be compared to looking through a telescope to observe the distance connections between objects and then narrowing our lens to see the constituent parts that form the whole.

The Dance Event

Fundamental to multicultural dance education is the recognition that dance culture is a component of the larger culture in which it exists. Dance cultural knowledge is influenced by the greater knowledge system that people strategically use to interact and negotiate meaning in various settings. Based on these concepts, Keali'inohomoku coined the term "dance event" to remind us of the importance to study dance within the broader context. In order to understand the dance itself, one must examine "the relevant personnel, their behavior, the entire *mise-en-scène* of the dance event, and knowledge of the large cultural universe and population."[2] By *mise-en-scène*, Keali'inohomoku refers to the arrangement of activities in the total environment that happen before, during, and after the actual dancing. This interconnectedness of activities supports the notion that dance is integrally woven within life's fabric. We also refer to the concept of the dance event to acknowledge that dance is dependent upon its relationship to the community of people in which it occurs and cannot be meaningfully studied as an isolated phenomenon.

There are two types of dance events: contained and extended. A contained event is framed by an identifiable beginning and conclusion. Theatrical performances are good examples of contained events and demonstrate a "low context" setting as we discussed in Chapter 11.[3] Almost any type of concert in which an audience is expected to appreciate a performance without an in-depth background is a contained event. Competitive dance performances also exemplify contained events. When dance genres, such as ballroom, Irish step, and American Indian hoop dancing (fig. 12-1) are transformed from an informal to formal performance with strict rules that are observed by all the participants, they are contained dance events. Competitive dancing is highly structured and

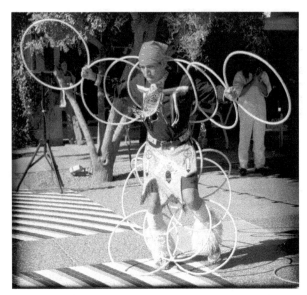

Figure 12-1. Tony Duncan, World Champion Teen Hoop Dancer and performer with Yellow Bird Dancers, Mesa, Arizona (Photograph by Sigrun Saemundsdottir, Glendale, Arizona, 2004).

all the participants must follow specific regulations in order to remain competitive.

Competitive events tend to be restricted in their expression, however their contexts are often flexible, and because of this, they are usually portable. For example, a dance concert can be given in differing theatrical spaces in venues that vary from town to town or even country to country. Competitive Irish step dancing can occur in Hawaii or Japan, as well as in Ireland. It may be performed in a dance studio, on a stage, in a gymnasium, on a platform out of doors, and so forth. The basic requirement for the performance space is that there is a hard floor on which the percussive sound of the shoes is heard. The other requirements are that all dancers play by the same rules, and all the judges use the same criteria for judging.

Extended dance events, in contrast, are tied entirely to their cultural context. These are not portable. Without much experience with the cultural knowledge system, an outsider will have a limited understanding of an extended dance event, and in fact, may misunderstand it completely. An extended dance event also is not necessarily bound by an identifiable time frame. Additionally, there often is an emphasis on repetition for part of the overall effect.[4] In its traditional form, *quadrilha* is an extended dance event. It only happens at certain times and in certain places, specifically Brazil during *Festas Juninas*,

previously discussed in Chapter 8. It is highly contexted, like all extended events, so that "meaning" is specific to those sharing cultural knowledge. To perform it at any other time or place would create cognitive dissonance among those from whom the dance originates. On the other hand, if *quadrilha* is taken out of context to be performed as a demonstration piece in a museum, or at a festival in Los Angeles, it will be a "contained event" at that particular time and place.

A fine example of an extended dance event is the potlatch (fig. 12-2), found among Northwest Pacific Coast tribes such as the Nuu-chah-nulth, Coast Salish, Bella Coola, Haida, Tsimshian, Tlingit, and Kwakwaka'wakw. The Kwakwaka'wakw (kwalk-walk-aye-walk), also known as Kwakiutl and studied by Boas in the early 1900s, live on Vancouver Island, Canada, and surrounding vicinities. For them, potlatches are extremely important social occasions given by a host to establish or uphold his status in society. These elaborate events are held to mark a special occasion in the family, such as the birth of a child, a daughter's first menses, a son's marriage, a parent's death, the raising of a totem pole, and the bestowal of titles. It may be interesting to know that during the British colonization of that area, beginning in the 1700s, potlatches were considered illegal until approximately 1951.

A potlatch is the center of history and puts on record by memory significant happenings over the course of time within the society. Potlatch, in the Chinook language, means to give; therefore, the person or family that hosts a potlatch gives away surplus wealth in the form of food, materials, and money. Every activity during a potlatch highlights the host's status by demonstrating wealth or inherited privileges and may include speeches, singing, dancing, feasting, and gift-giving. Speeches are important because the host is able to assert his ancestral privileges. Masks and headdresses worn during dances depict the supernatural being who had "given" the dance to the host or one of his ancestors. Traditionally, there were intensive preparations and the event itself took place over many days. Contemporary potlatches are usually compressed into one evening or weekend but still involve the efforts of many people to prepare and conduct the various activities that constitute the event. It creates cultural continuity, strengthens social organization, and governs behavior before, during, and after the event.[5] The context in which this event takes place is critical and if taken

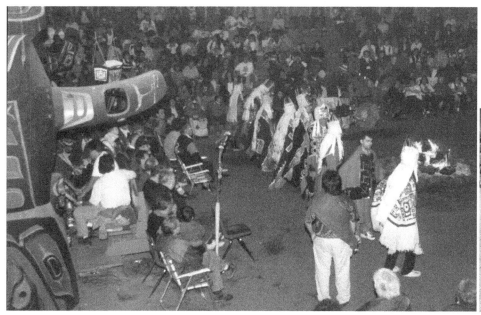

Figure 12-2. Kwakwaka'wakw potlatch, totem pole in foreground. Betty Walkus dancing at potlatch (Photographs by Jean-Guy Rousseau, Vancouver Island, Canada, 1999).

out of context, as it was at the Chicago Columbian Exposition in 1893, it is no longer a "real" potlatch.[6]

Macro Features

It is valuable to identify and describe macro features, which provides information about a particular dance event. Our discussion includes six macro features, although other classifications for analysis may be used.[7] Basic journalistic questions of what, where, when, why, how, and who support the framework for understanding the dance event. Responses to each question should be as detailed as possible and include the cultural insiders', in addition to the researcher's, observations. We may begin our analysis of macro features by defining what type of situation is happening, such as a rehearsal, performance, class, rite of intensification, rite of passage, other type of celebration/ceremony, or spontaneous activity. Also important is ascertaining where and when the event takes place, specifically the physical location, time of the year, month, and/or day, as well as the overall duration of the entire event or each component. Another macro feature we may describe involves determining the purpose or why the event happens, which requires dialogue with the dance and non-dance participants sharing cultural knowledge. Additionally, it is essential to study how the body moves, how the selection and sequence of movements happen, and how the dancers prepare. Finally, study

of the dance event must include a description of who participates in terms of age and sex, the number of total participants, and the relationship of participants to one another. We also may discuss whether the dancers are professionals, apprentices, or amateurs and if they are from the same family, church, school, village, tribe, community, country, or combination of these.

Recording this information is useful for studying the extent of change from one instance in which

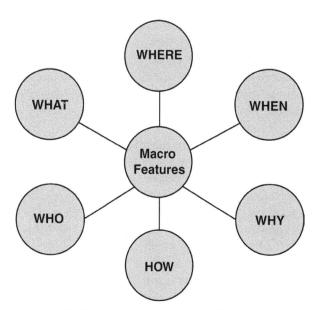

Figure 12-3. Diagram by Pegge Vissicaro illustrating macro features for analyzing dance events.

the dance event occurs to the next or to compare various types of dance events. Throughout the research process, we should pay extra attention to the words participants use to describe the dance, the participants, the locale(s) and time of the event, and the actual dancing. These words are specific to the cultural knowledge system from which the dance originated, providing insight about dance meaning. Additionally, since macro features situate the dance event within the total culture of those sharing knowledge, data such as who does not dance and how this event ties in to other activities must be considered.[8] All macro features are interconnected and inform each other so an analysis of these relationships is important to studying dance events.

Micro Features

We continue our description of the dance event by shifting our attention from macro to micro features. These features focus on the smallest components of the dance; in particular, the movements.[9] The study of micro features may reveal information about how dances are performed by looking at the form or structure, and refer to the internal arrangement of formal elements. Like macro features, the correlation between all micro features is important to observe and the analysis should include emic and etic interpretive frames. Combining perspectives deepens understanding of the dance event and emphasizes multiple interpretive practices to create a rich tapestry of representations, a primary objective for multicultural dance study.

We launch our discussion about micro features by recognizing Laban, as well as other pioneers of nonverbal behavior and communication research. The collective insight of these individuals provides a conceptual model and taxonomy from which to describe dance.[10] As mentioned in Chapter 3, Labanotation is a tool to define basic characteristics of movement, specifically movement direction, time, and weight shifts of the body. An underlying objective of this system is to record information for preservation and reconstruction.[11] From the identification of basic characteristics, another etic framework emerges. It is known as Labanalysis or Laban Movement Analysis (LMA), which deals with analyzing processes of movement in its spatial and dynamic aspects.[12] Irmgard Bartenieff, a student of Laban's, was one of the first to acknowledge the potential of movement analysis as a cross-cultural research tool and develop approaches for comparing common and differentiating movement elements.[13]

LMA and other systems of movement analysis focus broadly on the ideas of space, time, and force/energy. Teachers and students use these concepts to study and describe dance composition or choreography. Additionally, space, time, and force/energy are the primary categories listed on assessment rubrics used to measure dance skills taught in public school curricula.[14] Each of the three concepts relates to the other and may be examined in greater detail. For our purpose, instead of the term "force/energy," we will adopt the word "energy" since its use may remind us of the principle of dynamism and the activity of subatomic particles discussed in Chapter 4. Before proceeding, it is important to state that our list of micro features is not definitive and advance one point of view for investigating dance cultures around the world.

Space

There are a variety of ways to describe dance events in terms of space. This discussion explores movement type, formation, patterns, body parts, body extensions, personal space, spatial relationships, size, design or shape of the movement, direction, and level. Our analysis of micro features starts by classifying movement into two basic types: stationary and locomotor. Stationary movement does not travel through space. Examples of stationary movements are bending, twisting or axial, and stretching. In contrast, locomotor movement travels through space. Ten basic locomotor movements are walk, run, hop, skip, jump, leap, slide, crawl, roll, and gallop. All other movements are combinations of these basic types.

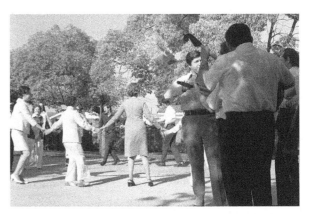

Figure 12-4. Croatian social event in Los Angeles, California. Participants dancing *kolo* in a linked, open circle formation with *tamburica* music ensemble (Photograph by Elsie Dunin, Los Angeles, California, 1975).

Analysis of space also must consider formation. Formation refers to how movements "look" in terms of an overall design, such as linked or unlinked circles. A different formation is created by dancers performing in straight or curved rows. There may be several actions going on at once, like a small ensemble moving in a line while a large group of performers travel around them. The formation of serpentine lines is sometimes quite complex, especially when two lines intertwine. Other types of formations include square-like designs and various shapes. Visual diagrams, photographs, and videotape are valuable to document information for future analysis and/or comparison with different groups.

We may explore space by noticing the structure of patterns, which reveals the way movements are organized. The movement of steps, hand gestures, arm, head, torso, and other body parts (as well as vocalizations and the use of instruments), create specific patterns. These patterns or sequences of movements may be repetitive or change in relative degree. How the pattern changes, its length, and form are important to distinguish.

Figure 12-6. Mei Kuei Chan Cruise performing a Chinese Ribbon Dance, Phoenix, Arizona (Photograph by David Barr, Courtesy of Arizona Commission on the Arts, Phoenix, Arizona, 2000).

Description of the body can be quite complex and involve many different parts moving at the same time. We may study the body by examining movement type, weight placement, and determining what the leg, head, arm, foot, hand, torso, and various body parts are doing. In addition, it is important to look at relationships between body parts. For example, both the arms may move in the same manner or can be doing completely different gestures and communicate completely different information.

When analyzing space, we also must discuss body extensions, sometimes called properties or paraphernalia. These usually refer to what is held or worn by the dancer, such as swords, sticks, cloth, flowers, shakers, make-up, masks, or apparel (costume, regalia). All extensions directly influence the dancer's performance, "look," and the timing of movements, as well as energy quality.

Another way of describing the element of space is by looking at the personal space that the dancer occupies. Silhougraphs® (fig. 12-7) are a powerful tool for studying personal space based on the idea that dancers create shapes with their bodies, costumes, and paraphernalia.[15] Keali'inohomoku coined the word "Sihougraph®," which combines the word "silhouette" with "photograph." The image shows distinct and recognizable shapes without the features of movement, color, facial expressions, and sound

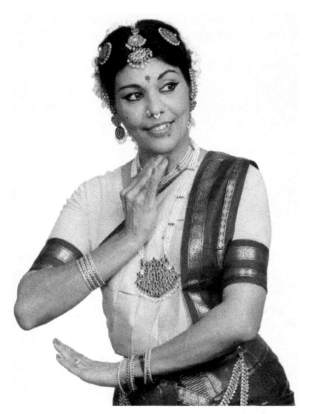

Figure 12-5. Asha Gopal performing *Bharatanatyam*, Phoenix, Arizona (Photograph courtesy of Asha Gopal, Phoenix, Arizona, 1995).

Figure 12-7. Silhougraphs® of Quetzal dance of Totonacs from Mexico and Korean monk dance (Courtesy of Joann Keali'inohomoku, 2004).

of a single dancer or group of dancers. Rendered from photographs, this information reveals human bodies' individual and cultural use of space.

We may describe space by studying spatial relationships or proxemics to examine the distance between dancers, and between dancers and other objects in the environment, including the audience or non-dance participants. The term "proxemics" was coined by Hall to refer to the inquiry of humankind's "perception and use of space."[16] This distance, like Silhougraphs, communicates information about individual and culturally defined use of space.

It also is interesting to study the micro feature of space by noticing the size of dancers' movements, which range on a scale from relatively small to large. Additionally, we must analyze movement size in relation to various body parts. For instance, the hands may be articulating a tiny gesture while the legs are extending through space. We must always keep in mind that movement size in addition to all the other micro features reflect values and beliefs considered ideal by those who share dance culture.

The study of space includes describing the design(s) that the dancer's body makes. In one dance, the performer may generate large sweeping motions with his arms to create circular shapes, characterized by curved lines. In another situation, he may bend his arms at the elbows to form straight lines, producing angular shapes. What the dancer holds or wears also adds to the design of the body. Movement of a sword, ribbon, and/or clothing also creates linear or curvilinear designs that enhance the actions of the dancer.

Another way to explore space in a dance event is by explaining the direction(s) dancers face or move. In the dance literature, this is generally referred to as L.O.D. (line of direction). This may change from step to step or remain the same for an extended duration of time. Movements travel forward, backward, sideward, or diagonal in relation to certain objects. For example on theatrical stages, dancers move downstage or toward the audience and upstage or away from someone or something in addition to locomoting stage right and left. Dancers also move relative to geographic direction, such as east, north, west, and south, as well as clockwise and counterclockwise.

In addition, the study of space should consider the positioning of the body and/or body parts in reference to a vertical and/or horizontal axis. This involves analyzing the level of the dancer relative to the ground, which ranges from low to high. Some movements are low, while other movements are high. The body may be completely upright or there may be movements that travel into the air, away from the floor. Extensions of the body often impact size and thus, level. For instance, a mask or certain types of

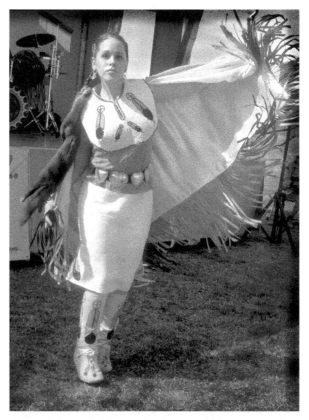

Figure 12-8. Intertribal Pow Wow Fancy Shawl dancer, Melissa Maldonado (Photograph by Sigrun Saemundsdottir, Avondale, Arizona, 2004).

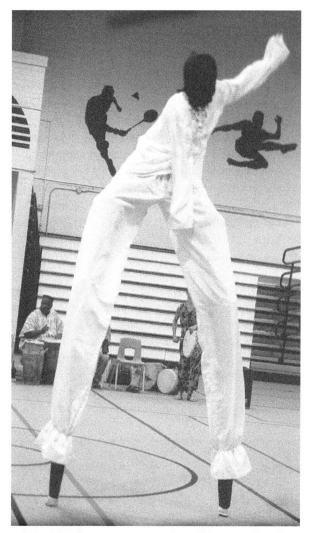

Figure 12-9. Stilt dancer performing with West African dance and music group *Agbe Nunya*, Tempe, Arizona (Photograph by Sigrun Saemundsdottir, Tempe, Arizona, 2004).

apparel make the dancer appear larger, with movements performed at a level higher than the other people in the setting.

TIME

Time relates both to the dancing and accompaniment, such as the instruments and/or other sound-making devices (voice, body, etc.) used in conjunction with the dance. Some descriptors pertaining to time are rhythm, tempo, duration, pulse, and accent. The study of time refers to a particular period during which movements or sounds exist. Different ways of organizing time produce certain rhythms, which may be analyzed by grouping beats into specific measures or units to form rhythmic patterns. If these patterns repeat the same way throughout the dance, then the rhythm has an even meter or

measurement of time; if they change, the rhythm has an uneven meter. Some patterns have specific designations, such as 4/4 or 6/8. Those are called time signatures, which specify the meter of the dance and/or accompaniment. In Western European forms of musical notation, the first number indicates how many beats in a measure, while the second number refers to the length of each beat. For example in the time signature 4/4, there are four quarter notes per measure.

Especially for dance events with musical accompaniment, it is beneficial to determine what instrument is central to "keeping time" and to which the other instruments adhere. In West Africa, the double bell sets the rhythm, provides the tempo, and serves as a common reference point for the other drummers, as well as the dancers. This instrument is called *gankogui* in the Ewe language and is a requisite part of the musical family for most groups in Ghana, Togo, Benin, and Nigeria (fig. 12-10).

Tempo signifies the relative speed, pace, or rate of the rhythm, which may be judged from the number of beats, steps, or other actions performed in a given length of time.[17] Speed can range from very fast to very slow. An even tempo means that the speed remains the same throughout the dance; an uneven tempo suggests change. We have discussed duration in terms of the length of time in which a dance event occurs. However, duration may refer to how long a particular movement, movement phrase, and or

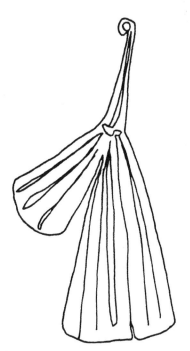

Figure 12-10. *Gankogui* or double bell.

section of a dance lasts. One technique for notating tempo and duration includes using a stop watch and noticing the amount as well as type of information that happens in a certain number of seconds, minutes, and/or hours.

Pulse and accent may be described as emphasizing or punctuating particular moments in the rhythm. The pulse is the downbeat or heaviest accent, usually at the beginning of a movement phrase and is generally repetitive. A pulse also is an accent because it places stress in the rhythm, or organization of time. Accents that are unexpected, especially those that are irregular and fall in between the pulse or beats, create syncopation. The following diagram demonstrates a rhythm common to many West African dances performed for social occasions (fig. 12-11). The pulse is on the first beat shown by the letters A, B, C, and D. The "x" marks indicate where the bell accents occur. Numbers are placed in between the letters to divide each beat into four equal parts, signifying quarter notes.

ENERGY

It is not coincidental that we conclude our discussion as well as the chapter and textbook by describing energy since this takes us full circle to the idea that energy is fundamental to all aspects of the universe. Energy implies action, power, or type of force. We may explore energy in terms of type, amount, and dynamics. The five basic categories of energy qualities are sustained, percussive, swing, collapse, and vibratory. All movement may be defined as having a specific energy quality. One quality may be dominant in a movement sequence; however, many different qualities are often represented throughout an entire dance. Also, an individual dancer may demonstrate separate qualities by juxtaposing movement in different parts of the body.

Movement that is continuous and smooth may be described as sustained. This may be slow or fast, as long as it keeps flowing with no interruptions. The Javanese court dance, Bedoyo, perfectly exemplifies sustained energy or movement. Percussive is a quality that applies to movement with obvious starts and stops; usually these are sharp and very quick. Sword

or stick dances, like those done in Morris Dancing from the United Kingdom, involve percussive movements as the swords or sticks strike one another (fig. 12-12). Collapse is a sudden falling movement that happens when support is removed. Muscles, other people, or things like a wall, tree, or prop maintain support. Without support, the body or individual body part collapses. This happens in Tango and other couple dances as the woman, without support, falls backward slightly to be "caught" by her partner in his arms. Swinging movements sway back and forth, like a pendulum on a clock. Waltz demonstrates this type of movement. Body parts also swing, especially the arms from the ball and socket joints at the shoulder or the legs at the hip. In addition, extensions of the body or properties, such as poi balls in Maori dances, produce a swinging energy quality. Vibratory energy involves fast, short, repeated movements, like shaking. These actions can take place by isolating body parts or can involve the entire body. Polynesian dances from Tahiti, Maori hand motions, as well as Middle Eastern Belly dancing illustrate this quality. It also is the vibratory movement that most clearly correlates to the dynamic universe. Sub-

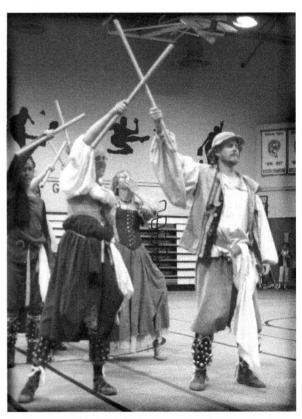

Figure 12-12. Bedlam Bells Morris and Sword, Phoenix, Arizona (Photograph by Sigrun Saemundsdottir, Tempe, Arizona 2004).

A 2 3 4 B 2 3 4 C 2 3 4 D 2 3 4
x x x x x

Figure 12-11. West African 4/4 rhythm showing accents for bell.

atomic elements shake in response to their thermal environment. These vibrations are inherent to every aspect of nature that connects all things.

The amount of force or weight of a given movement ranges on a scale from one extreme to another. For example, dancers may exert a sustained movement with very little effort to appear as though they are floating or with great force to suggest resistance, like moving in water. We also study dynamics by looking at the relationship between the different types and amount of energy used throughout dance. Measuring dynamics during a dance event is usually difficult because numerous activities may be going on at the same time and it is challenging to record all the information available. One solution is to focus on a specific aspect and use graphing techniques to notice changes in energy qualities and the amount of force utilized by one dancer, several individuals, or the entire group over a discrete period of time.

Summary

We have explored a broad framework consisting of theories and concepts designed to enable cross-cultural dance study. The multidimensional approach is both general and specific and promotes the use of emic and etic perspectives to create a holistic analysis. Our examination of dance descriptors focuses primarily on the dance event, a key concept in cross-cultural dance studies that situates dance within the broader context of society. Analysis of macro and micro features facilitates understanding of the various components of the event. This framework is one point of departure that can be adapted, reorganized, and changed to suit specific needs, situations, values, and instructional methods. With increased awareness and access to comparative strategies and tools, we may embrace the study of dance cultures around the world and feel empowered to develop insights and make new contributions to the field of multicultural dance education.

Notes

1. Keali'inohomoku, Joann W. (1976). ibid.
2. Keali'inohomoku, Joann W. (1976). ibid.
3. Keali'inohomoku, Joann W. (1976). ibid; Hall, Edward T. (1983). *The dance of life: The other dimension of time.* Garden City, NY: Anchor Press/Doubleday.
4. Keali'inohomoku, Joann W. (1976). ibid.
5. Peabody Museum of Archaeology and Ethnology Web site. Harvard University. (1998). Gifting and feasting in the northwest coast potlatch. What is a Potlatch? Accessed April 30, 2004 at http://www.peabody.harvard.edu/potlatch/potlat1.html.
6. Rohner, Ronald P. (1966). Franz Boas among the Kwakiutl, interview with Mrs. Tom Johnson. In J. Helm (Ed.), *Pioneers of American anthropology* (pp. 213–221). Seattle, WA: University of Washington Press. Special thanks to Joann Keali'inohomoku for calling this reference to my attention.
7. Dunin, Elsie. (2003). Personal communication.
8. Keali'inohomoku, Joann. (1972). ibid.
9. Golshani, Forouzan, Vissicaro, Pegge, & Park, Youngchoon. Multimedia information repository for cross-cultural dance studies. *Multimedia Tools and Applications* (in press).
10. Movement research is mostly the domain of anthropologists, ethnochoreologists, sociologists, psychologists, physiologists, and other scientists/scholars. A few of the major contributors not mentioned in the textbook but whose work informs the use of techniques for understanding and describing movement are Ray Birdwhistell, F. Matthias Alexander, Moshe Feldenkrais, Gertrude Kurath, Lulu Sweigard, Mabel Todd, and Barbara Clark.
11. Bartenieff, Irmgard, & Davis, Martha. (1965). *Effort-shape analysis of movement: The unity of expression and function.* New York: Arno Press.
12. Bartenieff, Irmgard. (1972). Effort/shape in teaching ethnic dance. In T. Comstock (Ed.), *CORD Research Annual VI,* (pp. 175–192).
13. Bartenieff, Irmgard. (1972). ibid; Bartenieff, Irmgard, Hackney, Peggy, Jones, Betty T., Van Zile, Judy, & Wolz, Carl. (1984). The potential of movement analysis as a research tool: A preliminary analysis. *Dance Research Journal 16/*1, 3–26.
14. The Arizona Department of Education, like education departments in other states, provides arts standards for skills assessment to measure dance proficiency of K–12 students in the public schools. Besides movement skills, students also learn to compare different dance cultures around the world in terms of space, time, and force/energy. Their web site is http://www.ade.state.az.us/standards/arts/arts-dance.asp.
15. Keali'inohomoku, Joann W. (1989). Silhougraphs. Accessed on April 12, 2004 at http://ccdr.org/silhougraphs.html; Keali'inohomoku, Joann W. (1989, Summer). Introduction to silhougraphs. *Cross-Cultural Dance Resources Newsletter*, 8, 1.
16. Hall, Edward T. (1963). A system for the notation of proxemic behavior. *American Anthropologist, 65,* 1003–1026.
17. Goodridge, Janet. (1999). *Rhythm and timing of movement in performance.* London: Jessica Kingsley Publishers.

Discussion Questions/Statements

Write your responses to the following questions in the space provided. Collaborate with one or two other students and explore their ideas to the same questions. Examine similarities and differences to the various responses.

1. Describe a memorable dance event in which you interacted as a dancer or non-dance participant. What types of activities did you do before and after the dancing?

2. From your perspective, with what are you most familiar, contained or extended dance events? Which do you prefer or value most? Why? How do your values about dance events reflect information pertaining to your personal cultural knowledge system?

3. Think of at least two different types of contained dance events and two types of extended dance events that you know or read about in this text or elsewhere. Compare the types of activities that occur before and after the dancing, as well as the actual dance itself. How do the activities contextualize understanding about the dance event?

4. Using an example from your own experience, discuss a dance event by describing its macro features. Follow the diagram on page 139 to address the various features in as much detail as possible.

5. Identify a photo in this textbook and analyze the information pertaining to the element of space. In what ways does this data demonstrate ideal behavior among those who share meaning in the group from which the dance derives? Compare your interpretation of these micro features with two or three other students.

6. Think about how you most like to dance. Do you prefer to move around the space or stay in one spot? What body parts do you enjoy moving and how? What rhythm and accompaniment is your most favorite? Is there one energy quality that feels particularly good? Continue analyzing the dance in terms of other movement descriptors to examine how this information reveals aspects of your personal cultural knowledge system.

Creative Projects

Art Application—Take a photo of a dancer moving or use one of the examples in this text. Use tracing paper to create an outline of the image. Shade in the shape with a dark pencil, black crayon, or other tool. Photocopy the image on 8½" x 11" paper. Exchange your Silhougraph® with another student. Describe the image in terms of shape, level, and any other dance descriptors. What information is transmitted? How does the image reveal data about ideal behavior? What can you tell about the identity of the dancer?

Movement/Rhythmic Activity—As a class, study the diagram on page 144. Have everyone practice by counting out loud the letters and numbers that continue repeating. Then divide the group in half. While one side counts, the other side claps on the appropriate accents. Switch sides so both groups experience creating the accents. Now repeat the process so that one group performs a "4 count" walking pattern, but must emphasize the accents by moving a body part. Explore accents with changes of energy quality, levels shift, and directional changes. Have the other group perform the same series of explorations.

Class Activity—Design a potlatch in which the entire class will participate. Begin by choosing a group of students to represent the family of the host and one student to be the host of the potlatch. Assign specific responsibilities to groups of students, such as making invitations, creating or obtaining gifts for each person attending, designing ceremonial aspects (regalia, masks, dances), arranging entertaining, and providing a seating arrangement for guests. Seating is in order of importance with the host's family or tribe sitting on the left-hand side, toward the back of the room. Plan the sequence of activities to include a welcoming address by the speaker (the host does not speak during a potlatch), dances, the feast, food or feast songs that are sung after eating, passing out ceremonial items, other types of speeches, and gift giving as guests leave.

Notes

Works Cited

Aronowitz, Stanley, & Giroux, Henry A. (1993). Education still under siege (2nd ed.). Westport, CT: Bergin & Garvey.

Ausubel, David P. (1963). Cognitive structure and the facilitation of meaningful verbal learning. *Journal of Teacher Education, 14*, 217–221.

Bali and Indonesia on the Net Web site. (2004). Dance, music, and theatres of Bali. Accessed on April 27, 2004 at http://www.indo.com/culture/dance_music.html.

Banks, James. (1999). *An introduction to multicultural education.* (2nd edition). Boston: Allyn and Bacon.

Bamshad, Michael, & Olson, Steve E. (2003, December). Does race exist? *Scientific American, 289*(6), 78–85.

Bartenieff, Irmgard, & Davis, Martha. (1965). *Effort-shape analysis of movement: The unity of expression and function.* New York: Arno Press.

Bartenieff, Irmgard. (1972). Effort/shape in teaching ethnic dance. In T. Comstock (Ed.), *CORD Research Annual VI,* (pp. 175–192).

Bartenieff, Irmgard, Hackney, Peggy, Jones, Betty T., Van Zile, Judy, & Wolz, Carl. (1984). The potential of movement analysis as a research tool: A preliminary analysis. *Dance Research Journal 16*/1, 3–26.

Black, John, & McClintock, Robbie. (1996). An interpretation construction approach to constructivist design. In B. Wilson (Ed.), *Constructivist learning environments: Case studies in instructional design* (pp. 25–32). Englewood Cliffs, NJ: Educational Technology Publications.

Boas, Franz. (1942). Dance and music in the life of the northwest coast Indians of North America. In F. Boas (Ed.), *The function of dance in human society*, 5–19. Brooklyn, NY: Dance Horizons.

Brislin, Richard. (1993). *Understanding culture's influence on behavior.* New York: Harcourt Brace College Publishers.

Capra, Fritjof. (1975). *The tao of physics.* New York: Bantam Books.

Clarke, John, Hall, Stuart, Jefferson, Tony, & Roberts, Brian. (1981). "Sub cultures, cultures and class." In T. Bennet, G. Martin, D. Mercer, & J. Woollacott (Eds.), *Culture, ideology, and social process* (pp. 219–234). London: Batsford Academic and Educational.

Cody, Ernestine. (1998). The children of changing woman. Accessed March 20, 2004 at http://www.peabody.harvard.edu/maria/Sunrisedance.html.

Cognitive Science Laboratory. Princeton University. Word Net. Accessed April 20, 2004 at http://www.cogsci.princeton.edu/cgi-bin/webwn?stage=1&word=phenomenon.

D'Andrade, Roy G. (1995). *The development of cognitive anthropology.* New York: Cambridge University Press.

DiMaggio, Paul. (1997). Culture and cognition. *Annual Review of Sociology, 23*, 263–287.

Dareini, Ali Akbar. Iran's best-known dancer detained after dancing in public. Accessed on March 22, 2004 at http://cnews.canoe.ca/CNEWS/World/2003/12/25/296739-ap.html.

Driscoll, Marcy. (1994). *Psychology of learning for instruction.* Boston: Allyn & Bacon.

Erickson, Frederick. (1986). Qualitative methods in research on teaching. In M. Wittrock (Ed.), *The handbook of research on teaching* (3rd ed., pp. 119–161). New York: MacMillan.

Feleppa, Robert. (1990). Emic analysis and the limits of cognitive diversity. In T. Headland, K. Pike, & M. Harris (Eds.), *Emic and etics: The insider/outsider debate* (pp.100–119).

Festinger, Leon. (1962). *A theory of cognitive dissonance.* Stanford, CA: Stanford University Press.

Ford, Clellan S. (1967). (Ed.), *Cross-cultural approaches: Readings in comparative research.* New Haven: Human Relations Area Files Press.

Geertz, Clifford. (1960). *The religion of Java.* Chicago: University of Chicago Press.

Golshani, Forouzan, Vissicaro, Pegge, & Park, Youngchoon. (2004). "Multimedia information repository for cross-cultural dance studies." *Multimedia tools and applications* (in press).

Goodenough, William H. (1957). Cultural anthropology and linguistics. In P. Garvin (Ed.), *Report of the seventh annual round table meeting on linguistics and language study.* Washington, D.C.: Georgetown University Monograph Series on Language and Linguistics 9.

Goodridge, Janet. (1999). *Rhythm and timing of movement in performance.* London: Jessica Kingsley Publishers.

Hall, Edward T. (1959). *The silent language.* Garden City, NY: Doubleday.

Hall, Edward T. (1963). A system for the notation of proxemic behavior. *American Anthropologist, 65,* 1003–1026.

Hall, Edward T. (1977). *Beyond culture.* Garden City, NY: Anchor Press/Doubleday.

Hall, Edward T. (1983). *The dance of life: The other dimension of time.* Garden City, NY: Anchor Press/Doubleday.

Harris, Marvin. (1990). Emics and etics revisited. In T. Headland, K. Pike, & M. Harris (Eds.), *Emics and etics: The insider/outside debate* (pp. 48–61). Newbury Park, CA: Sage Publications.

Peabody Museum of Archaeology and Ethnology Web site. Harvard University. (1998). Gifting and feasting in the northwest coast potlatch. What is a potlatch? Accessed April 30, 2004 at http://www.peabody.harvard.edu/potlatch/potlat1.html.

Heard Museum Web site. The Yaqui today. Accessed March 23, 2004 at http://www.heard.org/rain/cultura5/raincu11.html.

Herskovits, Melville. (1948). *Man and his works.* New York: A. A. Knopf.

Holt, Claire, & Bateson, Gregory. (1944). Form and function of the dance of Bali. In F. Boas (Ed.) *The function of dance in human society,* (pp. 55–63). Brooklyn, NY: Dance Horizons.

Holtzman, Jon D. (2000). *Nuer journeys, Nuer lives.* Boston: Allyn & Bacon.

Hong, Ying-yi, Morris, Michael W., Chiu, Chi-yue, & Benet-Martinez, Veronica. (2000). Multicultural minds: A dynamic constructivist approach to culture and cognition. *American Psychologist, 55*(7), 709–720.

Insider's Guide to Rio de Janeiro, Brazil Web site. (2004). Carnival in Rio de Janeiro. Accessed on April 4, 2004 at http://www.ipanema.com/carnival/parade.htm.

International Council on Traditional Music Web site. Accessed on January 16, 2004 at http://www.ethnomusic.ucla.edu/ICTM/.

Ito, Sayuri. (1978). Some characteristics of Japanese expression as they appear in dance. In P. A. Rowe & E. Stodelle (Eds.), *CORD Dance Research Annual, 10,* (pp. 267–277).

Jenks, Kathleen. (2003). Autumn greetings, customs, and lore. Accessed March 15, 2004 at http://www.mythinglinks.org/autumnequinox~archived2001.html.

Jonas, Gerald. (1992). *Dancing.* New York: Harry N. Abrams, Inc., p. 171.

Judson, Katharine B. (Ed.) (1994). *Myths & legends of California and the old Southwest.* Lincoln, NE: University of Nebraska Press.

Ka 'Imi Na'auao O Hawaii Nei, "The history of hula." Accessed on March 24, 2004 at http://www.kaimi.org/history_of_hula.htm.

Keali'inohomoku, Joann W. (1965). A comparative study of dance as a constellation of motor behaviors among African and United States negroes. Unpublished master's thesis. Northwestern University, Evanston, IL.

Keali'inohomoku, Joann W. (1969–1970). An anthropologist looks at ballet as a form of ethnic dance. In M. Van Tuyl (Ed.), *Impulse* (pp. 24–33). San Francisco, CA: Impulse Publications.

Keali'inohomoku, Joann W. (1974). Dance culture as a microcosm of holistic culture. In T. Comstock (Ed.), *CORD Research Annual VI,* (pp. 99–106).

Keali'inohomoku, Joann W. (1974). "Folk dance." In R. M. Dorson (Ed.), *Folklore and folklife: An introduction,* (pp. 381–404).

Kealiʻinohomoku, Joann W. (1976). *Theory and methods for an anthropological study of dance.* Ph.D. dissertation, Indiana University. *Dissertation Abstracts International 37–04*, #7621511, ProQuest, Ann Arbor, MI, p. 2278.

Kealiʻinohomoku, Joann W. (1985, Summer/Autumn). Cross-cultural, inter-cultural, pan-cultural, transcultural. *Cross-Cultural Dance Resources Newsletter, 2,*1.

Kealiʻinohomoku, Joann W. (1986). Honoring Gertrude Kurath. *UCLA Journal of Dance Ethnology, 10*, 4.

Kealiʻinohomoku, Joann W. (1989a, Summer). Introduction to Silhougraphs. *Cross-Cultural Dance Resources Newsletter, 8*, 1.

Kealiʻinohomoku, Joann W. (1989b). Silhougraphs. Cross-Cultural Dance Resources Web site. Accessed on April 12, 2004 at http://ccdr.org/silhougraphs.html.

Kealiʻinohomoku, Joann W. (1990, Summer). Angst over ethnic dance. *Cross-Cultural Dance Resources Newsletter, 10,*1–6.

Kearney, Michael. (1984). *World view.* Novato, CA: Chandler & Sharp Publishers.

Korac-Kakabadse, Nada, Kouzmin, Alexander, Korac-Kakabadse, Andrew, & Savery, Lawson. (2001). Low- and high-context communication patterns: Towards mapping cross-cultural encounters. *Cross Cultural Management—An International Journal, 8*(2), 3–24.

Kumar, Nitin. Accessed on March 17, 2004 at http://www.exoticindia.com.

Kurath, Gertrude. (1960). Panorama of dance ethnology. *Current Anthropology 1*(3), 235.

Laws, Kenneth. (1984). *The physics of dance.* New York: Schirmer Books.

Lessa, William A., & Vogt, Evon Z. (1979, 4th ed.). *Reader in comparative religion.* New York: Harper & Row.

Lett, James. (1996). Emic/etic distinctions. In D. Levison & M. Embers (Eds.), *Encyclopedia of cultural anthropology* (pp. 382–383). New York: Henry Holt and Company.

Long, Edward. (1774). *History of Jamaica II.* (New edition: Frank Cass, London 1970). London: Lowndes. London: 424–25.

Maclouf, Malika. (August 8, 1998). Actualités 67: Encadré tambours Burundi le tambour, tout un symbole. Journal L'Alsace. Accessed on April 7, 2004 at http://www.alsapresse.com/jdj/98/08/21/ST/article_3.html.

Malnig, Julie. (2001). Introduction. *Dance Research Journal, 33*(2), 7–10.

Malpeque People of a Sacred Bay Web site. (1999). The drum. Accessed on April 6, 2004 at http://collections.ic.gc.ca/malpeque/drum.html.

McAllester, David P. (1972). Music and dance of the Tewa pueblos by Gertrude Prokosch Kurath and Antonio Garcia (book review). *Ethnomusicology, 16*(3), 546–547. Ann Arbor, Michigan: Society of Ethnomusicology.

Metzner, Jim. (2002). Jonkonnu origins. Jim Metzner Productions & National Geographic Society. Accessed on April 15, 2004 at http://pulseplanet.nationalgeographic.com/ax/ archives/01_culture template.cfm?programnumber=2555.

National Endowment for the Humanities. Accessed on January 10, 2004 at http://www.neh.fed.us/whoweare/overview.html.

National Human Genome Research Institute. (2002). International consortium launches genetic variation mapping project. Accessed December 10, 2003 at http://www.genome.gov/10005336.

Nisbet, Robert. (1966). *The sociological tradition.* New York: Basics Books, Inc.

Ohio State University, Department of Dance Web site. Labanlab. Accessed on March 30, 2004 at http://www.dance.ohio-state.edu/labanlab/index.html.

Persada, Sangga S. (1998). Joglosemar online. Javanese traditional dance. Accessed on April 17, 2004 at http://www.joglosemar.co.id/trad_dance.html.

Pike, Kenneth. (1954). *Language in relation to a unified theory of the structure of human behavior* (p. 41), Glendale, CA: Summer of Institute of Linguistics.

Pike, Kenneth. (1990). On the emics and etics of Pike and Harris. In T. Headland, K. Pike, & M. Harris (Eds.), *Emics and etics: The insider/outsider debate* (pp. 28–47). Newbury Park, CA: Sage Publications.

Puri, Rajika. (2004). Bharatanatyam performed: A typical recital. *Visual Anthropology, 17*(1), 45–68.

Redfield, Robert. (1956). *Peasant society and culture.* Chicago: University of Chicago Press.

Reedy, Hirini. (2003). Tu strategies. "From the earliest times, the haka has inspired and energized generations of Maori in both peace and war…" Accessed on April 15, 2004 at http://www.tu.co.nz/haka.htm.

Rohner, Ronald P. (1966). Franz Boas among the Kwakiutl, interview with Mrs. Tom Johnson. In J. Helm (Ed.), *Pioneers of American anthropology* (pp. 213–221). Seattle, WA: University of Washington Press.

Royal Scottish Country Dance Society Web site. Accessed on March 24, 2004 at http://www.scottishdance.org/.

Royce, Anya P. (1977). *The anthropology of dance.* Bloomington, IN: Indiana University Press.

Rumelhart, David E. (1980). Schemata: The building blocks of cognition. In R. J. Spiro, B. C. Bruce, & W. F. Brewer (Eds.), *Theoretical issues in reading comprehension.* Hillsdale, NJ: Erlbaum.

Samovar, Larry A., & Porter, Richard E. (1997). An introduction to intercultural communication. In L. Samovar and R. Porter (Ed.), *Intercultural communication.* Belmont, CA: Wadsworth Publishing Company.

Schieffelin, Edward. (1976). *The sorrow of the lonely and the burning of the dancers.* New York: St. Martin's Press.

Sewell, William H. (1992). A theory of structure: Duality, agency, and transformation. *American Journal of Sociology, 98,* 1–29.

Seidel, Miriam. *Philadelphia Inquirer,* February 2, 1997.

Shira. (2000). The art of middle eastern dance. Scenes from Turkey: Whirling dervishes. Accessed on April 3, 2004 at http://www.shira.net/dervturk.htm.

Simmel, Georg. (1908). The isolated individual and the dyad. In K. Wolff (Ed.), *The sociology of Georg Simmel* (pp. 118–144). Glencoe, IL: Free Press.

Snyder, Allegra F. (1972). The dance symbol. In T. Comstock (Ed.) *CORD Research Annual 6,* 213–224.

Society for Dance History Scholars Web site. (2002). About SDHS. Accessed on February 12, 2004 at http://www.sdhs.org/.

Tapei Journal. (July 21, 2000). Autonomy for orchid island. Accessed on March 29, 2004 at http://www.taiwanheadlines.gov.tw/20000728/20000725f1.html.

Tasawwuf.org Web site. (2004). What is tasawwuf? Accessed on April 17, 2004 at http://www.tasawwuf.org/what_tasawwuf.htm.

Tönnies, Ferdinand. (1925). The concept of gemeinschaft. In W. J. Cahnman & R. Herberle (Eds.), *Ferdinand Tönnies on sociology: Pure, applied and empirical selected writings* (pp. 62–72). Chicago: University of Chicago Press.

Truzzi, Marcello. (1971). *Sociology: The classic statements.* New York: Oxford University Press.

Vissicaro, Pegge. (1995). Sowu, the dance of life: Ideal representation of Ewe society. Paper presented at the Society of Ethnomusicology regional conference. Tempe, AZ.

Vissicaro, Pegge. (2001). Cross-cultural dance pedagogy. Paper presented at the Congress on Research in Dance Annual Conference, New York University.

Vissicaro, Pegge, & Godfrey, Danielle C. (2003a). Immigration and refugees: Dance community as healing among East Central Africans in Phoenix, Arizona. *Ethnic Studies Review 25*(2), 43–56.

Vissicaro, Pegge. (2003b). *Emic etic interaction: Processes of cross-cultural dance study in an online learning environment.* Ph.D. dissertation, Arizona State University. *Dissertation Abstracts International, 64–10,* #AAT3109623, ProQuest, Ann Arbor, MI, p. 3588.

Vissicaro, Pegge, & Godfrey, Danielle C. (2004, winter). The making of refugee dance communities. *Animated,* 20–23.

Vygotsky, Lev. (1978). *Mind and society: The development of higher psychological processes.* Cambridge, MA: Harvard University Press.

Waterman, Richard. (1962). Role of dancing in human society: Address and communication. *Focus on Dance 3,* 46–55.

Weber, Max. (1947). *The theory of social and economic organization.* (A. M. Henderson & T. Parsons, Trans.). New York: Oxford University Press. (Original work published 1921).

Wolcott, Harry F. (2001). *The art of fieldwork.* Lanham, MD: Rowman & Littlefield Publishers, Inc.

Woolfolk, Anita. (1998). *Educational psychology* (7th ed.). Boston: Allyn & Bacon.

Selected Bibliography

Articles / Books

Adshead, Janet. (Ed.). (1988). *Dance analysis: Theory and practice.* London: Dance Books.

Aldrich, Elizabeth. (1991). *From the ballroom to hell: Grace and folly in nineteenth century dance.* Evanston, Ill.: Northwestern University Press.

Almeida, Bira. (1986). *Capoeira, a Brazilian art form: History, philosophy, and practice.* Berkeley, CA: North Atlantic Books.

Amiotte, Arthur. (1992). The sun dance. In C. Heth (Ed.), *Native American dance: Ceremonies and social traditions*, (pp. 135–37). New York: National Museum of the American Indian.

Asante, Kariamu W. (Ed.) (1996). *African dance: An artistic, historical and philosophical inquiry.* Trenton, NJ: African World Press Inc.

Blacking, John. (1985). Movement, dance, music and the Venda girls' initiation cycle. In P. Spencer (Ed.), *Society and the dance* (pp. 64–91). Cambridge, England: Cambridge University Press.

Bartenieff, Irmgard. (1980). *Body movement. Coping with the environment.* London: Routledge.

Boas, Franz. (1955). *Primitive art.* New York: Dover Publications.

Barrand, Anthony. (1991). *Six fools and a dancer: The timeless way of the Morris.* Plainfield, VT: Northern Harmony Publishing Company.

Brehm, Mary A., & McNett, Lynne. (forthcoming). *Making kinesthetic sense: Creative dance as a tool for learning.*

Browner, Tara. (2002). *Heartbeat of the people: Music and dance of the northern powwow.* Urbana, IL: University of Illinois Press.

Browning, Barbara. (1995). *Samba: Resistance in motion.* Bloomington, IN: Indiana University Press.

Browning, Barbara. (1998). *Infectious rhythm: Metaphors of contagion and the spread of african culture.* New York: Routledge.

Buckland, Theresa. (Ed.) (1999). *Dance in the field: Theory, methods and issues in dance ethnography.* Houndmills, England: Palgrave Macmillan.

Carr, David. (1998). Meaning in dance. *Journal for the Anthropological Study of Human Movement 10/2,* 59–76.

Capoeira, Nestor. (2002). *Capoeira: Roots of the dance-fight-game.* Berkeley, CA: North Atlantic Books.

Daniel, Yvonne. (1995). *Rumba: Dance and social change in contemporary Cuba.* Bloomington, IN: Indiana University Press.

Daniel, Yvonne. (2004). *Dancing wisdom: Embodied knowledge in Haitian vodou, Cuban Yoruba, and Bahian candomble.* Champaign, IL: University of Illinois Press.

Desmond, Jane C. (Ed.). (1997). *Meaning in motion: New cultural studies of dance.* Durham, NC: Duke University Press.

Dils, Ann, & Albright, Ann C. (Eds.) (2001). *Moving history/dancing cultures: A dance history reader.* Hanover, NH: University Press of New England.

Dunin, Elsie. (1995). *Dances of Macedonia: Performance genre—Tanec ensemble.* Skopje, Macedonia: Tanec Ensemble.

Dunin, Elsie. (Ed.) (2003). *Proceedings of the symposium on applying dance ethnology and dance research in the 21st century.* Flagstaff, AZ: Cross-Cultural Dance Resources, Inc.

Ginn, Victoria. (1990). *The spirited earth: Dance, myth, and ritual from South Asia to the South Pacific.* New York: Rizzoli.

Gottschild, Brenda D. (2002). *Waltzing in the dark: African American vaudeville and race politics in the swing era.* Palgrave Macmillan.

Fine, Elizabeth. (2003). *Soulstepping: African American step shows.* Urbana: University of Illinois Press.

Erdman, Joan. (1985). *Patrons and performers in Rajasthan: The subtle tradition.* Columbia, MO: South Asia Books.

Epes, Joseph, & E. Cousins. (2001). *Teaching spirits: Understanding Native American religious traditions.* Oxford, England: Oxford University Press.

Fraleigh, Sandra H. (1996). *Dancing into darkness: Butoh, Zen, and Japan.* University of Pittsburgh Press.

Fraleigh, Sondra H., & Hanstein, Penelope. (1999). *Researching dance: Evolving modes of inquiry.* Pittsburgh, PA: University of Pittsburgh Press.

Flinn, Juliana. (1993). Who defines custom? Dance and gender in a micronesian case. *Anthropological Forum 6/4,* 557–66.

Frosch-Shroder, Joan. (1991, March). A global view: Dance appreciation for the 21st century. *Journal of Physical Education, Recreation and Dance, 62/3,* 60–66.

Golston, Sydele. (1996). *Changing woman of the Apache: Women's lives in past and present.* New York: Franklin Watts, Inc.

Guillermoprieto, Alma. (1993). *Samba.* New York: Simon and Schuster.

Hackney, Peggy. (1998). *Making connections: Total body integration through Bartenieff fundamentals.* Amsterdam: Gordon and Breach.

Halman, Talat Sait, & And, Metin. (1983). Mevlana Celaleddin Rumi and the whirling dervishes. Turkey: Cem Ofset Matbaacihk San. A.S. Safakoy.

Hanna, Judith L. (1979). *To dance is human: A theory of nonverbal communication.* Austin, TX: University of Texas Press.

Hanna, Judith Lynne. (1992). Dance. In H. Myers (Ed.) *Ethnomusicology: An introduction,* (pp. 315–26), New York: W. W. Norton.

Hoxie, Frederick E., Mancall, Peter C., & Merrell, James H. (2001). *American nations: Encounters in Indian country, 1850 to the present.* New York: Routledge.

Jonaitis, Aldona. (Ed.). (1996). *Chiefly feasts: The enduring Kwakiutl potlatch.* Seattle, WA: University of Washington Press.

Jones, Betty T. (1973). Möhiniyăttam: A dance tradition of Kerala, South India. *CORD Dance Research Monograph 1,* 9–47.

Kaeppler, Adrienne. (1972). Method and theory in analyzing dance structure with an analysis of Tongan dance. *Ethnomusicology, 16/2,* 173–217.

Kaeppler, Adrienne. (Ed.). (1980). *Polynesian music and dance.* Berkeley, CA: University of California Press.

Kaeppler, Adrienne. (Ed.). (1993). *Hula pahu : Hawaiian drum dances.* Honolulu: Bishop Museum Press.

Kaeppler, Adrienne. (2003). An introduction to dance aesthetics. *Yearbook for Traditional Music, 35,* 153–162.

Keali'inohomoku, Joann W. (1967). Hopi and Polynesian dance: A study in crosscultural comparison. *Ethnomusicology, 11,* 343–368.

Keali'inohomoku, Joann W. (1970). Ethnic historical study. *Dance History Research,* 86–97. New York: CORD.

Keali'inohomoku, Joann W. (1970). Hula. *The Encyclopedia Americana, 14, 542.* Danbury, CT: Grolier, Inc. reprinted in subsequent editions. 2002 on line key word: hula http://go.grolier.com.

Keali'inohomoku, Joann W., & Gillis, Frank J. (1970). Special bibliography: Gertrude Prokosch Kurath, *Ethnomusicology, 14,* 114–128.

Keali'inohomoku, Joann W. (1974). Field guides. In T. Comstock (Ed.), *Research Annual 6* (pp. 245–260). New York: CORD.

Keali'inohomoku, Joann W. (1977). Hopi social dance as a means for maintaining homeostasis. *Journal of Association of Graduate Dance Ethnologists, UCLA 1,* 1–11.

Keali'inohomoku, Joann W. (1978). Hopi social dance events and how they function. *Discover,* 27–38. Santa Fe, N.M.: School of American Research.

Keali'inohomoku, Joann W. (1979). Culture change: Functional and dysfunctional expressions of dance, a form of affective culture. *The Performing Arts,* pp. 47–64. The Hague: Mouton.

Keali'inohomoku, Joann W. (1979). You dance what you wear & you wear your cultural values. In J. M. Cordwell & R. W. Schwarz (Eds.), *The fabrics of culture* (pp. 77–83). World Anthropology Series. The Hague: Mouton.

Keali'inohomoku, Joann W. (1980). The drama of the Hopi ogres. In C. Frisbie (Ed.), *Southwestern Indian Ritual Drama*, (pp. 37–69). Albuquerque, New Mexico: University of New Mexico Press.

Keali'inohomoku, Joann W. (1980). Alan P. Merriam (1923–1980). *Dance Research Journal 13/1*, 57–58.

Keali'inohomoku, Joann W. (1980). The non-art of the dance: An essay. *Journal for the Anthropological Study of Human Movement at New York University 1/1*, 38–44.

Keali'inohomoku, Joann W. (1981). Ethical considerations for choreographers, ethnologists, and white knights. *Journal for the Association of Graduate Dance Ethnologists, UCLA 5*, 10–23.

Keali'inohomoku, Joann W. (1981). Dance as a rite of transformation. In C. Carl et al. (Eds.), *Discourse in ethnomusicology II: A tribute to Alan P. Merriam*, (pp. 131–152). Bloomington, Indiana: Ethnomusicology Publications Group, Indiana University.

Keali'inohomoku, Joann W. (1985). Music and dance of the Hawaiian and Hopi peoples. *Becoming human through music*, 5–22. The Wesleyan Symposium on the Perspectives of Social Anthropology in the Teaching and Learning of Music. Reston, Virginia: Music Educators National Conference.

Keali'inohomoku, Joann W. (1985). Hula space and its transmutations. *Dance Research Annual 16*, 11–21. New York: CORD.

Keali'inohomoku, Joann W. (1989). Variables that affect gender actions and reactions in dance ethnology fieldwork: A praxis. *UCLA Journal of Dance Ethnology 13*, 48–53.

Keali'inohomoku, Joann W. (1989). The Hopi Katsina dance event 'doings'. In L. J. Bean (Ed.), *Seasons of the Kachina*, (pp. 51–64). Hayward, California: A Ballena Press/California State University, Hayward Cooperative Publication.

Keali'inohomoku, Joann W. (1992). In C. E. Robertson (Ed.), Hopi and Hawaiian music and dance: Responses to cultural contact. *Musical Repercussions of 1492*, (pp. 429–450). Washington and London: Smithsonian Institution Press.

Keali'inohomoku, Joann W. (1993). Music and dance of the Hawaiian and Hopi peoples (orig. 1985). In R. L. Anderson & K. L. Fields (Eds.), *Art in small scale societies: Contemporary readings*, (pp. 334–348). Englewood Cliffs, N.J.: Prentice-Hall.

Keali'inohomoku, Joann W. (1995). The conviction of Gertrude Prokosch Kurath about the interconnections of dance and music. *UCLA Journal of Dance Ethnology*, 19, 1–5.

Keali'inohomoku, Joann W. (1995–96). The dances of Tibet. *The International Journal of Humanities and Peace*, 11/2, 53–54.

Keali'inohomoku, Joann W. (1997). Dance, myth and ritual in time and space. *Dance Research Journal* 29/1, 65–72.

Keali'inohomoku, Joann W. (1997). Dances of peace. *The International Journal of Humanities and Peace, 13/*1, 63–66.

Keali'inohomoku, Joann W. (1999). Thoughts on a warm-up. (Re: Jonathan Berkman), *Dance Research Journal, 31/*2, 2–6.

Keali'inohomoku, Joann W. (1995). Dance in traditional religions. In J. Z. Smith (Ed.), *HarperCollins Encyclopedia of Religion*, (pp. 304–307). San Francisco: Harper San Francisco.

Keali'inohomoku, Joann W. (1996). Gestures. In J. H. Brunvand (Ed.), *American folklore: An encyclopedia, 1551*, (pp. 333–335). New York: Garland Publishing Co.

Keali'inohomoku, Joann W. (1998). Gertrude Prokosch Kurath. Hopi dance. Primitive dance. *International encyclopedia of dance*, Selma Jeanne Cohen, founding editor. New York: Oxford University Press.

Keali'inohomoku, Joann W. (1998). Folk dance. In B. Winard (Ed.), *Academic american encyclopedia, 8*, 199–201. Danbury CT: Grolier. 2002 on line key word: dance http://go.grolier.com.

Keali'inohomoku, Joann W. (2001). Music and dance in the United States. In E. Koskoff (Ed.), *The Garland encyclopedia of world music, 3*, (pp, 206–222), New York: Garland Publishing Co.

Keali'inohomoku, Joann W. (2001). The study of dance in culture: A retrospective for a new perspective. *Dance Research Journal 33/1*, 89–90.

Keali'inohomoku, Joann W. (2001). New functions and contexts for old dance cultures. *Proceedings 21st Symposium oft the ICTM Study Group on Ethnochoreology: 2000 Korcula:* 197–201. International Council for Traditional Music Group on Ethnochoreology and Institute of Ethnology and FolkInternational Council for Traditional Music, Ethnochoreology Section. Croatia, 2000.

Keali'inohomoku, Joann W. (2002). Hula. online key word: hula http://go.grolier.com *Grolier Multimedia Encyclopedia*, Danbury, Connecticut.

Kurath, Gertrude P. (1960). Panorama of dance ethnology. *Current Anthropology, 1/3*, 223–254.

Kurath, Gertrude P. (1964). *Iroquois music and dance; Ceremonial arts of two Seneca longhouses.* U.S. Government Printing Office.

Kurath, Gertrude P., & Garcia, Antonio. (1970). *Music and dance of the Tewa pueblos.* Santa Fe: NM: Museum of New Mexico Press.

Kurath, Gertrude. Native american arts. *Encyclopaedia Britannica.* Retrieved May 20, 2004, from Encyclopaedia Britannica Premium Service. http://www.britannica.com/eb/article?eu=119492.

Locke, David. (1987). *Drum gahu.* Crown Point, IN: White Cliffs Media Co.

Locke, David. (1992). *Kpegisu: A war drum of the Ewe.* Crown Point, IN: White Cliffs Media Co.

Ness, Sally A. (1992). *Body, movement, and culture: Kinesthetic and visual symbolism in a Philippine community.* Philadelphia, PA: University of Pennsylvania Press.

Nettl, Bruno. (1964). *Theory and method in ethnomusicology.* New York: Free Press of Glencoe.

Painter, Muriel T. (1971). *A Yaqui Easter.* Tucson, AZ: University of Arizona Press.

Pegg, Carole. (2001). *Mongolian music, dance, and oral narrative.* Seattle, WA: University of Washington Press.

Redfield, Robert. (1955). *The little community.* Chicago: University of Chicago Press.

Savigliano, Marta E. (1995). *Tango and the political economy of passion.* Boulder, CO: Westview Press.

Shay, Anthony. (1998). In search of traces: Linkages of dance and visual and performative expression in the Iranian world. *Visual Anthropology 10,* 2–4, 335–360.

Shoupe, Catherine. (2001). Scottish social dancing and the formation of community. *Western Folklore* 60(2/3).

Sklar, Deidre. (2001). *Dancing with the virgin.* Berkeley, CA: University of California Press.

Spicer, Edward H. (1988). *People of Pascua.* Tucson, AZ: University of Arizona Press.

Sweet, Jill D. (1992). The beauty, humor, and power of Tewa pueblo dance. In C. Heth (Ed.), *Native american dance,* (pp. 83–72, 74–103). New York: National Museum of the American Indian.

Taylor, Julie. (1998). *Paper tangos.* Durham, NC: Duke University Press.

Torp, Lisbet, & Giurchescu, Anca. (1993). Folk dance collections and folk dance research in Denmark and the Faeroe islands. *Yearbook for Traditional Music, 25,* 126–135.

Van Zile, Judy. (2001). *Perspectives on Korean dance.* Middletown, CT: Wesleyan University Press.

Williams, Drid. (Ed.) (1997). *Anthropology and human movement: The study of dances.* Lanham, MD: The Scarecrow Press, Inc.

Williams, Drid. (Ed.) (2000). *Anthropology and human movement: Searching for origins.* Lanham, MD: The Scarecrow Press, Inc.

Wisniewski, Mark. (in press). *Dyeing to dance.* Tokushima, Japan: Tokushima Publication Company.

Wolz, Carl. (1977). *Bugaku: Japanese court dance.* Providence, RI: Asian Music Publications.

Yearbook for Traditional Music. (2001). Los Angeles, CA: International Council for Traditional Music.

Online Databases / Libraries

Cross-Cultural Dance Resources—http://www.ccdr.org

Dance Heritage Coalition—http://www.danceheritage.org/

Database on Traditional/Folk Performing Arts in Asia and the Pacific. Asia/Pacific Cultural Centre for UNESCO 2002—http://www2.accu.or.jp/paap/index2.html?1

Library of Congress—http://www.loc.gov/

New York Public Library for the Performing Arts, Dance Division—http://www.nypl.org/research/lpa/collections/

Smithsonian—http://www.si.edu/

Videos

COLLECTIONS

JVC Video Anthology of World Music and Dance. (1995). Smithsonian/Folkways Recordings. Multicultural Media. 30 volumes, 9 books.

Dancing. (1993). Thirteen/WNET in association with RM Arts and BBC-TV. 8 volumes.

SINGLE VIDEOS

A dance the gods yearn to witness. (Bharatanatyam). (1997). Montreal, Quebec, Canada. Concordia Visual Media Resources.

African dance: Sand, drum and Shostakovich. (2003). Watertown, MA: Documentary Educational Resources.

Bali beyond the postcard. (1991). New York: Filmakers Library.

Circles-cycles Kathak dance. (1989). Berkeley, CA: University of CA Extension Media Center.

Classical Indian dance. (1994). Princeton, NJ: Films for the Humanities & Sciences. *Cosmic dance of Shiva.* (1992). Madison, CT: Audio-Forum. *Folkloric dances of Mexico.* (1990). Bellaire, TX: Inside Mexico.

Khmer court dance: Cambodian royal court dances. (1995). Montpelier, VT: Multicultural Media Video Series.

Kumu hula: Keepers of a culture. (1990). New York: Rhapsody Films.

Kwakiutl life on the northwest coast. (In the land of the headhunters). (1992). New York: Milestone Film and Video.

Oggun. (1991). Havana, Cuba: Imagenes.

Potlatch: A strict law bids us dance. (1975). Vancouver, B.C.: Gastown Post & Transfer. *Samba da criacao do mundo.* (1978). New York: Cinema Guild.

Seraikella chhua: The masked dance of India. (1980). Lansing, MI: Instructional Media Center.

Sunrise dance. (1994). New York: Filmakers Library.

Swingin' at the Savoy, Frankie Manning's story. (1995). Seattle, WA: Living Traditions.

Tango, baile nuestra. (1994). Chicago, IL: Facets Video.

Tango es una historia. (1983). New York: First Run/ Icarus Films.

The world ofAmerican Indian dance. (2003). Mountain Lakes, NJ: DVD International.

Three worlds of Bali. (1988). Alexandria, VA: PBS Video.

Ke kulana he mahu (Remembering a sense of place). (2001). Honolulu, HI: Zang Pictures, Inc.

Maps

The Nations of the World

© MAGELLAN Geographix℠Santa Barbara, CA (800) 929-4MAP Robinson Projection

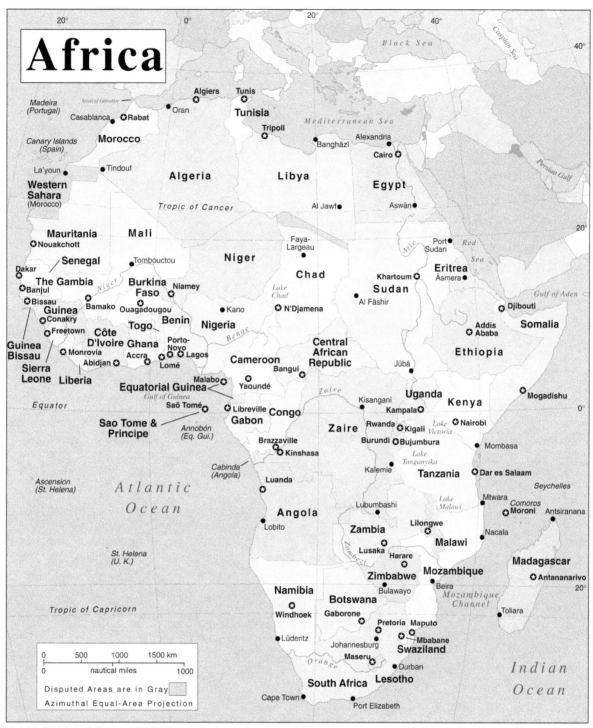

Africa

20° 0° 20° 40°

Black Sea Caspian Sea 40°

Algiers Tunis
Oran **Tunisia**
Casablanca ⊕Rabat **Tripoli** Mediterranean Sea Alexandria
Madeira
(Portugal) Strait of Gibraltar Banghāzī Cairo ⊕

Morocco Persian Gulf

Canary Islands
(Spain) **Libya** **Egypt** 20°

La'youn ⊕Tindouf **Algeria**
**Western
Sahara**
(Morocco) Tropic of Cancer Al Jawf⊕ Aswān⊕

Faya-
Largeau Port
Sudan Red
Sea
Mauritania **Mali** **Niger** Nile
⊕Nouakchott **Chad** Khartoum⊕ **Eritrea**
Senegal Tombouctou Āsmera⊕
Dakar **Burkina** Niamey **Sudan** Gulf of Aden
The Gambia Niger **Faso** Al Fāshir Djibouti⊕
⊕Banjul ⊕ N'Djamena Addis
⊕Bissau Bamako Ouagadougou ⊕Kano ⊕N'Djamena Ababa **Somalia**
Guinea **Benin** **Nigeria** Benue **Central** **Ethiopia**
⊕Conakry **Togo** Porto- **African**
⊕Freetown **Côte** **Ghana** Novo **Cameroon** **Republic** Jūbā⊕
Guinea **D'Ivoire** Accra⊕ ⊕Lagos Bangui⊕ Mogadishu⊕
Bissau ⊕Monrovia ⊕ Lomé Yaoundé⊕ **Uganda** **Kenya**
Sierra Abidjan⊕ Malabo⊕ Kisangani⊕ Kampala⊕
Leone **Liberia** Equator **Equatorial Guinea** Zaïre **Rwanda** ⊕Nairobi
Saõ Tomé⊕ ⊕Libreville **Congo** ⊕Kigali Lake 0°
Gulf of Guinea **Gabon** **Zaïre** **Burundi** Victoria
Sao Tome & Annobón Brazzaville ⊕Bujumbura ⊕Mombasa
Principe (Eq. Gui.) ⊕Kinshasa Lake
Cabinda Kalemie Tanganyika **Tanzania** ⊕Dar es Salaam
(Angola) Luanda Seychelles
Ascension ⊕ Lake Mtwara Antsiranana
(St. Helena) Atlantic Lubumbashi Malawi ⊕Moroni Comoros
Ocean **Angola** **Lilongwe**⊕ Nacala **Madagascar**
Lobito **Zambia** **Malawi**
St. Helena Lusaka⊕ Harare ⊕Antananarivo
(U. K.) Zambezi ⊕ **Mozambique** 20°
Zimbabwe Beira
Tropic of Capricorn **Namibia** Bulawayo Mozambique
Botswana Channel Toliara
Gaborone Pretoria Maputo
⊕Windhoek ⊕ ⊕ ⊕Mbabane
Lüderitz Johannesburg **Swaziland**
Maseru⊕ Indian
South Africa ⊕Durban Ocean
Cape Town⊕ **Lesotho**
Orange Port Elizabeth

0 500 1000 1500 km
0 nautical miles 1000
Disputed Areas are in Gray
Azimuthal Equal-Area Projection

© MAGELLAN Geographix℠Santa Barbara, CA (800) 929-4MAP

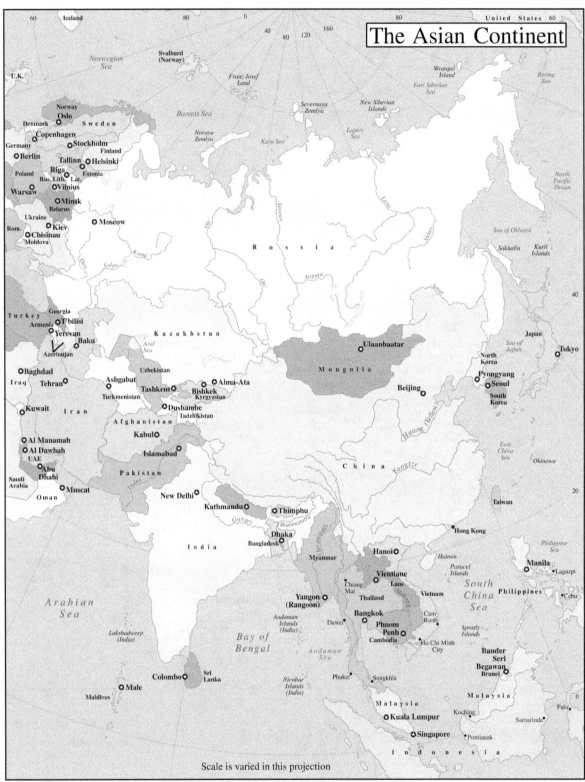

The Asian Continent

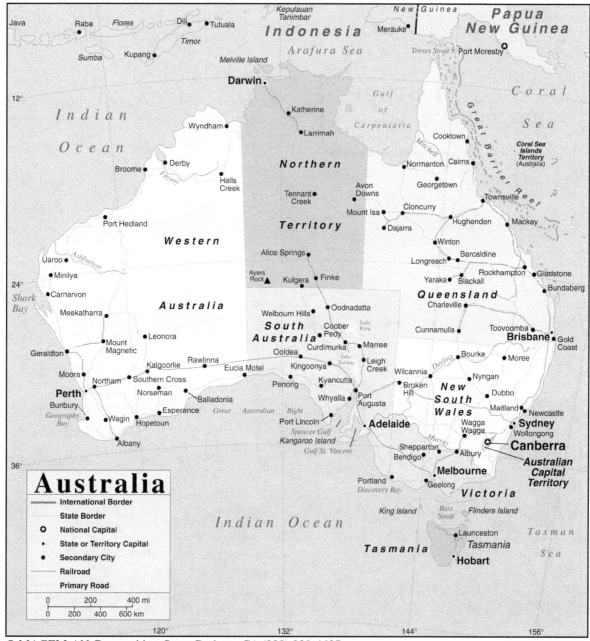

Australia

	International Border
	State Border
✪	National Capital
•	State or Territory Capital
●	Secondary City
	Railroad
	Primary Road

0 200 400 mi
0 200 400 600 km

© MAGELLAN Geographix℠ Santa Barbara, CA (800) 929-4627

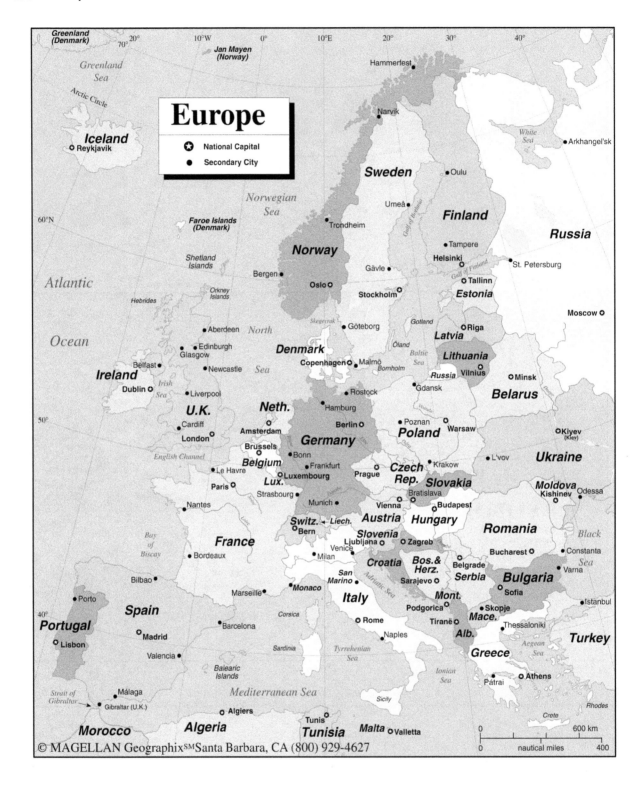

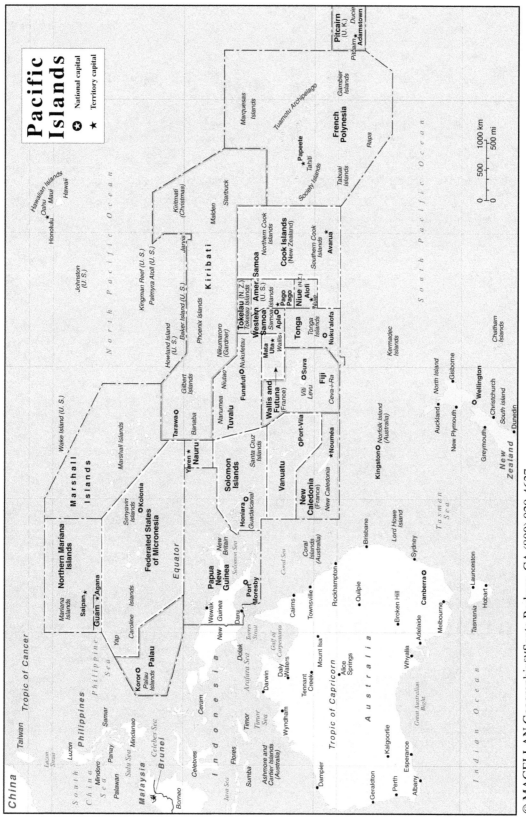

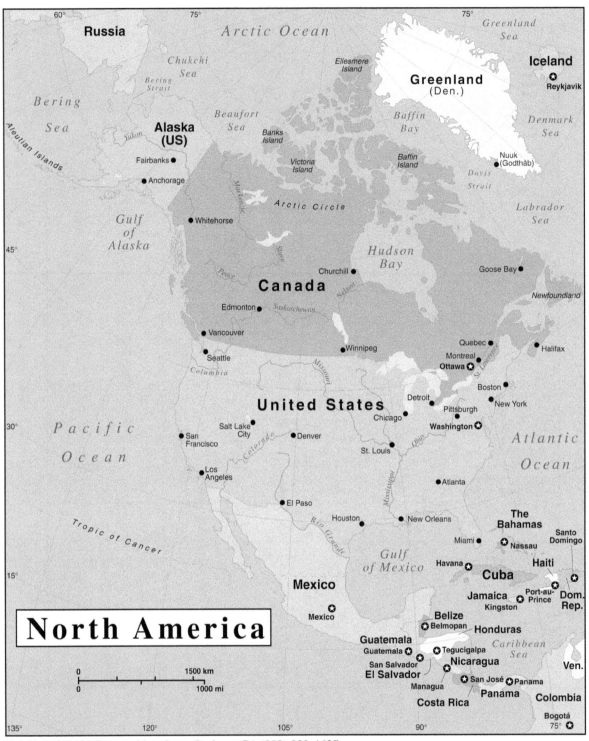

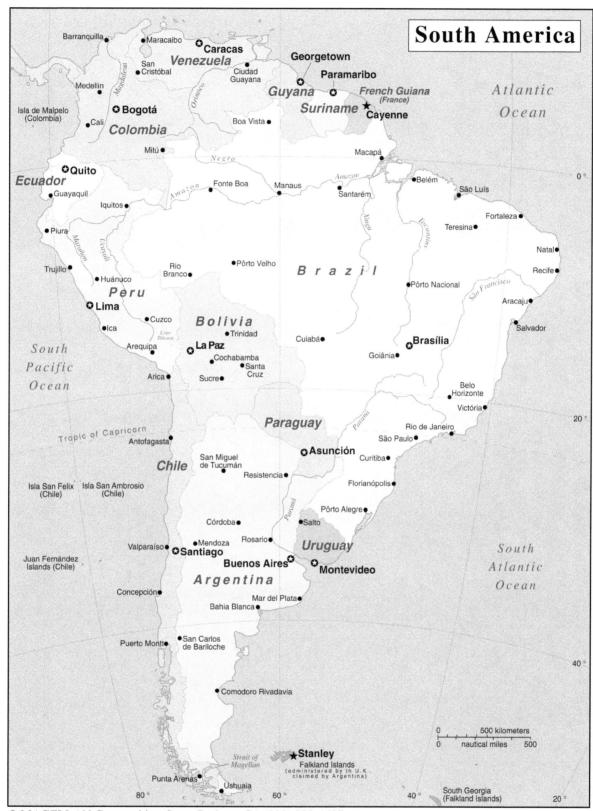

South America

Barranquilla
Maracaibo
Caracas
Georgetown
Venezuela
San
Cristóbal
Ciudad
Guayana
Paramaribo
Medellin
Guyana
French Guiana
(France)
Suriname
Cayenne
Bogotá
Atlantic
Ocean
Cali
Boa Vista
Colombia
Macapá
Mitú
Negro
0°
Amazon
Quito
Belém
Fonte Boa
Manaus
São Luís
Ecuador
Guayaquil
Santarém
Iquitos
Fortaleza
Teresina
Piura
B r a z i l
Natal
Pôrto Velho
Recife
Trujillo
Rio
Branco
Pôrto Nacional
São Francisco
Huánuco
Aracaju
Peru
Lima
Cuzco
B o l i v i a
Salvador
Ica
Trinidad
Lago
Titicaca
Brasília
La Paz
Cuiabá
Arequipa
Cochabamba
Goiânia
Arica
Santa
Cruz
Sucre
Belo
Horizonte
South
Pacific
Ocean
Victória
Paraná
Paraguay
Rio de Janeiro
20°
Tropic of Capricorn
São Paulo
Antofagasta
San Miguel
de Tucumán
Asunción
Curitiba
Isla San Felix
(Chile)
Isla San Ambrosio
(Chile)
Chile
Resistencia
Florianópolis
Paraná
Córdoba
Pôrto Alegre
Juan Fernández
Islands (Chile)
Valparaíso
Mendoza
Rosario
Salto
South
Santiago
Uruguay
Atlantic
Buenos Aires
Montevideo
Ocean
Argentina
Concepción
Mar del Plata
Bahia Blanca
40°
Puerto Montt
San Carlos
de Bariloche

Comodoro Rivadavia

500 kilometers
0
nautical miles
500

Strait of
Magellan
Stanley
Falkland Islands
(administered by th U.K.,
claimed by Argentina)
Punta Arenas
Ushuaia
80°
60°
40°
South Georgia
(Falkland Islands)
20°

CPSIA information can be obtained
at www.ICGtesting.com
Printed in the USA
LVHW051149101118
596626LV00005B/16/P